CO-MIX

ART SPIEGELMAN

A RETROSPECTIVE OF COMICS, GRAPHICS, AND SCRAPS

DRAWN + QUARTERLY
MONTREAL

FOR RINA ZAVAGLI-MATTOTTI
of the Galerie Martel in Paris, my dear friend
and curator of the exhibition that led to this
book. With impeccable taste, she has
disproven the old saying, "You can't make
a silk purse out of a sow's ear."

THE EXHIBITION:
CO-MIX: A Retrospective of Comics,
Graphics, and Scraps was produced
by 9eArt+ as part of the Festival
International de la Bande Dessinée
in Angoulême, where it was
on display from January 26
to March 5, 2012.

TRAVELING VENUES:
The BPI at the Centre Pompidou
in Paris, France (March 21 to May 21, 2012).
Museum Ludwig in Cologne, Germany
(September 22, 2012 to January 6, 2013).
Vancouver Art Gallery in Vancouver, Canada
(February 16 to June 9, 2013).
The Jewish Museum in New York, United States
(November 8, 2013 to March 30, 2014).

EDITORS:
Tom Devlin, Jeet Heer, Chris Oliveros
GRAPHIC DESIGN:
Philippe Ghielmetti
PRODUCTION ASSISTANCE:
John Kuramoto

This book is an expanded and revised version of
a title published in France in 2012 as a bilingual
edition by Editions Flammarion. Published
by arrangement with Editions Flammarion.

First Drawn & Quarterly edition:
September 2013.
Printed in China.
10 9 8 7 6 5 4 3 2 1

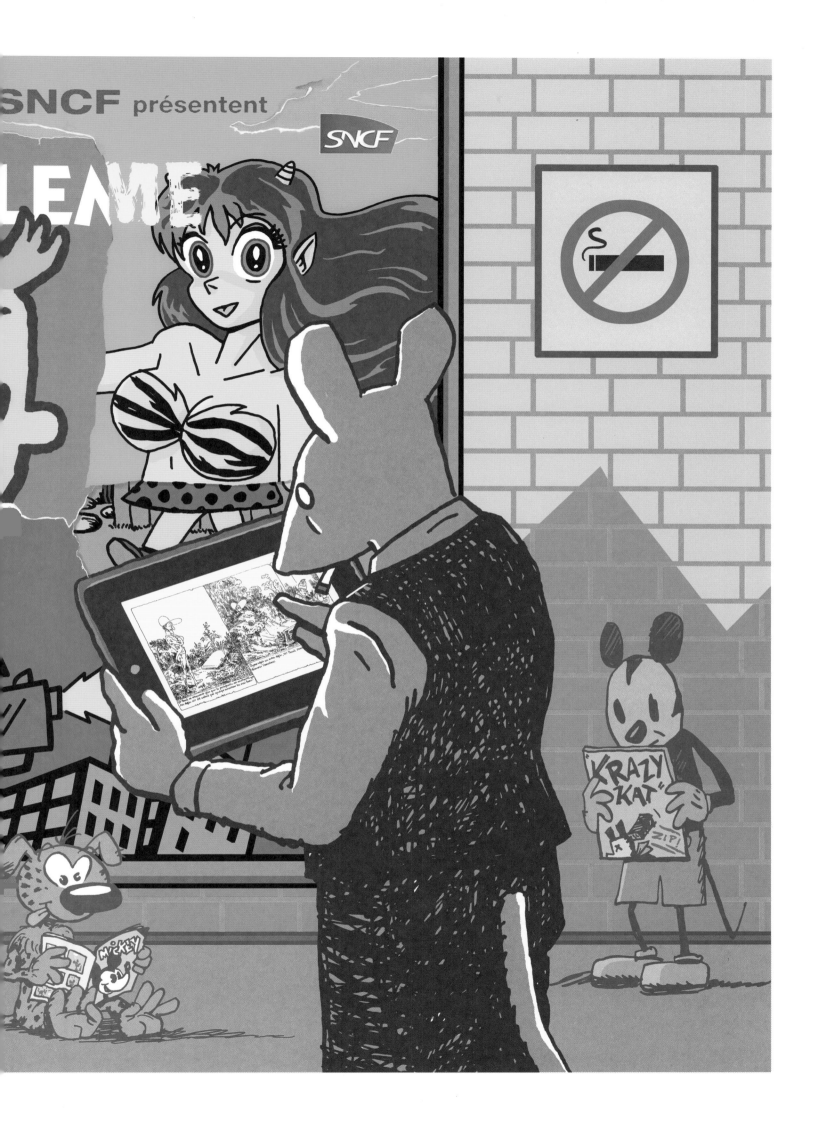

1974 ARTIST'S STATEMENT

Immediately after giving up on the idea of becoming a cowboy or a fireman, I decided to become a big-time syndicated cartoonist. I spent years developing the necessary skills, but then found myself interested in things that weren't necessarily compatible with this goal. I decided to follow my new interests and schlep comics along with me. It's as if I had become a cowboy and later decided to become an opera star. I'd sing arias while swinging a lariat.

Good comix are nourishing comix—unlike the Hostess Twinkies to be found in most children's comic books or in newspaper funny sections. The comix I like, and try to do, can be read slowly and often. Hopefully each reading serves up something new. I try to make every panel count and sometimes work as long as a month on a page. It's like concentrated orange juice.

Although I'm still concerned with the narrative and comic aspects of comix, I am also excited by the "secret language" of comix—the underlying formal elements that create the illusions. As an art form, the comic strip is barely past its infancy. So am I. Maybe we'll grow up together.
ART SPIEGELMAN, *The Apex Treasury of Underground Comix*, 1974

1978 THREE QUOTATIONS FROM ART SPIEGELMAN'S INTRODUCTION TO *BREAKDOWNS*

"If the author of this little volume is an artist, he draws poorly, but he has a certain knack for writing... if he's a writer, he's just middling, but to make up for that he has a nice little flair for drawing."
RODOLPH TÖPFFER, comic-strip artist, 1837

"My dictionary defines COMIC STRIP as a 'narrative series of cartoons.' A NARRATIVE is defined as 'a story.' Most definitions of STORY leave me cold. Except the one that says: 'A complete horizontal division of a building... [from Medieval Latin HISTORIA... a row of windows with pictures on them].' The word CARTOON implies humorous intent... a desire to amuse and entertain. I'm not *necessarily* interested in entertainment... in creating diversions. Better than CARTOONS is the word DRAWINGS; or better still... DIAGRAMS." **ART SPIEGELMAN**

"It is up to the careful comic artist to see that he offends no one, hurts no group and that his strip is all in good, clean fun. All in all, drawing comic strips is very interesting in a dull, monotonous sort of way."
CHIC YOUNG, creator of *Blondie*

CONTENTS

9 DRAWING HIS OWN CONCLUSIONS: THE ART OF SPIEGELMAN by J. Hobermann

14 EARLY WORKS

17 UNDERGROUND

24 TOPPS

26 BREAKDOWNS

32 BORIS VIAN

34 RAW

40 MAUS

48 THE WILD PARTY

54 THE NEW YORKER

62 IN THE SHADOW OF NO TOWERS

66 KIDS' COMICS

72 COMICS SUPPLEMENT

91 PORTRAIT OF THE ARTIST AS A YOUNG %@?*!

94 ILLUSTRATIONS AND VARIOUS SCRAPS

99 SKETCHBOOKS

104 COLLABORATIONS

106 IT WAS TODAY, ONLY YESTERDAY...

114 LITHOGRAPHY

126 MAKING *MAUS* by Robert Storr

132 CHRONOLOGY

136 BIBLIOGRAPHY AND EXHIBITS

2012 AN ARTIST'S PROGRESS. DETAILS FROM *IT WAS TODAY, ONLY YESTERDAY...*

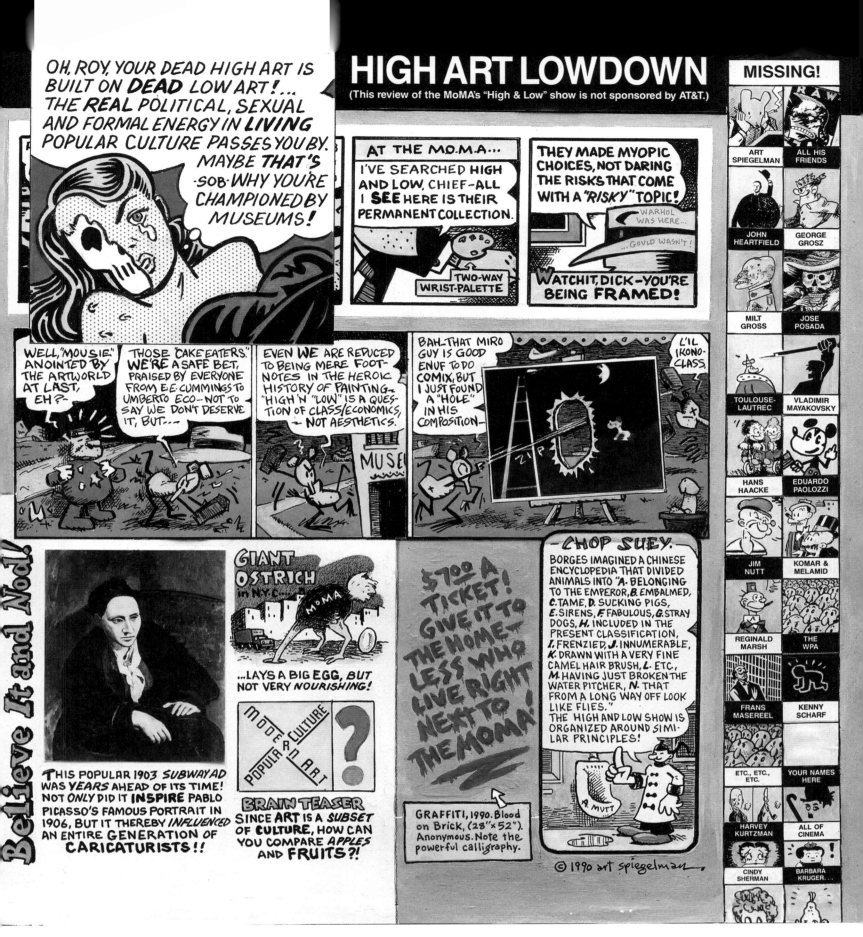

CO-MIX: TR. V. To mix together. As in words and pictures.

A review in comics form of the Museum of Modern Art exhibition, *High and Low: Modern Art and Popular Culture*, a project for *Artforum*, December 1990.

COVER: *Comics as a Medium for Self Expression?* Ink and watercolor on paper. Cover, *Print* magazine, May–June 1981.

FRONT ENDPAPER: *Crash!* Pencil and crayons on paper. *Lead Pipe Sunday* no. 2, 1997.

PAGE 2: Back cover for *In the Shadow of No Towers*, 2004. Ink on tracing paper.

TITLE PAGE: *Art Spiegelman. Megalomaniac with an Inferiority Complex*, 2007. Sketchbook page.

Nude Self-Portrait, india ink and colored pencil. 1999.

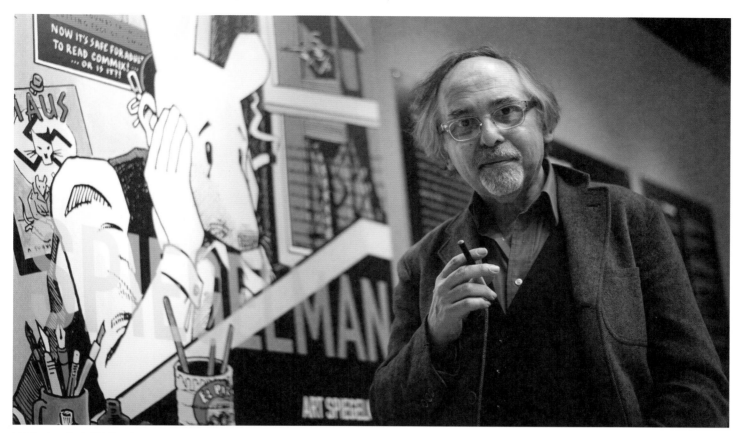

Art Spiegelman, March 2012. Photo Copyright 2013 Bertrand Langlois/Getty Images.

DRAWING HIS OWN CONCLUSIONS: THE ART OF SPIEGELMAN

J. Hoberman

In the dime stores and bus stations, People talk of situations, Read books, repeat quotations, Draw conclusions on the wall.
—**BOB DYLAN**, "Love Minus Zero/No Limit" (1965)

It's a truism that popular culture and the avant-garde arrive on the same train at the same station and the same historic moment in response to the same historical processes—industrialization, urbanization, the development of the mass market, and the rise of mechanical reproduction. Neither form of culture conceivable before the mid-nineteenth century, they represent the two poles of modern art—not to mention the two sides of the unique master (and meta-) cartoonist, Art Spiegelman.

A member of the underground comix movement that, initially associated with R. Crumb's *Zap* comics, coalesced out of the late 1960s counterculture, Spiegelman is a workmanlike draftsman with a varied personal style. His drawing may lack Crumb's virtuoso fluency or the charmingly stilted primitivism of a Kim Deitch, but as an artist, Spiegelman has learned how to make his limitations work for him. His gift is for design; his genius is manifest in his profound understanding of his medium (and his particular condition) and—at all times evident—his intellectual concepts. With the art of Art Spiegelman, the making of cartoons and comic books reaches an unprecedented degree of historical consciousness, formal innovation, and personal self-awareness.

Roy Lichtenstein achieved art-world celebrity by turning simple-minded comic strips into boldly simplified canvases. Spiegelman took the discoveries of Lichtenstein's precursors, Picasso, Schwitters, and Duchamp, to make comic strips as complex as anyone's paintings. The tension between the marginal avant-gardist and the mass-market audience informs the entire Spiegelman enterprise. It is present in his work as an underground cartoonist, as a graphic "fine" artist, as the creator of a schoolyard craze, as the co-editor of two influential magazines (*Arcade* and *RAW*), and as a contributor to other journals, as a designer of book and CD jackets (typically for such pop culture vanguardists as faux noir-iste Boris Vian or musique concrète primitive Spike Jones), as the compiler (along with Bob Schneider) of the 1973 hippie Bartlett's *Whole Grains*, and as a provocateur and a promoter of fellow cartoonists.

It is further evident in his writings (uniformly excellent and fully deserving of a single volume anthology), his theatrical designs and public art works, his connoisseurship of obsolete mass-cultural forms, and of course, his magnum opus, *Maus*. This—how shall we say?—sui generis novelistic but true-life memoir in comic-book form, long-germinating, immediately recognized, greeted on publication with unprecedented accolades, including a Pulitzer Prize and an exhibition at the Museum of Modern Art, is also an international best seller, subsequently translated into twenty-six languages.

In short, Spiegelman confounds the high/low paradigm at every level. Who is to say that the wildly popular, intentionally disgusting and/or subversive trading cards—Wacky Packs and Garbage Pail Kids—that the artist conceived and designed for the Topps bubblegum company while working on *Maus* are any less scandalous than the incendiary visual puns of his *New Yorker* covers, or an any less consequential form of public address? Indeed, as grotesque caricature in the tradition of comic-book artist Basil Wolverton, Spiegelman's Garbage Pail Kids may actually have greater graphic pow than his magazine covers.[1]

The fact is that, in creating his own tradition, Spiegelman has taken as usable culture everything from the Swiss educator and author Rudolph Töpffer's nineteenth-century comic strips and Frans Masereel's expressionist graphic novels to the maps and architectural drawings once a feature of Dell paperback covers and the humorously pornographic eight-pagers popularly known as Tijuana Bibles.

"Eustace Deconstructed." Portfolio, the *New Yorker*, February 22, 1993.

Hot Nuts. Book cover for *The Tiajuana Bible Revival*, a series of anthologies from Belier Press, 1977.

In part, this is because few if any critics have anything approaching Spiegelman's understanding of his medium or encyclopedic knowledge of its history ("as a matter of fact, though nobody has been eager to bring it up before, the Tijuana Bibles were the very first real comic books in America to do more than merely reprint old newspaper strips," he wrote).[2] **In the high modernist tradition** of Joyce, Pound, and Eliot, Spiegelman has frequently been his own most eloquent explicator. The punning title of his first collection, *Breakdowns,* suggests a form of auto-analysis—not just personal but aesthetic as well. In the course of developing his oeuvre, he has, in effect, (re)conceptualized a number of his precursors. The abstract sensationalist Chester Gould (inventor of *Dick Tracy*), the Bronx expressionist Will Eisner (author of *The Spirit*), and the vulgar modernist Harvey Kurtzman (creator of *Mad* magazine), all look different today through the Spiegelman prism—and so, in a way, does the jazzy, economical non-drawing funny animalism of George Herriman's *Krazy Kat*. Comparing the obscure 1940s comic-book artist Henry Fletcher to René Magritte or declaring that Winsor McCay "convincingly mapped out the mind's inner dreamscape decades before [Salvador Dalí] draped a melted clock on a tree," Spiegelman illuminates a form of vernacular Americana and naive surrealism.[3]
But there is nothing naive about his own work.

I sound my barbaric yawp over the roofs of the world.
—**WALT WHITMAN**, "Song of Myself"

What have I in common with Jews? I have hardly anything in common with myself.—**FRANZ KAFKA**, diary entry (January 8, 1914)

The 1990 Museum of Modern Art show *High and Low: Modern Art and Popular Culture* inspired all manner of criticism, disdain, and outright ridicule (including a Dia Center symposium and a special issue of *October*) but nothing was pithier or more intentionally hilarious than the one-page strip Spiegelman drew for the December 1990 issue of *Artforum*: "Oh, Roy, Your Dead High Art is built on Dead Low Art," moans the cartoon babe on a mock Lichtenstein canvas.
Riotously conflating Duchamp's signed urinal with parody of the venerable, aphoristic syndicated daily panel *Ching Chow*, and reinterpreting Picasso's portrait of Gertrude Stein as a subway ad for the hemorrhoid remedy Preparation H ("Believe It and Nod!"), this cleverly titled "High Art Lowdown" is an impossibly busy burlesque. Ignatz Mouse beans Krazy Kat with a brick fired through the negative space of a Miró abstraction while just above, Dick Tracy reports into his two-way wrist-palette: "I've searched High and Low, Chief—All I see here is their permanent collection." (A graffito on his fedora notes that "Warhol was here... Gould wasn't.")[4]
Spiegelman works in the gap between art and commerce, the exalted and the debased, and the private and the public, often without a net.

As demonstrated by his "High Art Lowdown," he is an innately democratic, inherently non-hierarchical artist. (Old newsprint serves as his leaves of grass.) This child of Polish-Jewish wretched refuse (or refugees), socialized by television, politicized by *Mad* magazine, a natural beatnik educated in a New York City trade school, is an all-American boy. The stained-glass windows Spiegelman recently designed for his alma mater, the High School of Art and Design, are not only slyly satiric and spatially complex but, in their address to the students who might follow in the artist's path, positively inspirational and utterly personal: "I sing the song of myself."
A story the artist lived with since childhood, *Maus* had its origins in two short pieces conceived and published in the early 1970s. The first three-page iteration of *Maus* appeared in the 1972 underground comic *Funny Aminals* (edited by Terry Zwigoff), a discomfiting episode of black-humor realness in the context of several routinely randy pieces by Crumb and Bill Griffith's swampy whatsit "The Toadette King." This was followed in 1973 by "Prisoner on the Hell Planet," a first-person account of Spiegelman's mother Anja's suicide four years earlier, which was published as the last story in the first issue of *Short Order Comix* (co-edited by Spiegelman). With characteristic generosity and an acute sense of history, Spiegelman has given Justin Green credit for opening up "confessional autobiography" as an area for cartoonists to

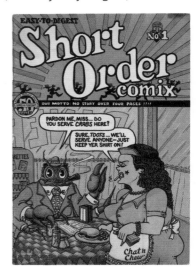

explore, thanks to the forty-four-page single-story comic *Binky Brown Meets the Holy Virgin Mary* (1972). *Maus,* too, has its precursor. A reader of old EC Comics, Spiegelman had long ago discovered Bernard Krigstein's 1955 story "Master Race" (in which a concentration camp survivor recognizes his camp commandant on a New York subway and, amid vivid flashbacks, takes appropriate revenge) and, while a college sophomore, written a formidable frame-by-frame analysis (perhaps yet another comic-book first) for his art history class.
This precocious paper, "Master Race: The Graphic Story as an Art Form," was eventually published in expanded form by the EC Comics fanzine *Squa Tront* in 1975, at a period when Spiegelman's sustained interest in his medium's formal-structural issues—reinforced by his friendships with the avant-garde filmmakers Ken Jacobs and Ernie Gehr—was most pronounced. "Prisoner on the Hell Planet" was not only startling for its portrait-of-the-artist subject matter but also its overt formal qualities—while working with the entire page, Spiegelman imbues individual, obsessively crosshatched, scratchboard-drawn

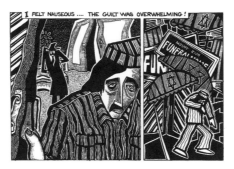

panels with the expressionist energy of Lynd Ward's woodcuts. The often deranged dialogue is integrated into the design while the panel-to-panel breakdown is predicated on a sort of subjective lysergic slippage.

Rough sketch and gag, ink and colored markers on layout paper. Parody magazine cover for Wacky Packages, 1974.

Detail, "Prisoner on the Hell Planet," 1972. A four-page strip about Spiegelman's mother's suicide, incorporated into the 1986 book, *Maus: A Survivor's Tale.* It first appeared in *Short Order Comix* no. 1, 1973.

"Don't Get Around Much Anymore" (a one-page strip produced after "Prisoner on the Hell Planet" in 1973 and placed on the inside cover of *Short Order*'s second and last issue) was an overtly cubist comic strip—a non-linear non-narrative incorporating collage and multiple perspective, as much designed as drawn. (At the same time, it was an homage to Chester Gould's *Dick Tracy*, a strip that—still drawn in the 1970s—had grown increasingly abstract and anticipated the work Chris Ware would produce some twenty-five years later.) "Don't Get Around Much" was the set up for the overtly avant-garde "Ace Hole, Midget Detective," the eight-page story with which *Short Order* no. 2 ended. This deconstructed comic strip noir was Spiegelman's most ambitious strip to date—one need only compare it to the relatively straightforward "Viper" stories he published in Roger Brand's *Real Pulp Comics* (1971) and *Bijou Funnies* no. 7 (1972), which put the "Vicar of Vice, Villainy, and Vickedness" on its cover, to see how Spiegelman's notion of genre and the comic-book medium had undergone a remarkable growth spurt.

Subsequent work would be notable for its self-reflexive approach both to the comic-strip medium and the media itself. "Little Signs of Passion," the three-page story published in the fourth, full-color issue of *Young Lust* (1974) not only riffs on pornographic movies but color-separated printing and the idea of narrative. Spiegelman's contribution to the first issue of *Arcade*, a quarterly magazine that he and

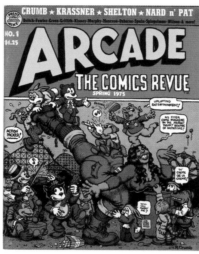

Griffith conceived in 1975 as a "lifeboat" for their mainly San Francisco–based cohort of underground comix artists, was a deliriously Freudian explication of humor, "Cracking Jokes." Featured in the fourth issue of *Arcade*, the four-page soap-opera travesty "As the Mind Reels" (1975), an homage to the Will Elder-drawn *Mad* magazine satires of the early 1950s, was Spiegelman's most densely drawn strip since "Prisoner on the Hell Planet." More radical, however, was the two-page collage-driven "Nervous Rex: The Malpractice Suite" (1976), more savage in its technique than "Don't Get Around Much Anymore," which appeared in *Arcade*'s sixth, penultimate issue.

Closely associated with R. Crumb (who furnished the magazine's first four covers and its sixth) as well as with Griffith (who had a major story in each issue), and replete with beatnik literature (illustrated stories by Charles Bukowski, William Burroughs, and Paul Krassner), *Arcade* may be considered the culmination of San Francisco underground comix; it also made Spiegelman, who (as detailed in a one-page story for the third issue) had moved back to New York in 1975, a leading creative force within the movement—and a controversial one. "Crumb and I had interesting arguments about the whole 'genteel versus vulgar' tension of comics," Spiegelman would later tell Andrea Juno. "After *Arcade*, [Crumb] went off and edited *Weirdo* comics. I went off and did *RAW* magazine… definitely tugging things toward a more elegant presentation, selecting work by people who were conscious of themselves as artists."[5]

***RAW*, which was edited by** Spiegelman and his wife, Françoise Mouly, had a new orientation. (The self-descriptive subtitle changed with each issue, e.g., "The Magazine That Lost Its Faith in Nihilism.") None of the

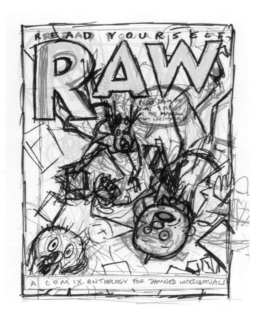

San Francisco artists were included in the first issue, dated Fall 1980, and there were as many European artists as there were Americans (all from New York City). In addition to the cover, Spiegelman's contribution was a tipped-in, full-color comic book, *Two-Fisted Painters*, that continued the formal explorations of his *Arcade* period. In the second issue of *RAW*, however, Spiegelman's tipped-in comic book was the first chapter of

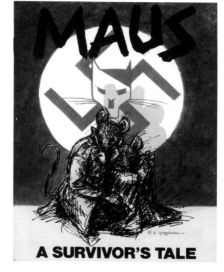

Maus; each of the next six issues (which introduced a range of new artists including Mark Beyer, Charles Burns, Sue Coe, Drew Friedman, Ben Katchor, Mariscal, Gary Panter, and Joost Swarte) would include another chapter. After the publication of *Maus I* in 1986, *RAW* changed format and became a trade paperback; the three last issues each contained a new chapter of *Maus*. After *RAW* folded, Spiegelman continued serializing *Maus* in the weekly *Forward* (the English-language offspring of New York's lone surviving Yiddish-language newspaper) until the concluding volume was published in 1992.[6]

The creation of *Maus*, which, *RAW* aside, would be Spiegelman's preoccupation for a dozen years, compelled him to draw on everything he knew (about comics) and had experienced (in life). To have told his parents' story in the sort of tight, highly crafted pages of "Prisoner on the Hell Planet" would have been unbearable; rather, the artist developed a deceptively loose style that, incorporating his father's voice along with his own, created an unprecedented interplay of form and content.

***Maus* further raised questions** that necessarily took Spiegelman beyond his personal concerns, taking him to the heart of twentieth-century darkness. There's an innate tension between the historical event now known as the Holocaust and the dynamics of popular culture. The issue, in making art of genocide, is always one of representation—how to show the unshowable without betraying or trivializing it. The issue with popular culture is typically one of resolution—how to wring closure, comfort, and a measure of recuperation from a monstrous situation.[7]

By casting the World War II survival story of the two Polish Jews who would become his parents with barnyard animals (Jews as mice, Poles as pigs, Germans as cats), Spiegelman engaged the issue of representation head-on. On one hand, the artist adopted a metaphor already latent in Franz Kafka (see "Josephine, the Mouse Singer") as well as a well-worn trope of anti-Semitic Nazi propaganda (see, or rather don't, the 1941 Nazi pseudo-documentary *The Eternal Jew*).

Spiegelman's use of funny animals was also founded upon a radical understanding of his medium: "The stereotype was invented early in the eighteenth century as a way of making relief-printing plates from paper pulp molds," he would later explain. "It's the way newspaper comics' plates were made until new technologies overtook the business in the 1960s. So comic strips were literally as well as figuratively generated from stereotypes."[8]

Generated from but not necessarily dependent on: using blatant cartoon stand-ins—radically simplified, uncannily expressive—for actual people and events, Spiegelman compelled the reader to *see through them*. No less impressively, he sidestepped the accepted

Arcade no. 1, 1974.

Cover for *Maus* Chapter One, an insert booklet from *Raw* no. 2, 1980.
Sketch for *Read Yourself Raw* cover, 1987.

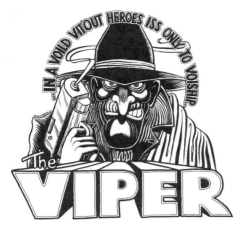

notion of cultural production by presenting this atrocious story as a comic book. In what must be the most widely quoted (and misunderstood) of twentieth-century observations, Theodor Adorno—an assimilated German Jew and leftist who managed to escape the Third Reich and survive World War II in the United States—had asserted that Auschwitz was an aesthetic game-changer. After the destruction of Western civilization and organized genocide orchestrated by the Nazis, poetry would necessarily be barbaric. (Poetry, not poetry-making.)

Along with the brutally laconic tales of the Polish concentration camp inmate Tadeusz Borowski's *This Way for the Gas, Ladies and Gentlemen* (the title tells all) or amateur filmmaker Claude Lanzmann's ineffably rude and excessively long documentary *Shoah, Maus* is one such barbaric poem. Asked by a German journalist if he didn't think that a comic book about Auschwitz was in bad taste, Spiegelman replied in the negative: "No, I thought Auschwitz was in bad taste."[9]

Put another way *Maus*, like Charles Chaplin's two-reelers and Louis Armstrong's early 78s over a half-century before, explores the distinction between high and low. The unbearable poignance of its final panel—balanced on a tombstone—brings together, in one image and two dialogue balloons, the accumulated weight of memory, representation, and impossible knowledge. (In this sense, as in others, *Maus* is the antithesis of the civilized feel-good literalism of Spielberg's Oscar-winning *Schindler's List*.) Remarkably, the first *New York Times* best seller on the subject of the Holocaust, *Maus* provoked another debate when the newspaper initially listed it among the fictional best sellers. A comic book can be true!?!

Spiegelman's allegiance to historical *vérité* and the authenticity of his work is underscored by his insistence on *Maus*'s integrity as lines on paper: "Many people have approached me about turning *Maus* into

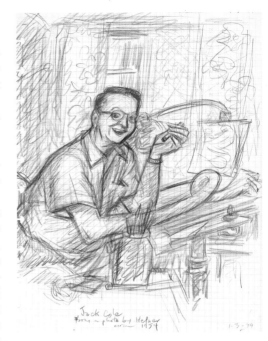

Jack Cole from a photo by Hefner circa 1958

illustrating Spiegelman's assertion that "All comic-strip drawings must function as diagrams, simplified picture-words that indicate more than they show."[12]

Spiegelman's highly diagrammatic drawings are infused with ideas; indeed, it was Spiegelman who, more than anyone else, taught intellectuals to read comic books without embarrassment and his example allowed younger artists like Ben Katchor and Chris Ware to cross over into the art world while remaining true to a medium that, per Spiegelman, has been for most of its 150-year history "the

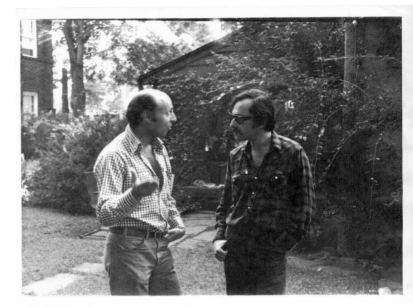

hunchback half-witted bastard step-child of the graphic arts." His is a comic-book way of knowledge.[13]

In the years since *Maus*, Spiegelman has brought his comic-book way of knowledge into other media (the unproduced opera *Drawn to Death*, the windows created for New York's High School of Art and Design, a performance conceived in collaboration with the dance troupe Pilobolus) while continuing to mine the history of the medium and his involvement with it. His marvelous monograph *Jack Cole and Plastic Man* (2001) is a tribute to a terrific, underappreciated artist and his greatest creation: "Plas literally *embodied* the comic-book form: its exuberant energy, its flexibility, its boyishness, and its only partially sublimated sexuality," Spiegelman writes. "The idea of a hard-core version of Plastic Man boggles the mind—but there was a polymorphously perverse quality to a character who personified Georges Bataille's notion of the body on the brink of dissolving its borders."[14]

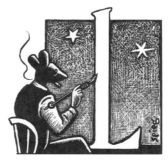

In 2010, Spiegelman was enlisted to escort the pioneer graphic novelist Lynd Ward into the Library of America; his introduction is not only a brilliant explication of Ward's work but includes a touching personal memoir of a chance meeting with the aged artist. **Spiegelman contributed** cartoon appreciations of elders like

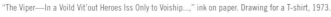

a film, and I've always resisted. I was offered one thing where I would have final cut, and I said. 'I don't want final cut. I don't want to make a movie.' And they said, 'But if you did want to make a movie, how would you do it?' I said, 'All right, I'd use real mice.'"[10]

Did you know that Gustave Doré started out by being essentially a comic book artist? **ART SPIEGELMAN,** 1980

***RAW* was notable** for reprinting the work of newspaper cartoonists, including Winsor McCay, George Herriman, and Milt Gross. In its final issue it even delved as far back as the nineteenth century, with the inclusion of the 1852 story, "A Fulfilling Career," by Gustave Doré. Not just an artist, Spiegelman is a scholar who approaches his chosen medium as both a historian and a theorist, couching both history and theory equally in pictures and words. "Don't Get Around Much Anymore" is, in effect, a manifesto

"The Viper—In a Voild Vit'out Heroes Iss Only to Voiship...," ink on paper. Drawing for a T-shirt, 1973.

"Head," pastel. 1982.

Portrait of Jack Cole, sketchbook drawing from 1999. Drawn from a 1958 photo by Hugh Hefner. Spiegelman with Harvey Kurtzman at his Mount Vernon home, circa 1973. (Photo: Jay Lynch)
Initial capital scratchboard drawing for "Reading Pictures," in Lynd Ward, *Six Novels in Woodcuts*, edited by Art Spiegelman. The Library of America, 2010.

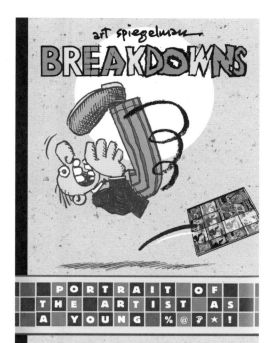

Maurice Sendak and Charles Schulz to the *New Yorker*, as well as an affecting obituary for his designated mentor Harvey Kurtzman.

Kurtzman is the single most important cartoonist in my personal pantheon, the reason I, and many cartoonists of my generation, became cartoonists in the first place. There was something genuinely subversive about his MAD... It was in the best vulgar comics tradition, yet was informed by a high moral and aesthetic intelligence. It was about something—reality for want of a better word—and was also highly self-reflexive, satirically questioning not only the world, but the underlying premises of the comics medium through which it asked the questions.[15] In thus praising Kurtzman, Spiegelman is also speaking of himself and his own enterprise.

In the Shadow of No Towers (2004) is at once a personal response to the events of 9/11, which Spiegelman and his family witnessed live and up close, a tribute to and an essay on the broadsheet comics of the early twentieth century, and a splendidly uncompromising book object; the nineteen-page introduction to the new 2008 edition of *Breakdowns* is, in its intricate cross references, graphic playfulness, and ruthless self-analysis, a mature successor to "Prisoner on the Hell Planet" and an accomplishment fully worthy of the author of *Maus*; and, in the writing of *MetaMaus* (2011), Spiegelman has done a heroic job in providing a twenty-first-century addendum to his own twentieth-century classic. (It's also a great book object.)

MetaMaus may finally exorcise Spiegelman's demons but I somehow doubt it—his subject, after all, is reality and the conclusions he can draw from it. Over the course of four decades, he has given a new meaning to the term *comic-book artist*—or perhaps it would be more accurate to say that Spiegelman has given new meaning to the terms *comic book* and *artist*.

J. Hoberman, who can remember smoking pot and reading *Dr. Strange* comics in Artie Spiegelman's Harpur College dorm room, was a film critic at the *Village Voice* for over thirty years. He is the author, co-author or editor of twelve books, most recently *Film After Film: (Or, What Became of 21st Century Cinema?)* published by Verso books in 2012.

Notes

1. Not to mention social significance: Spiegelman was delighted to learn that the Treasurer of West Virginia attempted to have Garbage Pail Kids banned for inculcating young children with a sense of irony and protest. Art Spiegelman, "The Organization Man in the Gray Flannel Jungle," *Harvey Kurtzman's Jungle Book* (San Francisco: Kitchen Sink Press, 1986), reprinted in Art Spiegelman, *Comix, Essays, Graphics and Scraps: From Maus to Now to Maus to Now* (Rio de Janeiro: Centro Cultural Banco do Brasil, 1998).

2. Art Spiegelman, "Dirty Little Books," *Tijuana Bibles: Art and Wit in America's Forbidden Funnies, 1930s-1950s* (New York: Simon & Schuster, 1997).

3. Art Spiegelman, "Comix: An Idiosyncratic Historical and Aesthetic Overview," *Comix, Essays, Graphics and Scraps*; Art Spiegelman, "Winsor McCay: Beautiful Dreamer," *USA Today*, June 23, 1987.

4. The same year, Spiegelman was involved in another sort of High Lowdown, producing the eleven-pass color lithograph *Lead Pipe Sunday*, homage to the Sunday comic supplements of the early twentieth century.

5. Andrea Juno, *Dangerous Drawings* (New York: powerHouse Books, 1997), reprinted in *Art Spiegelman Conversations*, ed. Joseph Witek (Jackson: University Press of Mississippi, 2007). The two-page "Art Drawings by Crumb" spread in *Weirdo* no. 2 might be considered Crumb's riposte to Spiegelman's interests. In any case, Crumb contributed a story to *RAW* no. 7 and furnished the cover of its last issue in 1991.

6. In 1992, Spiegelman and, soon after, Mouly were hired by the new *New Yorker* editor Tina Brown; given the notoriety of Spiegelman's covers and the number of associate artists that Mouly introduced into the graphically revitalized magazine, the post-Brown *New Yorker* might be considered the continuation of *RAW* by other means.

7. See, for example, the oeuvre of Spiegelman's contemporary and near homonym, Steven Spielberg. Indeed, Spielberg had already appropriated Spiegelman's Jews-as-mice metaphor in his animated features, the 1986 *An American Tail* and its 1991 sequel *Fievel Goes West*.

8. Art Spiegelman, "Little Orphan Annie's Eyeballs," *The Nation*, January 17, 1994, included in "The Complete Maus Files" [DVD], Art Spiegelman, *MetaMaus* (New York: Pantheon, 2011).

9. Art Spiegelman, *MetaMaus*, 155. It's worth noting that the Holocaust's most celebrated literary iteration is a teenage girl's diary and, however precocious in its writing and poignant in its prescience, essentially subliterary. *Maus* raises other questions regarding literary propriety. Although these aspects of the book have been largely overshadowed by its graphic elements, *Maus* is both a further refinement of the so-called nonfiction novel and as well as an innovative contribution to the practice of oral history.

10. Ella Taylor, "The 5,000 Pound Maus: On the Anniversary of Kristallnacht, Art Spiegelman Revisits His Legacy," *LA Weekly*, November 13–19, 1998, reprinted in *Art Spiegelman Conversations*, 1994.

11. Dean Mullaney, "*RAW* Magazine: An Interview with Art Spiegelman and Françoise Mouly," *Comics Feature* 4 (July–August 1980), reprinted in *Art Spiegelman Conversations*.

12. Art Spiegelman, "Don't Get Around Much Anymore: A Guided Tour," *Alternative Media* (Fall 1978).

13. Art Spiegelman, "Comix: An Idiosyncratic Historical and Aesthetic Overview," *Comix, Essays, Graphics and Scraps*. A telling example of Spiegelman's comic-book karma: The artist, an early appreciator of Philip K. Dick ("when I was in college, he was the only person describing accurately the same border problems I was having—not being able to figure out where I ended off and everybody else began—not being able to figure out what I was causing and what was being caused onto me ...") when he chanced upon a copy of Dick's *Zap Gun* on a drugstore rack. "The blurb said, 'A world gone mad and only a cartoonist can save them.' It was one of those messages—I thought, I was meant to buy this book." Andrea Juno, *Dangerous Drawings*, reprinted in *Art Spiegelman Conversations*. Another example of the comic-book way of knowledge is implicit in Spiegelman's work for children, including various anthologies edited in collaboration with Mouly.

14. Almost better than the book is the April 19, 1999, issue of the *New Yorker* in which a version of Spiegelman's essay first appeared; he managed to commandeer the cover for an image of Plastic Man visiting a modern art museum, craning his neck around the crowd of gawkers appreciating two Picasso-like canvases, one of a screaming horse and the other, a blue minotaur.

15. In Art Spiegelman, "Comix: An Idiosyncratic Historical and Aesthetic Overview," *Comix, Essays, Graphics and Scraps*, 78.

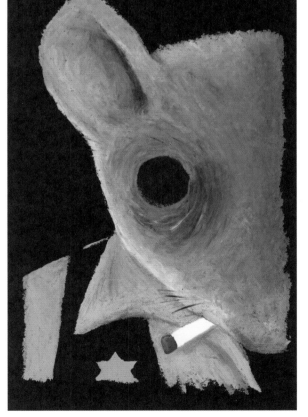

Breakdowns, Portrait of the Artist as a Young %@$!, 2008.*

MetaMaus. Book cover drawing, Pastel. 2010.

Spiegelman has said, "As soon as I was old enough to realize that cartoons were made by *people*—not natural phenomena like rocks and trees—I only wanted to be one of the people who made them." By the time he was fifteen years old he was contributing to the nascent world of humor fanzines (and even published two issues of his own primitive "crudzine," *Blasé),* editing his school's newspaper at the High School of Art and Design (a NYC vocational school that offered cartooning as a major), and drawing regularly for a local weekly newspaper in Queens. These beginnings led directly to his twenty year long relationship with Topps Chewing Gum, and to his regular contributions to alternative press magazines like EC cartoonist Wally Wood's proto-underground *Witzend,* Paul Krassner's seminal *Realist* magazine, and underground newspapers like the *East Village Other.*

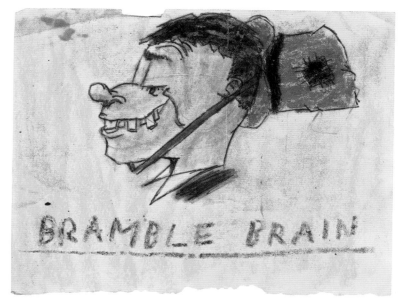

"Bramble Brain," ballpoint pen and crayolas, circa 1958.

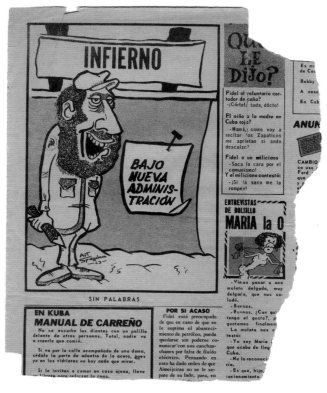

"Hell, Under New Management," drawn for the anti-Castro weekly, *Zig Zag Libre.* Spiegelman referred to himself as an "apolitical fifteen-year-old anglophone," but he took on the job because Antonio Prohias—creator of *Mad*'s Spy vs Spy—was a regular contributor to the paper. 1963.

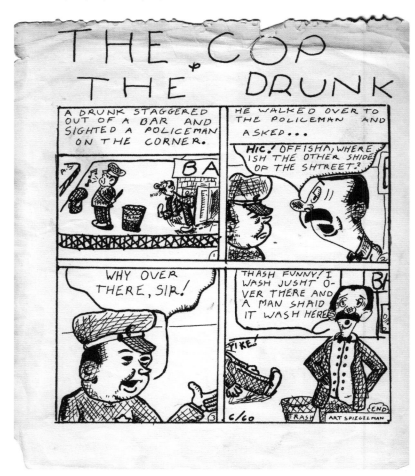

"The Cop and the Drunk," india ink on paper. The first comic strip the artist drew, at age twelve, June 1960.

Page for *Wild* no. 9, a fanzine that also featured future underground comix stars Jay Lynch and Skip Williamson. 1962.

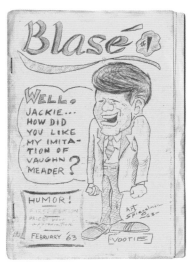

Cover, *Blasé* no. 1. 1963.

Caricature for a regular sports feature in *The Long Island Post,* 1964.

In 1965, as a senior at the High School of Art and Design, Spiegelman created a week's worth of daily newspaper strips as a class assignment. This led a visiting editor from the NEA syndicate to offer the young artist a chance to develop the strip for syndication. After drawing two or three more episodes, Spiegelman recalls, "I at least learned what kind of cartoonist I didn't want to be. Despite the potential rewards, I dreaded being married to my ill-conceived characters and a daily deadline. My subsequent work started to get weirder and often less commercial."

Unpublished daily strip, part of a series, done as a class assignment at the High School of Art and Design in 1964.

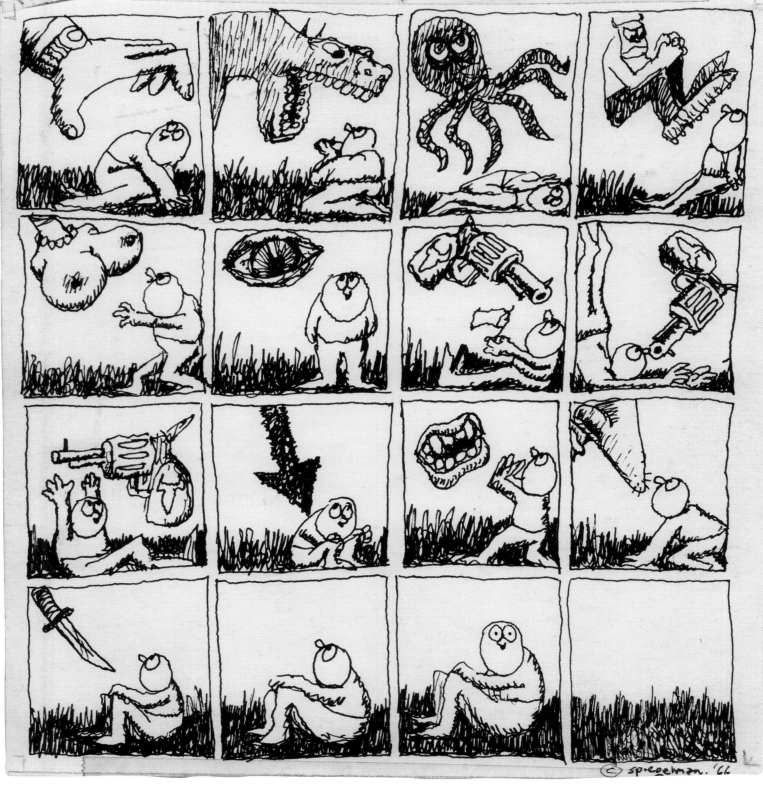

Untitled strip for *Pipe Dreams*, the weekly Harpur College (SUNY Binghamton) newspaper. Pen and ink, 1966.

An early version of a drawing that was published in a slightly altered form in *Douglas Comix*, 1972.

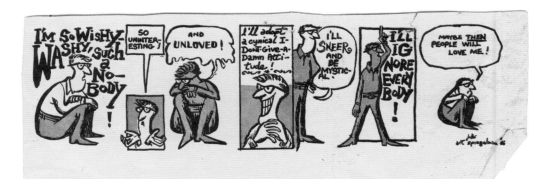

ABOVE: "I'm So Wishy-Washy, Such A Nobody," 1966, was one of many cartoons and comics drawn for *Pipe Dreams*, the weekly Harpur College (SUNY Binghamton) newspaper. BELOW: Two examples of "A Very Strange Comic Strip," drawn for *Pipe Dreams* and reprinted with the rest of that series in *Witzend* no. 3, 1967.

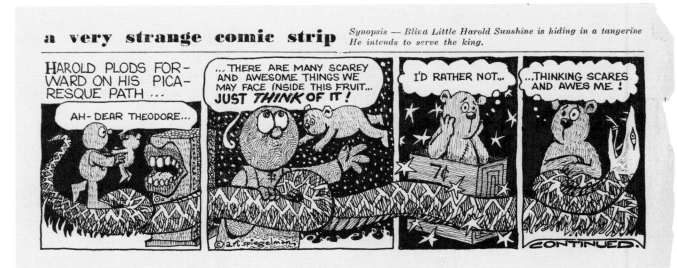

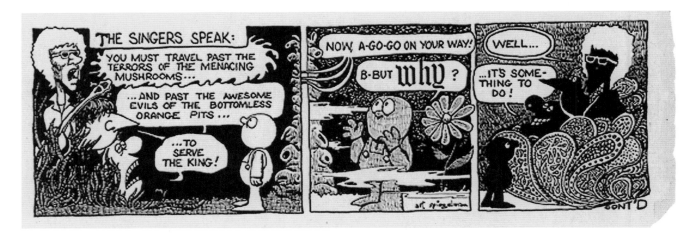

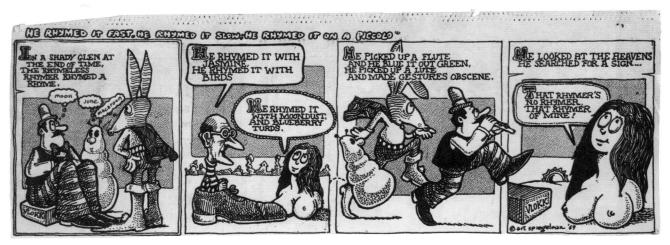

"He Rhymed it Fast, He Rhymed it Slow, He Rhymed it on a Piccolo." Published in the *East Village Other*, a weekly New York City underground newspaper, 1969. Reprinted in *Phucked-Up Phunnies*, 1970.

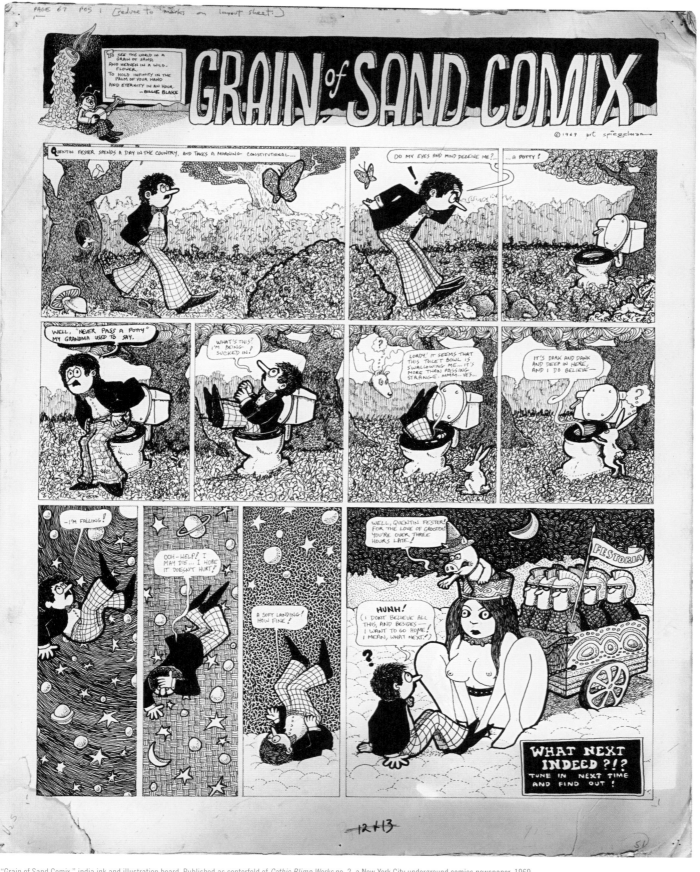

"Grain of Sand Comix," india ink and illustration board. Published as centerfold of *Gothic Blimp Works* no. 2, a New York City underground comics newspaper, 1969.

"Mister Infinity," india ink and marker on paper. First published in *Women's Wear Daily*, 1969–70.

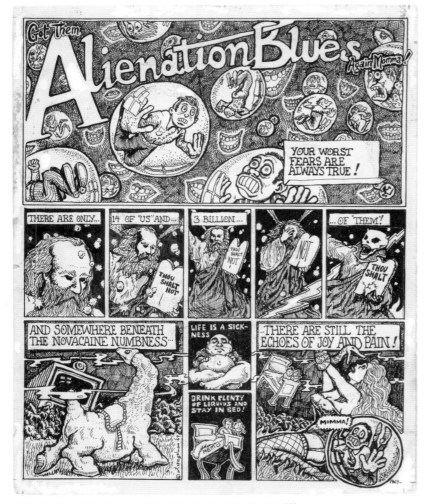

"Alienation Blues," india ink on paper. First published in *Phucked-Up Phunnies*, 1970.

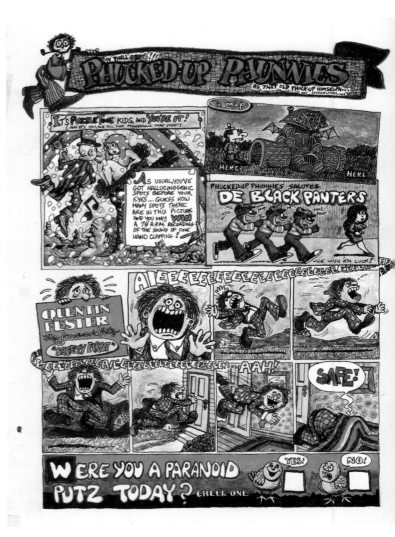

Cover of *Phucked-Up Funnies*. A large-format comics insert edited by Spiegelman, included in the 1970 Harpur College (SUNY Binghamton) yearbook and published in a small separate edition.

"The Baron Desert…," india ink and Zip-a-Tone on paper. Published in the *East Village Other*, 1968.

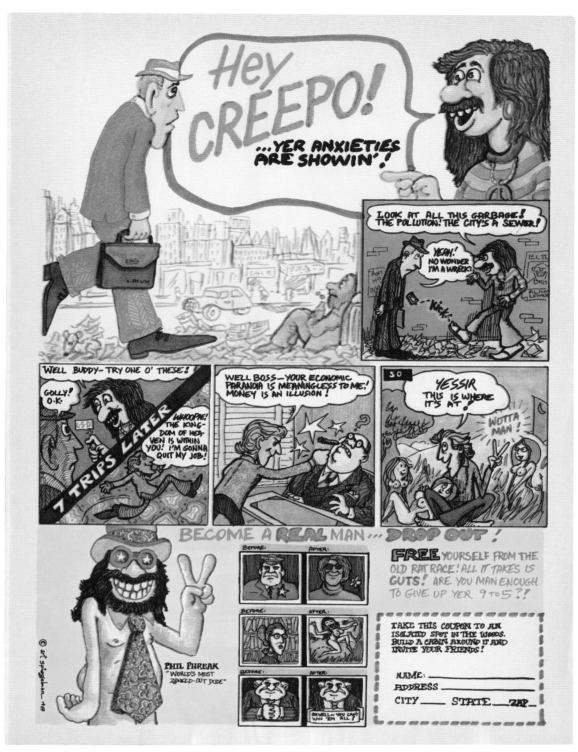

"Hey Creepo!" *Cavalier* magazine, July 1969.

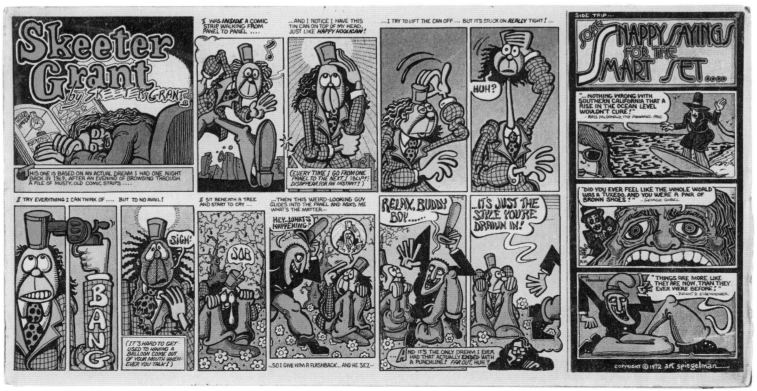

"Skeeter Grant." Commissioned by Willy Murphy, a fellow San Francisco underground cartoonist, and published in the *Sunday Paper*, a short-lived weekly broadsheet newspaper, 1972.

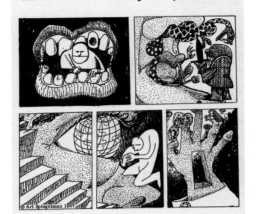

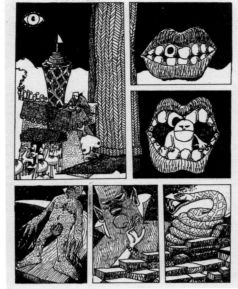

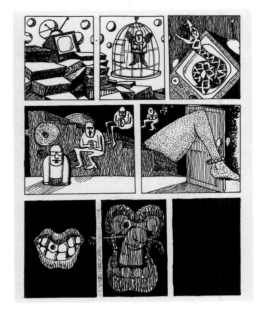

"A Flash of Insight…," ink on paper. Described by artist Wally Wood as "that three-page *thing* about masturbation." Wood published the strip in his proto-underground comics magazine, *Witzend*, in 1967.

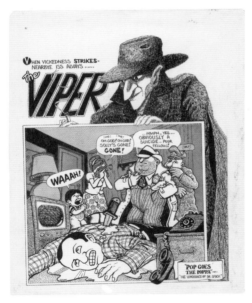

"The Viper: Pop goes the Poppa," india ink and Zip-a-Tone. The first of several stories inspired by Will Eisner's *The Spirit*. Published in *Real Pulp Comics* no. 1, 1971.

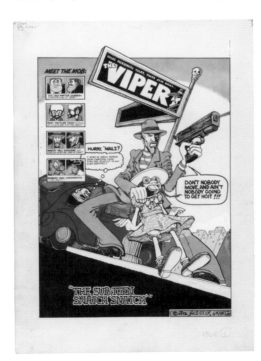

"The Viper: The Sub-Teen Snatch Snatch" (signed Skeeter Grant), india ink and Zip-a-Tone. Published in *Real Pulp Comics* no. 2, 1973. In *MetaMaus*, the artist writes that these stories "were a regrettable but necessary part of my learning curve… I was drawing the most perverse and violent atrocities I could, but not even consciously connecting them at all to the atrocities in my own life and background."

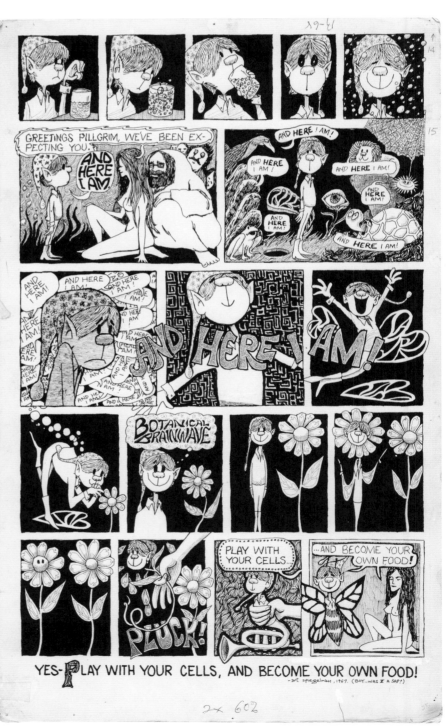

"Play with Your Cells and Become Your Own Food!," ink on paper. First printed as a giveaway leaflet, then widely reprinted in many underground weeklies and published in *Witzend* no. 3, 1967.

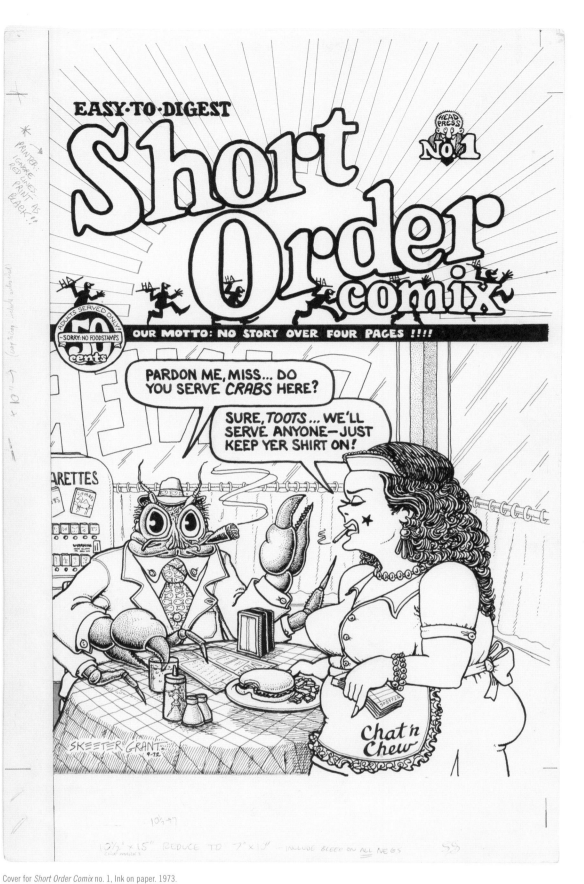

Cover for *Short Order Comix* no. 1, Ink on paper. 1973.

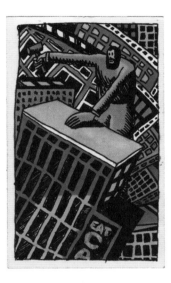

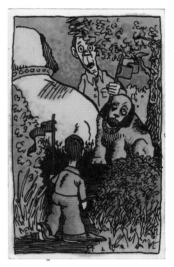

Three unpublished drawings on index cards.
Marker and india ink, 1972.

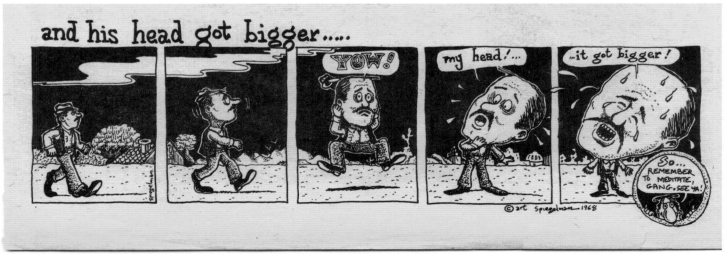

"And his head got bigger..." Detail from "Zen Frolics," *Gothic Blimp Works* no. 1, 1969.

As well as experimenting in the underground press, Spiegelman began to find slightly more lucrative freelance work, like the short-lived weekly strip "Mr. Infinity" for *Women's Wear Daily*, sponsored by a clothing company trying to be hip. Starting in the early 1970s, he had cartoons and illustrations published often in imitations of *Playboy* magazine, like *Cavalier*, *Dude*, and *Gent*. Later, from 1977 to 1983, he became a regular contributor and consulting editor for the "Playboy Funnies" feature in *Playboy*.

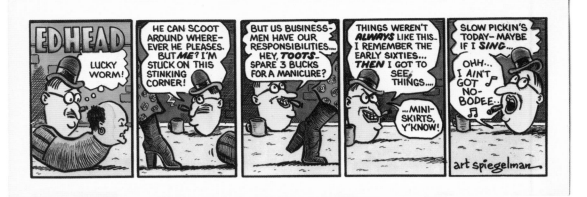

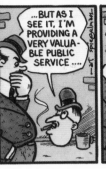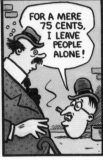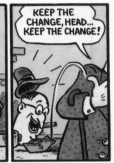

"Ed Head," ink and watercolor on paper. Published in *Playboy*, circa 1978.

"Jack'n'Jane & Rod'n'Randy," india ink and watercolor. Published in *Playboy*, circa 1981.

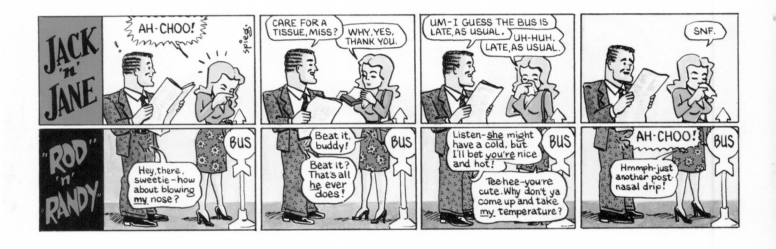

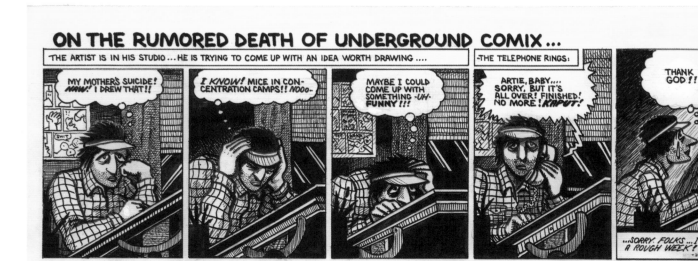

"On The Rumored Death of Underground Comix..." Published in *Eric Fromm's Comics and Stories* catalog, San Francisco, 1973.

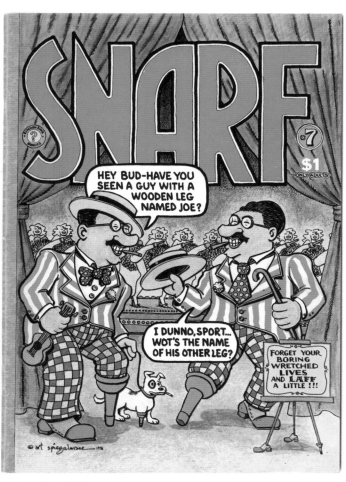

Cover, *Snarf* no. 7, 1977.

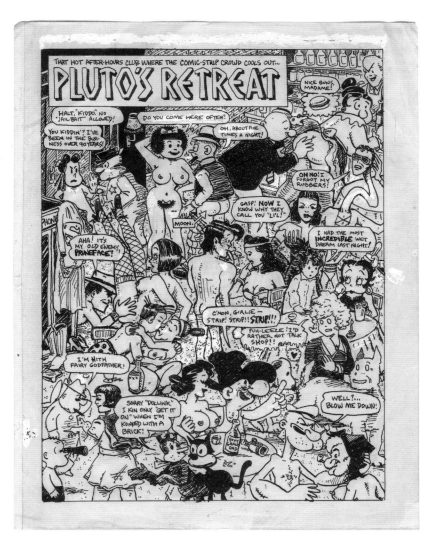

"Pluto's Retreat," pen and ink. Rejected rough for "Playboy Funnies," published in color in *Bizarre Sex* no. 8, 1972.

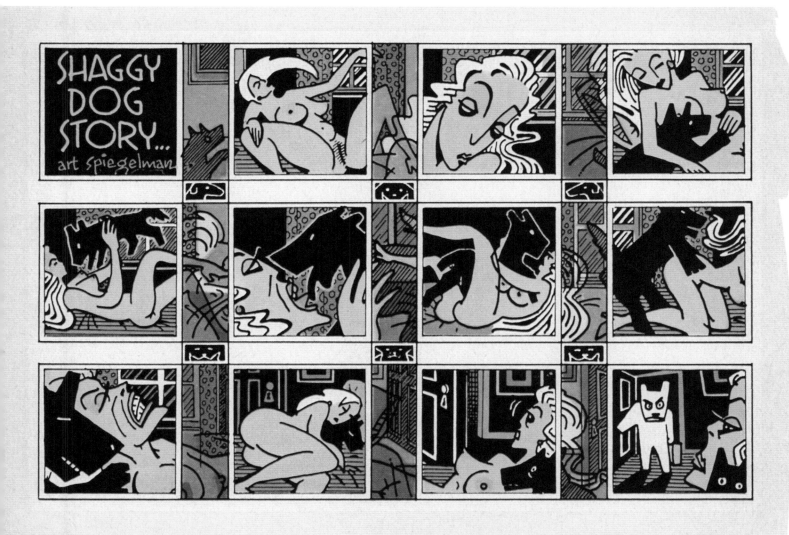

"Shaggy Dog Story..." Published in *Playboy*, 1979.

Spiegelman met Woody Gelman, the creative director of the Topps Chewing Gum company, when he was fifteen. He was hired for a summer job in 1966, right after graduating high school, and began a freelance relationship that sustained him for twenty years, allowing him the economic freedom to pursue his noncommercial comics work. The cartoonist described the bubblegum company as his counterpart to the Medicis, the family whose patronage supported many Renaissance artists. Spiegelman thrived at Topps in part because he shared with Gelman a passion for comics history. Gelman moonlighted as both a collector and reprinter of classic comic strips.

As a creative consultant at Topps, Spiegelman worked as idea man, writer, illustrator, art director, and graphic designer on novelty trading cards and stickers, and created many bubblegum and candy products. These novelty items often shared the same subversive spirit as *Mad* magazine and underground comics. Spiegelman frequently worked with the *Mad* magazine artists he admired as a kid on these projects, including Wally Wood and Basil Wolverton, while also offering assignments to underground comics artists who shared that sensibility.

T O P P S

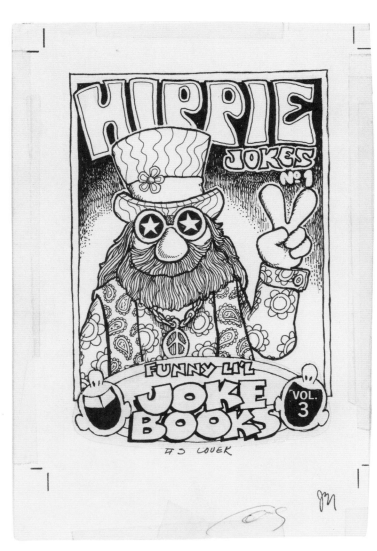

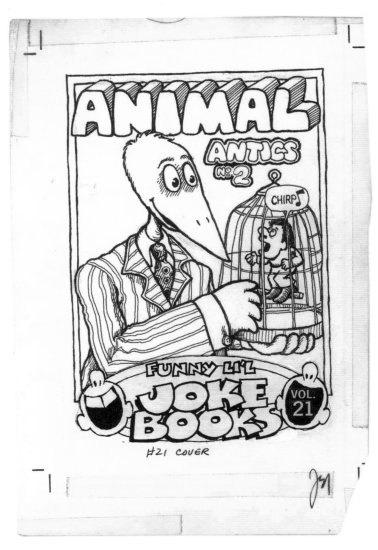

Original cover art and printed pages for *Hippie Jokes* and *Animal Antics,* two of the thirty-three *Funny Li'l Joke Books* drawn in 1970. These were eight-page, trading card-sized booklets, one of countless novelty projects Spiegelman was involved in. He designed this series with fellow underground cartoonist Jay Lynch.

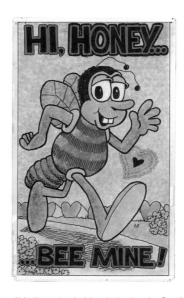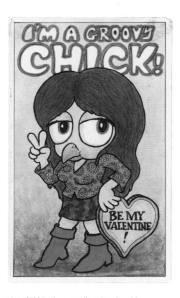

Valentine postcards, ink and colored marker. Two of a series of thirty-three small postcards sold with bubblegum in 1970.

Two rough sketches and gags, ink and colored markers on layout paper. Parody magazine covers for Wacky Packages, 1974.

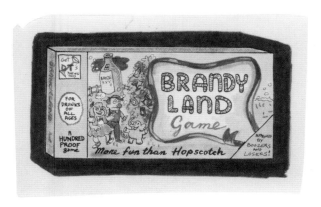

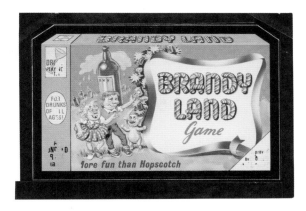

Brandy Land. Rough sketch parodying the popular Candy Land board game for Wacky Packages stickers in 1975. The final sticker was painted by classic pulp illustrator Norm Saunders.

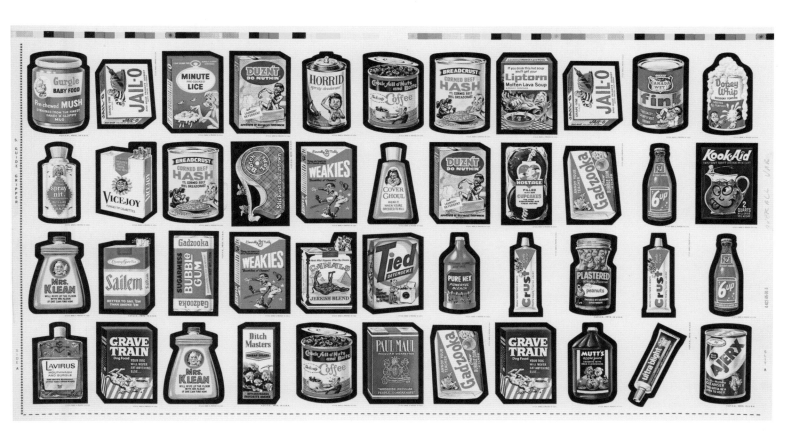

Uncut sheet of printed Wacky Packages, series 1, 1967. One of the most phenomenally popular series Spiegelman created for Topps. (Concept and most of the roughs in the first series were by him; most of the paintings by Norm Saunders.) There were seventeen series from its inception to 1976.

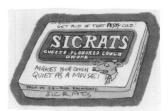 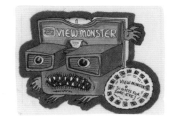

Wacky Packages, 1975.

Spiegelman has described his satirical work for Topps as "feeding back the *Mad* lessons that twisted me as a kid to corrupt yet another generation. In some ways Wacky Packages and Garbage Pail Kids—the two most successful projects I was involved with—were an extension of my underground comix work. It was all part of the counterculture...but some of it took place at the candy counter."

Garbage Pail Kids. Often confiscated by parents and banned in schools, these stickers, conceived by Spiegelman, became an international craze starting in 1985. Working with alternative cartoonist Mark Newgarden—his ex-student from the School of Visual Arts— as co-editor and co-writer, much of the art in the first few series (like Adam Bomb, shown here) was painted by John Pound. A major fad in the eighties, new series are still being generated by Topps today. The series spawned posters, cheap toys, masks, tee shirts, and even an exceptionally awful Hollywood movie.

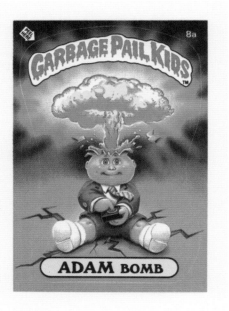

In 1977, Spiegelman's most important underground comics work from the 1970s was gathered together in a collection called *Breakdowns*—an oversized hardcover published by Belier Press. *Breakdowns* was Spiegelman's mature work—characterized by both psychological intensity and formalist invention, unlike the dominant scatological aesthetic of underground comics. The title alluded to psychological distress as well as the comics term for rough sketches and page blocking. The strips in the book range from autobiography—including an earlier three-page version of *Maus*—to a daring recasting of the conventions of newspaper cartoon soap operas into a modernist collage.

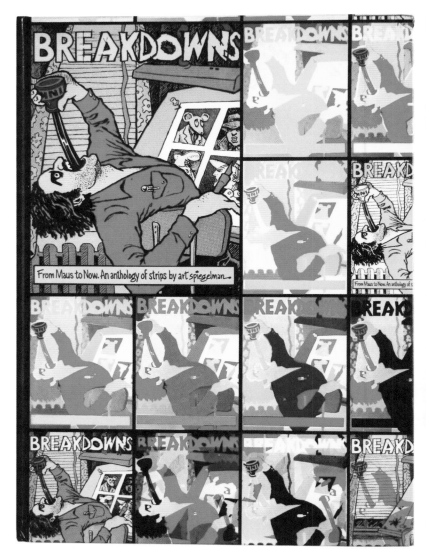

Self-portraits, india ink on paper, 1975–76. These were published as masthead self-portraits in various issues of *Arcade,* the comics magazine Spiegelman co-edited with Bill Griffith.

Front cover (ABOVE) and endpapers (BELOW) from *Breakdowns: From Maus to Now. An Anthology of Strips by Art Spiegelman*, 1977.

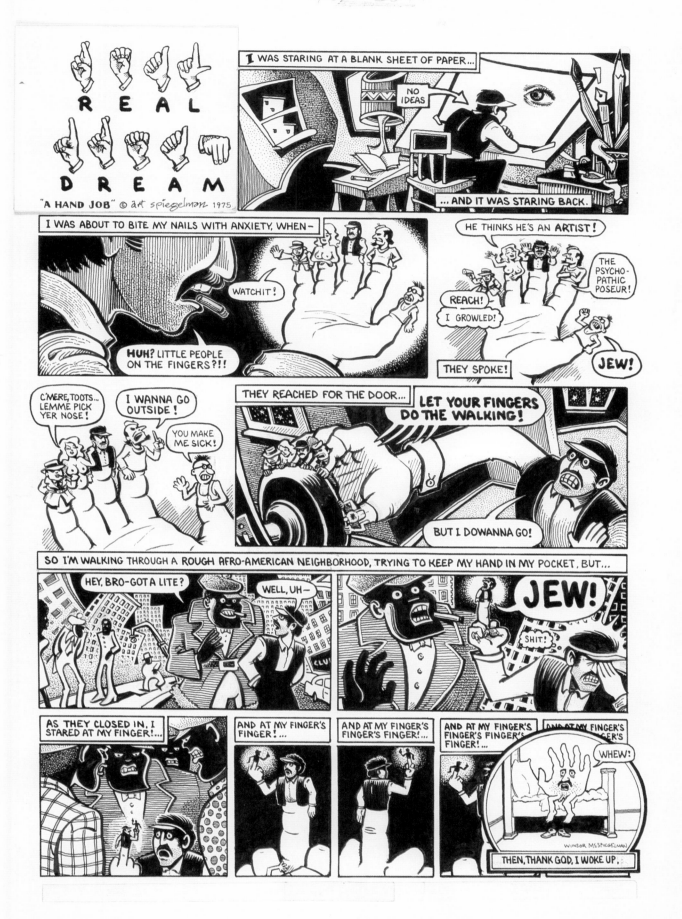

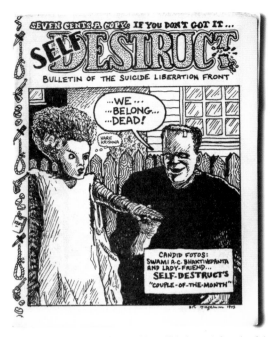

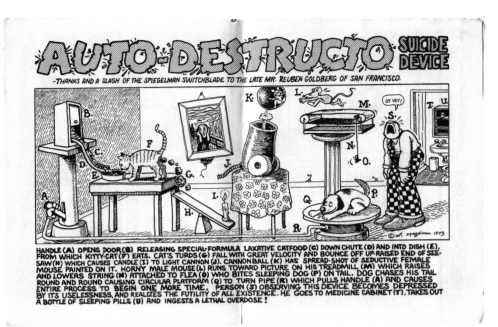

Self-Destruct. A small circulation pamphlet, published as part of a series of similar small-sized eight-page booklets by the San Francisco Comic Book Company, 1973. The centerfold, "Auto-Destructo," became the frontispiece drawing for *Breakdowns*.

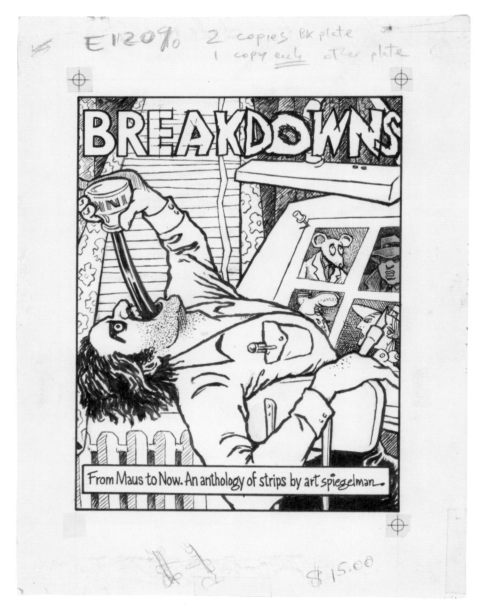

Breakdowns: From Maus to Now. An Anthology of Strips by Art Spiegelman, 1977. Ink on paper. Cover detail from the first edition.

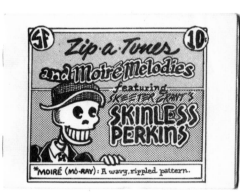

Zip-a-Tunes and Moiré Melodies. A very small sized sixteen-page booklet, published by the San Francisco Comic Book Company in 1972. The book explored the moiré patterns made by overlapping and rotating the mechanical dot screens often used to simulate gray tones in comic strips. The format echoed the pornographic Tijuana Bible booklets of the 1930s. It was reprinted as a one-page strip in *Breakdowns*.

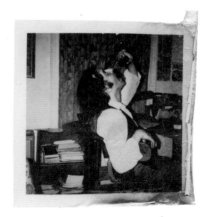

Polaroid photograph, circa 1977. Reference for cover drawing at left.

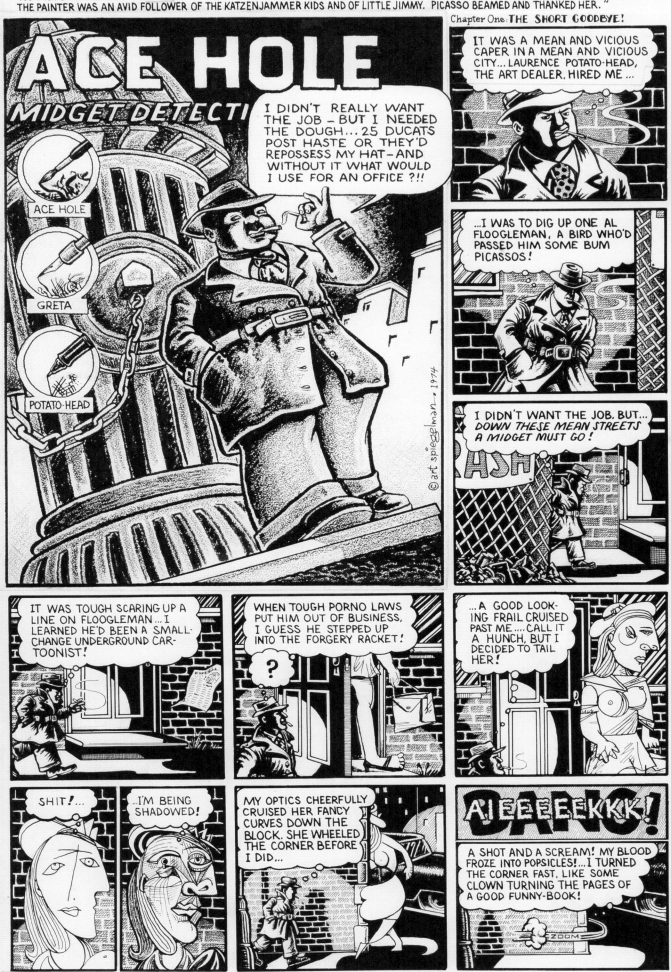

"Ace Hole, Midget Detective," page 1. Pencil, ink on paper. First published in *Short Order Comix* no. 2, 1974. Reprinted in *Breakdowns*, 1977 and 2008.

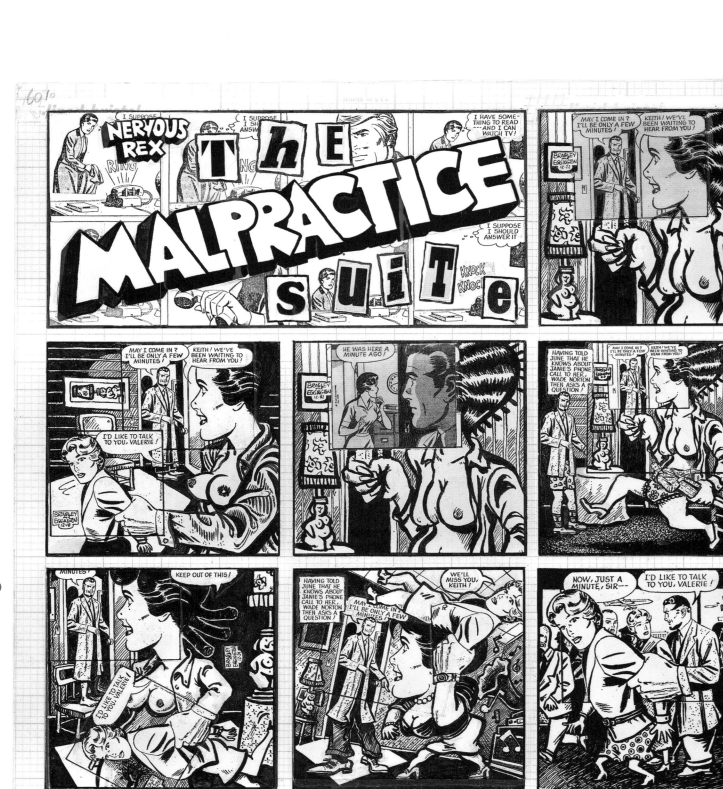

"Nervous Rex, the Malpractice Suite," india ink and collage on paper.
First published in *Arcade* no. 6, 1976. Reprinted in *Breakdowns*, 1977 and 2008.

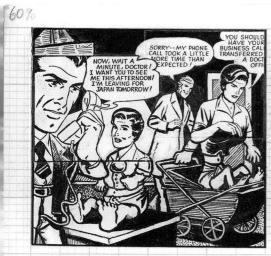
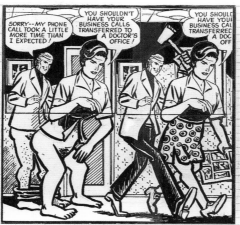
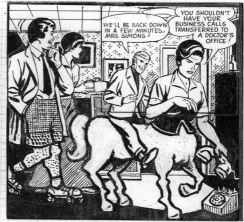
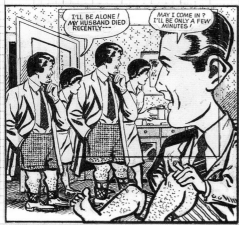
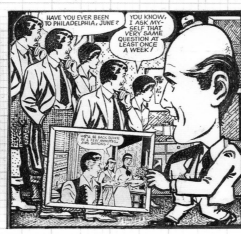
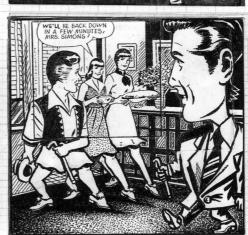
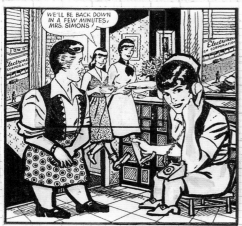
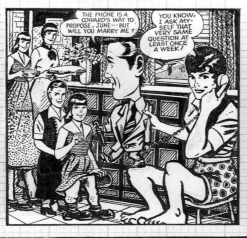
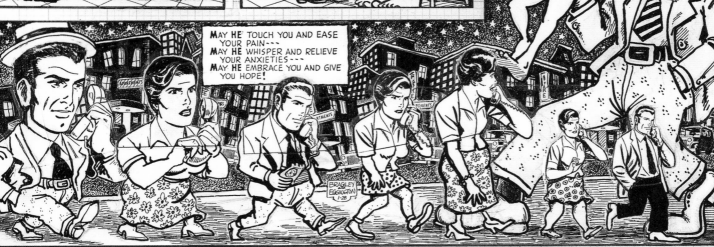

Between 1978 and 1989 Spiegelman was commissioned by a German publisher, Zweitausendeins, to create wraparound covers for their translations of the complete works of French author Boris Vian (1920–1959). With no editorial restraints or even concrete deadlines, these covers gave Spiegelman license to let his imagination run wild. This left-field design assignment was essential in honing Spiegelman's intense interest in design that would characterize *RAW* magazine, and they provided a necessary counterpoint to his *Maus* project that occupied him throughout this period.

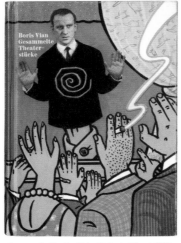

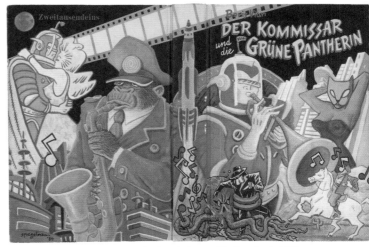

Gesammelte Theaterstücke (Collected Plays), 1983.

Der Kommissar und die Grüne Pantherin (The Commissioner and The Green Panther), 1984.

BORIS VIAN

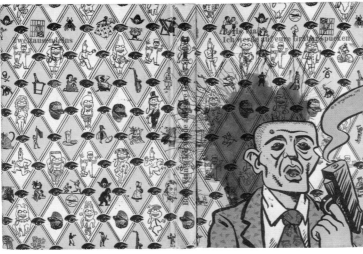

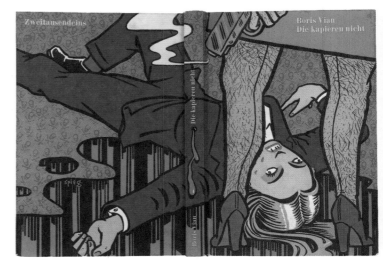

Ich werde auf eure Gräber spucken (I Spit on Your Grave), 1978.

Die kapieren nicht (Dames: They Don't Understand), 1980.

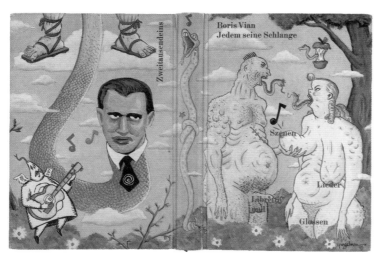

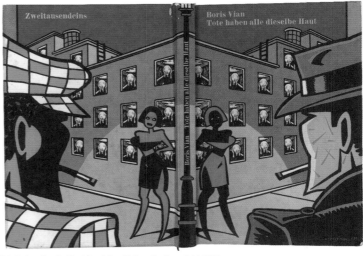

Jedem seine Schlange (Snake For Everyone), 1985.

Tote haben dieselbe Haut (Dead Men All Have the Same Skin), 1980.

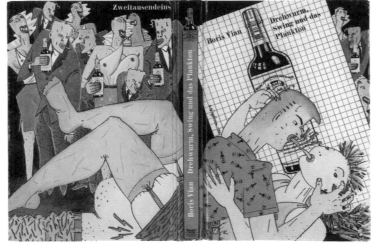

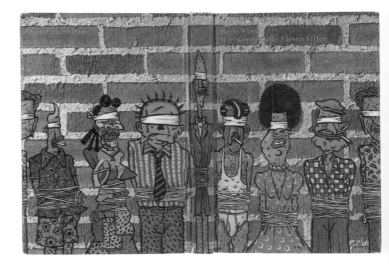

Drehwurm, Swing und das Plankton (Vercoquin and the Plankton), 1982.

Wir werden alle Fiesen killen (Kill All the Uglies), 1981.

Ich möchte nicht krepieren (I Wouldn't Want to Croak), 1985. Original drawing for the cover.

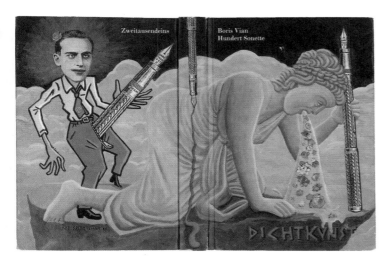

Hundert Sonette (A Hundred Sonnets), 1989.

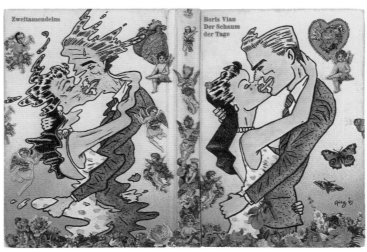

Der Schaum der Tage (Mood Indigo), 1986.

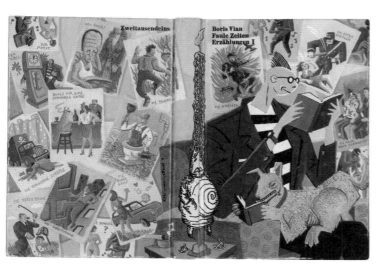

Faule Zeiten: Erzählungen I (Lazy Days: Collected Stories, vol. 1), 1983.

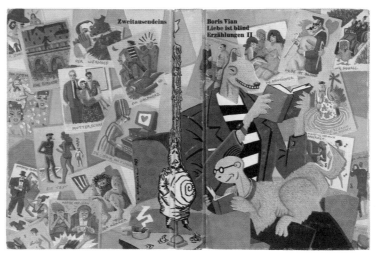

Liebe is Blinde: Erzählungen II (Love is Blind: Collected Stories, vol. 2), 1983.

"Drawn over two weeks while on the phone...," ink and felt-tip marker on paper. A page from *RAW* no. 1, *The Graphix Magazine of Postponed Suicides*, 1980.

Along with fellow cartoonist Bill Griffith, Spiegelman co-edited seven issues of *Arcade: The Comics Revue*, a late era underground comics anthology that ran from 1975 to 1976. It was a punishing experience, according to Spiegelman, and he swore never to take up the mantle of editorship again. However, by 1980 his wife, Françoise Mouly, convinced him that the time was right for a new publication. *RAW* was born out of a desperation of sorts. Underground comics, and their traditional pamphlet format, seemed to have lost both their vitality and their audience. As well, Spiegelman had had little success in convincing magazines like *Playboy* and *High Times* to be more adventurous in the comics they published. *RAW* filled this vacuum, offering venues for challenging, artistically ambitious cartooning. Self-published, oversized, and impeccably designed, the first issue quickly sold out its run of approximately 5,000 copies.

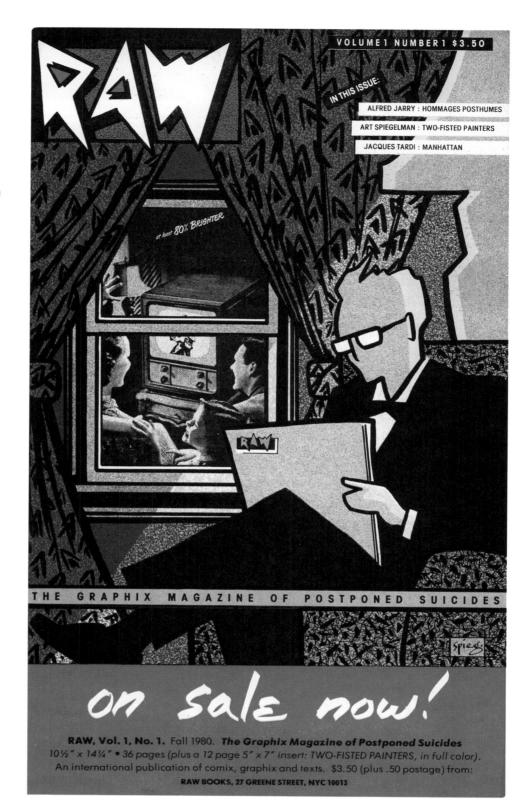

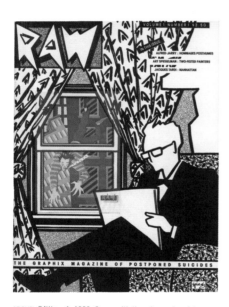

ABOVE: *RAW* no. 1, 1980. Cover, with tipped-on color plate.
RIGHT: *RAW*, 1980. Poster and flyer.
TOP LEFT OF THIS PAGE: *RAW* promotional sticker, 1980.

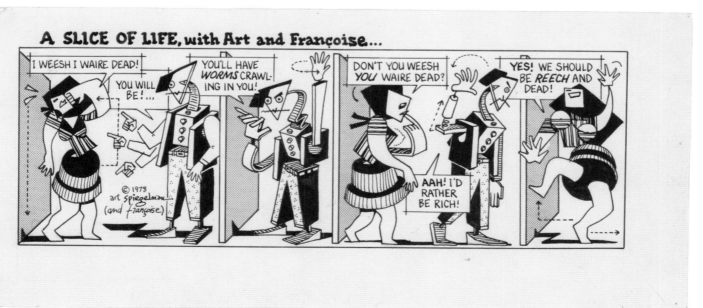

"A Slice of Life, with Art and Françoise," ink on paper. First published in *Snarf* no. 8, 1978.

Spiegelman and Mouly produced eight issues of the elaborate large-format *RAW* magazine between 1980 and 1986. Mouly's influence on *RAW* was not limited to co-designing it or overseeing the production, printing, and distribution—she was instrumental in pushing the magazine to decisively break from the countercultural aesthetic of the 1970s underground comix and embrace experimental and visually energetic comics from around the world.

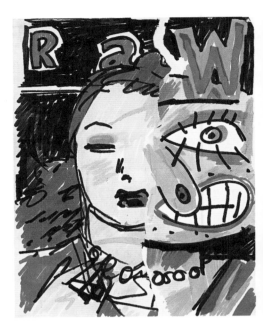

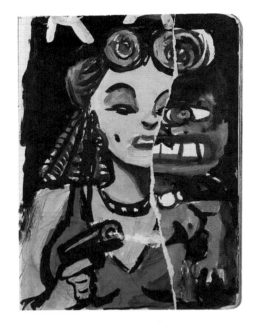

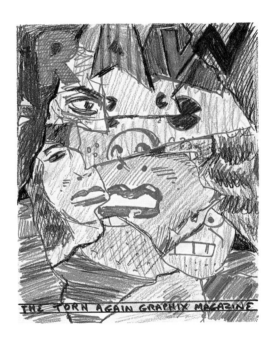

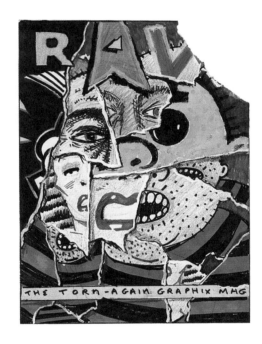

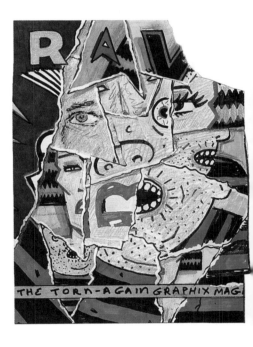

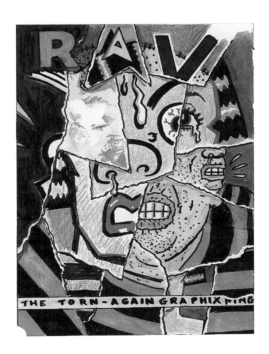

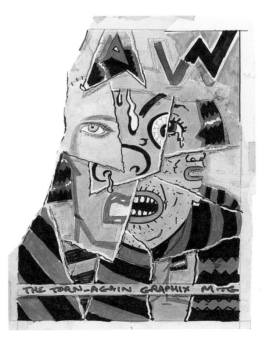

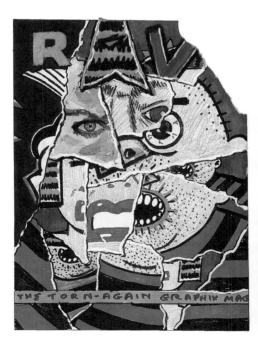

Studies for the cover of *RAW* no. 7, *The Torn-Again Graphix Mag*, 1985. Mixed media.
The plan was to have a corner of the cover physically torn off by hand, inspired by newsstand magazine
distributors who ripped the logo off their magazines to prove they hadn't been sold.

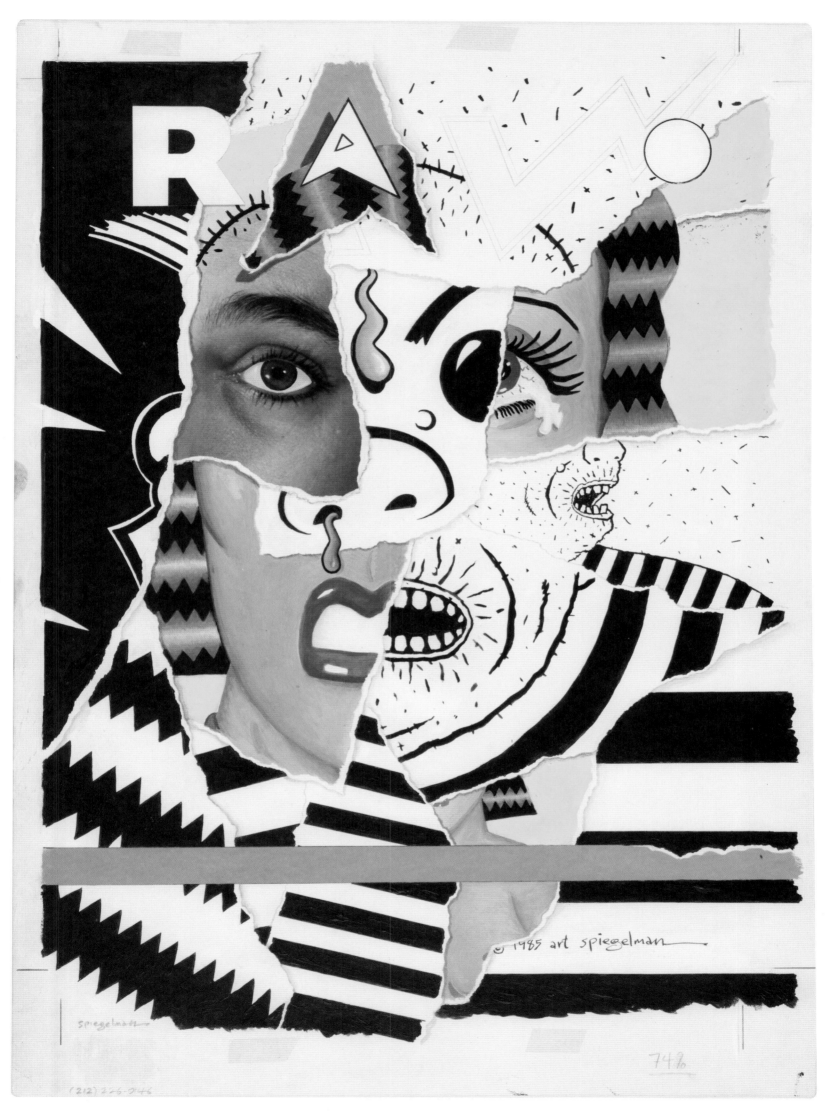

RAW no. 7, *The Torn-Again Graphix Mag.* India ink, gouache, and photo-collage (see page 133 for the final printed cover).

| THERE IS AN *IMMEDIACY* IN THE USE OF SPEECH BALLOONS... | A *DIRECTNESS* THAT CANNOT BE ACHIEVED BY A CAPTION FLOATING ABOVE THE IMAGE. | ...BUT CAPTIONS HAVE A *COOLNESS*, A *DISTANCE*, THE AUTHORITY OF REAL PROSE. SCREW THIS SELF-CONSCIOUSNESS! | A SMELL OF GARDENIAS WAFTED INTO THE ROOM. LYDIA ENTERED.. I LOVE YOU, HAROLD. SO WHAT? |

"One Row." A strip from "The Raw Color Supplement" in *RAW* no. 5, *The Graphix Magazine of Abstract Depressionism*, 1983.

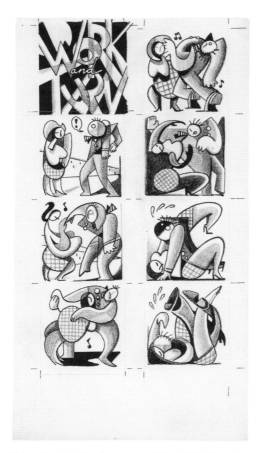

RAW gathered together avant-garde and demanding comics by European cartoonists (including Jacques Tardi, Francis Masse, the Bazooka artists, Pascal Doury, and Bruno Richard in France; Lorenzo Mattotti and the Valvoline artists in Italy; Joost Swarte and Ever Meulen in the Netherlands; and Mariscal in Spain) and aligned them with a new emerging generation in the United States (like Mark Beyer, Ben Katchor, Mark Newgarden, Drew Friedman, Kaz, Jerry Moriarty, Charles Burns, Sue Coe, and Chris Ware) producing a breakthrough magazine that enormously expanded the artistic range of comics.

Work and Turn. India ink and crayon on coquille board. Printed and published as a small-sized twenty-leaf booklet by Françoise Mouly, Raw Books & Graphics, 1979. This cubist-inspired Tijuana Bible, which utilized superimposed printing, was one of many small projects printed on the multilith press that sat in the Spiegelman-Mouly home.

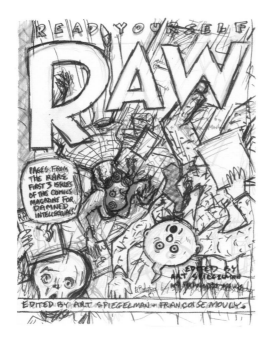

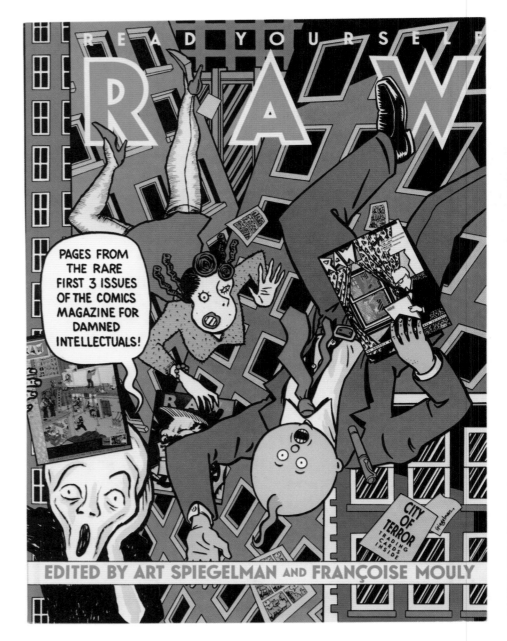

Study for cover of *Read Yourself RAW*, 1987. Felt-tip marker on layout paper.
Cover of *Read Yourself RAW*. An anthology of the first three issues published by Pantheon Books, 1987.

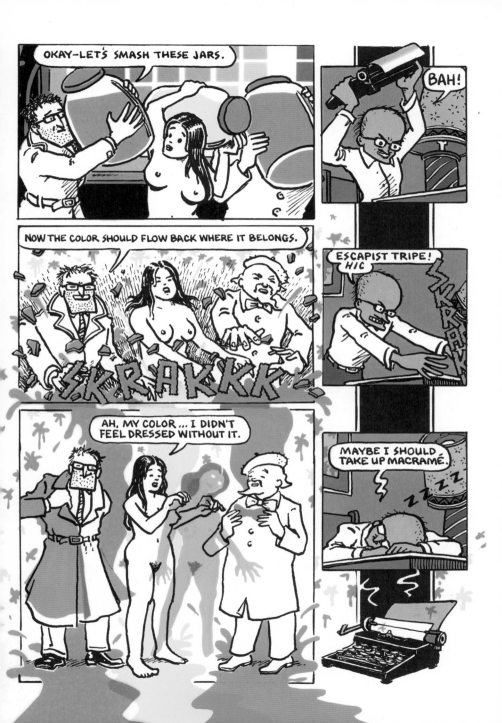

epilogue:

The performance artist did of course get his Guggenheim, as well as a National Endowment fellowship and a tenured teaching position at NYU.

Suzette lost five pounds and left Dabbler to live with the performance artist in his duplex 8,000 sq. ft. Soho loft.

August Dabbler, during one of his frequent fits of depression, did indeed swallow a tube of ultramarine blue pigment.

A neighbor, concerned about the smell, discovered his body three weeks later. Meanwhile...

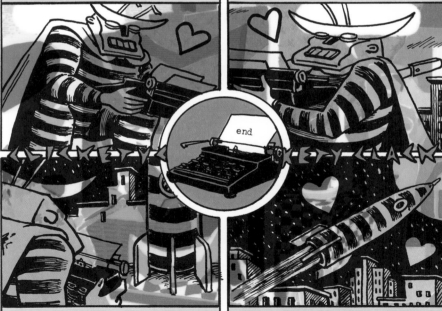

...The handsome stranger leaned over her and took her passionately in his powerful arms.

He drew the circle of flame that was her mouth toward him.

"I love you," he whispered. "Madly."

"And I you," she sobbed as her lips pressed tightly against those which would be hers forever more.

Together they floated off beyond the stars, with her hand... and her heart... in his.

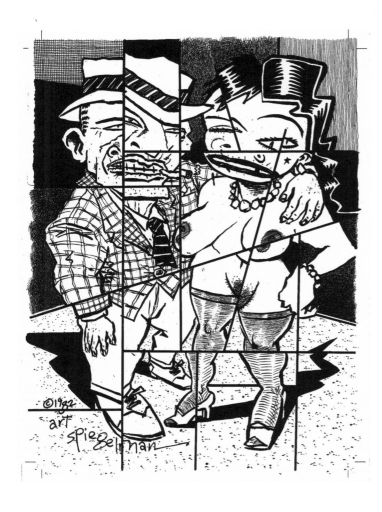

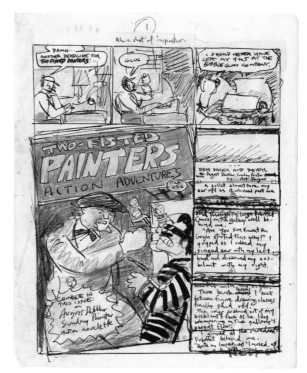

"The Couple," india ink on paper, 1982. Published in *RAW* no. 5. Later adapted into an edition of 100 copies of a fifteen-color serigraph print by Apex Novelties in San Francisco, 1991.

INSERT: Facsimile of *Two-Fisted Painters*, a comic book that appeared originally as an insert in the first issue of *RAW* in 1980. Spiegelman went on to utilize the insert booklet format in future issues of *RAW*, where early chapters of *Maus: A Survivor's Tale* were first serialized.

RIGHT: Three early draft pages from *Two-Fisted Painters*. Colored pencil, marker, and india ink on paper, 1979–80.

BELOW: Handmade cover for Françoise Mouly's production notebook for *RAW* no. 5, *The Graphix Magazine of Abstract Depressionism*, 1983. Felt-tipped markers on cardboard.

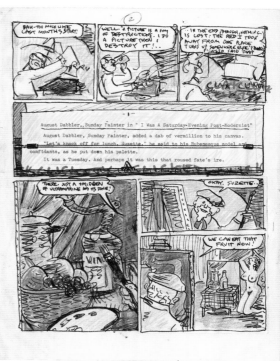

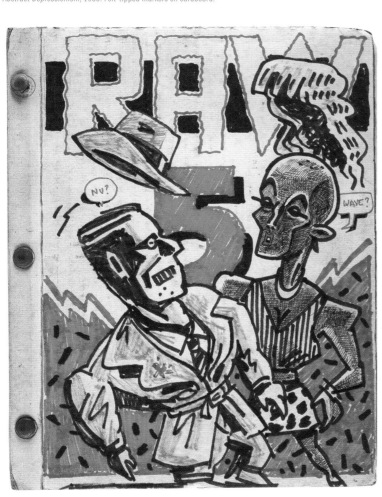

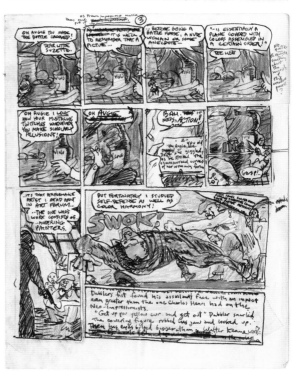

"Maus, Tefillin, Cat, and Traps," 1979. Printed by Françoise Mouly as a *RAW* postcard.

In 1972 Spiegelman contributed a three-page strip to an underground comic called *Funny Aminals,* whose only requirement was to offer stories with anthropomorphic characters. In "Maus," Spiegelman used cats and mice to retell some of his father's experiences as a Jew in Hitler's Europe. The work had a sobriety unusual among the comix of that moment. In 1978, as Spiegelman turned thirty, his ambitions led him to want to make "a long comic book that needed a bookmark and asked to be reread." Returning to the subject matter of his three-page "Maus" after the increasingly formal work he had gathered in *Breakdowns,* he conducted a series of interviews with his father. Beginning with *RAW* no. 2 in December 1980, each issue included a complete chapter of *Maus: A Survivor's Tale* as a work-in-progress in the form of a small insert booklet. In autumn 1986, the first six chapters were published as a trade paperback by Pantheon Books. Much to the publisher's and the artist's astonishment, the book was greeted with critical acclaim and commercial success. Five years later, the second volume, *Maus II: And Here My Troubles Began,* was published as a hardcover that appeared on the bestseller lists and garnered the author a special Pulitzer Prize.

MetaMaus, a book published in 2011, gathers together a wide-ranging assortment of materials related to this work, including historical documents, selections from Spiegelman's own notebooks and early drafts, and audio interviews. It represents the most authoritative analysis of this seminal graphic novel.

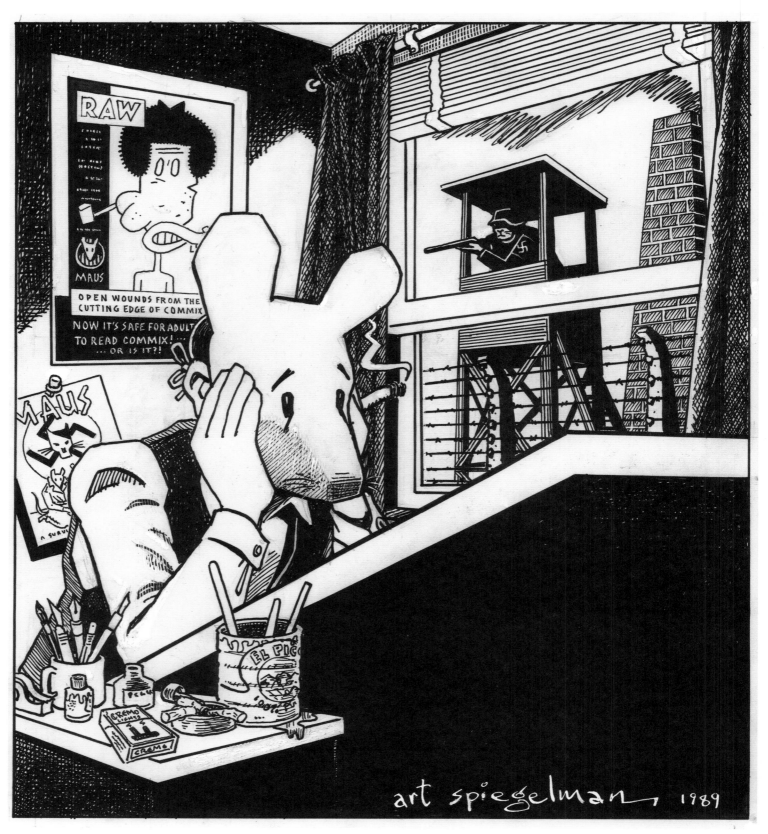

"Self-Portrait with Maus Mask." Ink on paper. Cover for *The Village Voice,* June 6, 1989. Used as author's portrait in *Maus II* hardcover.

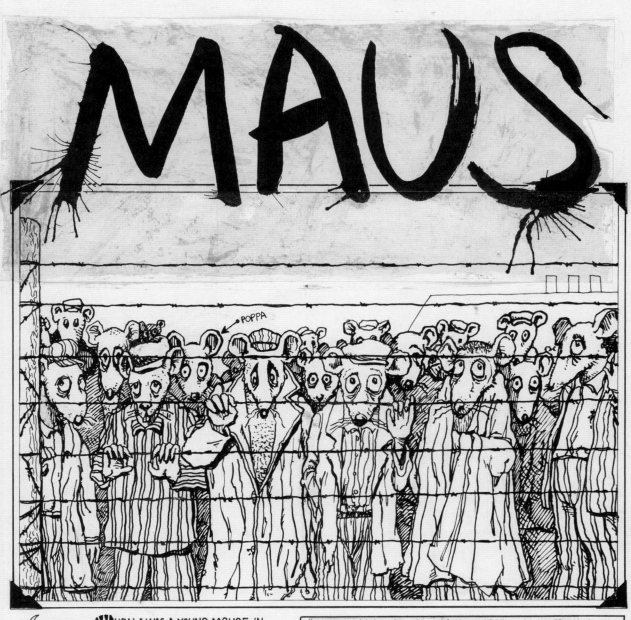

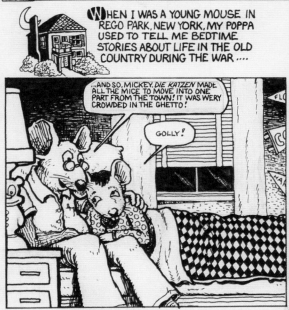

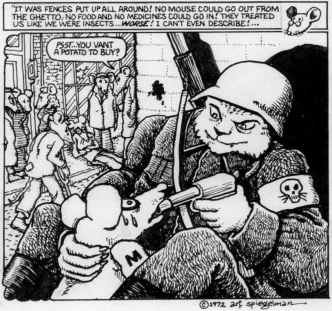

"Maus," page 1. Ink on paper. First published in *Funny Aminals* no. 1, 1972. Reprinted in *Breakdowns*, 1977 and 2008.

Maus: working process. The working process Spiegelman developed for *Maus* started with a transcript of the interviews with his father. He searched for a page breakdown in his notebook 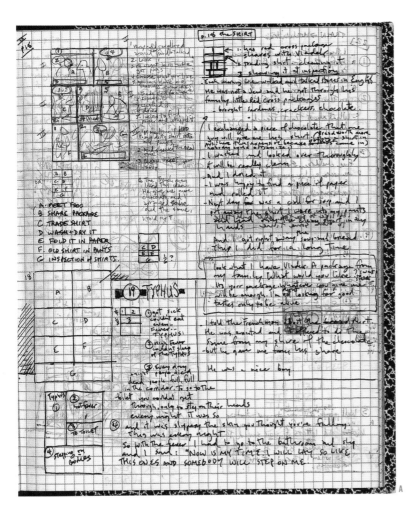A, looking for a logical narrative unit of information to form a drawn page out of key scenes. Tracing through a transparent grid B, he wrote and rewrote possible texts C, to get them to fit in his boxes, trying out various schemes D until arriving at a workable page sketch, as in this example from page 255 of *The Complete Maus* K. Once the page sketch was in place, he started to make studies to refine the drawing for each individual panel E, F, G, H, I, J.

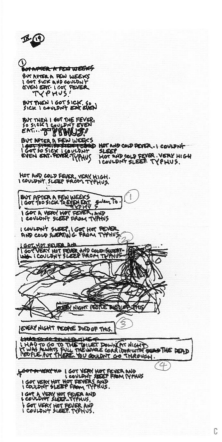

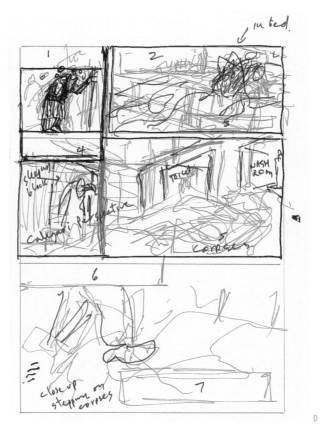

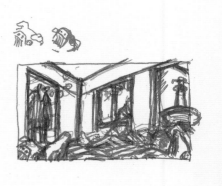

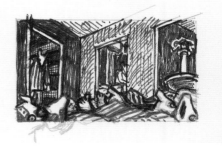

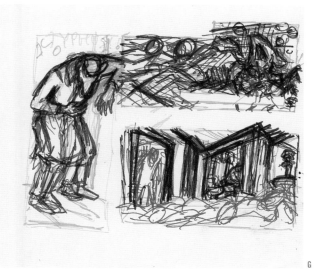

G

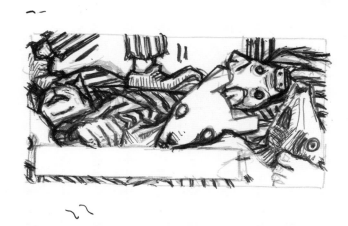

H

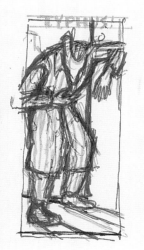

I

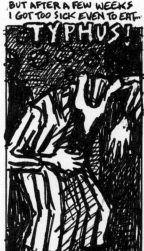

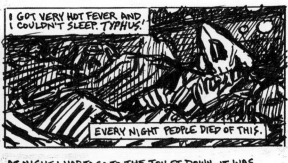

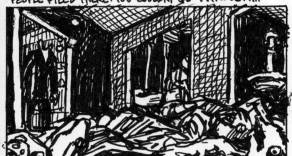

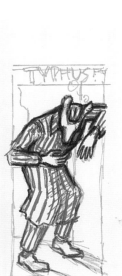

J

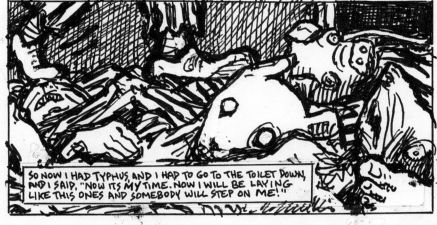

K

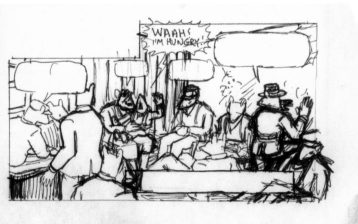

Studies for panel 1, page 125,
of *The Complete Maus.*
Marker and ink on tracing paper.

Numerous studies were made for each panel, using progressively darker felt-tip pens to bring the drawing into focus. The final pages were drawn at the same scale in which they were published, establishing a one-to-one relationship with the reader and precluding extraneous embellishment. Spiegelman was seeking a drawing style "that falls somewhere between the intimacy of handwriting and the clarity of a typeface." Referring to his laborious process, he has said: "In the time that other artists can draw forty pages, I can draw one page forty times."

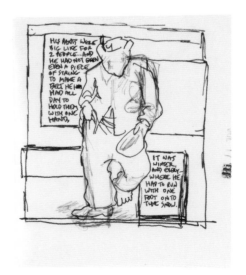

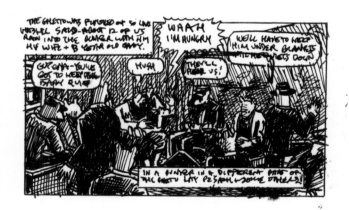

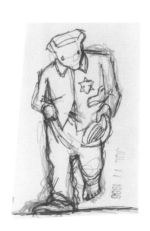

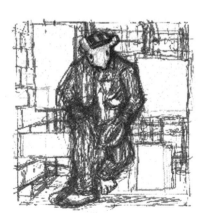

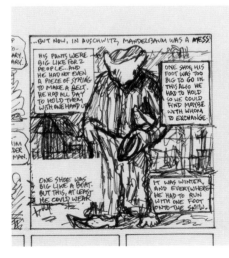

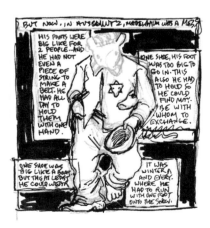

Studies for panel 3, page 189, of *The Complete Maus*. Marker and ink on tracing paper.
Part of the process here was redistributing the blocks of text so the negative space behind
the figure formed a swastika.

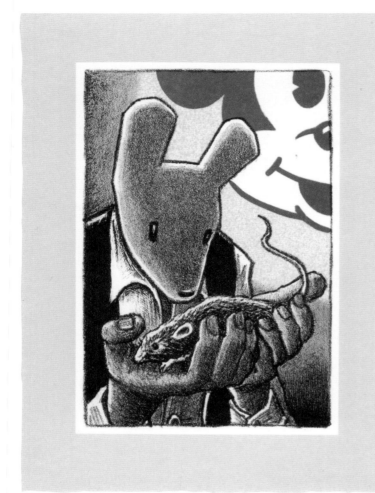

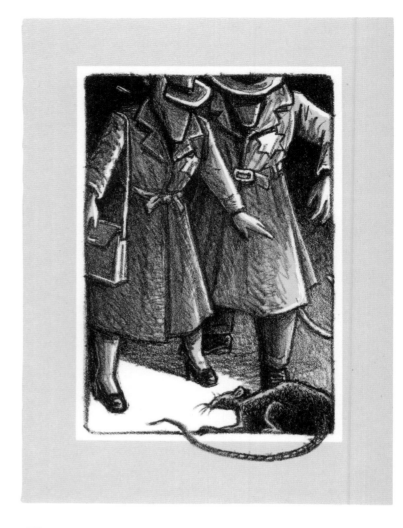

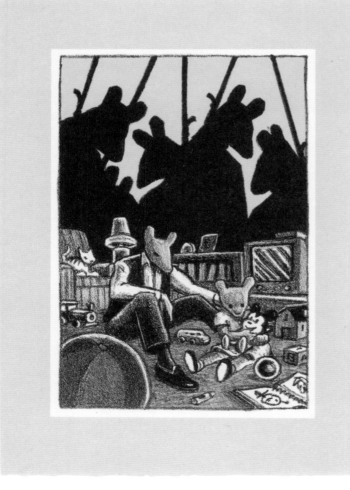

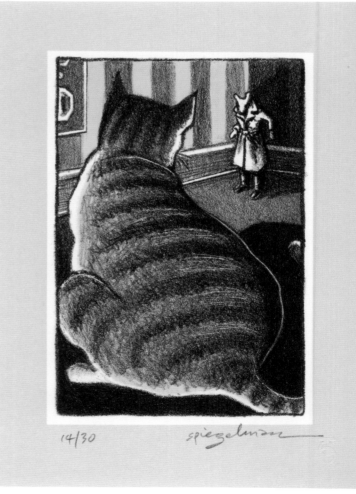

14/30 spiegelman

4 Mice.
Mickey, Maus + Mouse; Mäuse + Mouse.
Nadja, Mickey + Mäuse; Cat + Maus.
Portfolio of four stone lithographs. Published by *RAW* in an edition of 30, 1992.

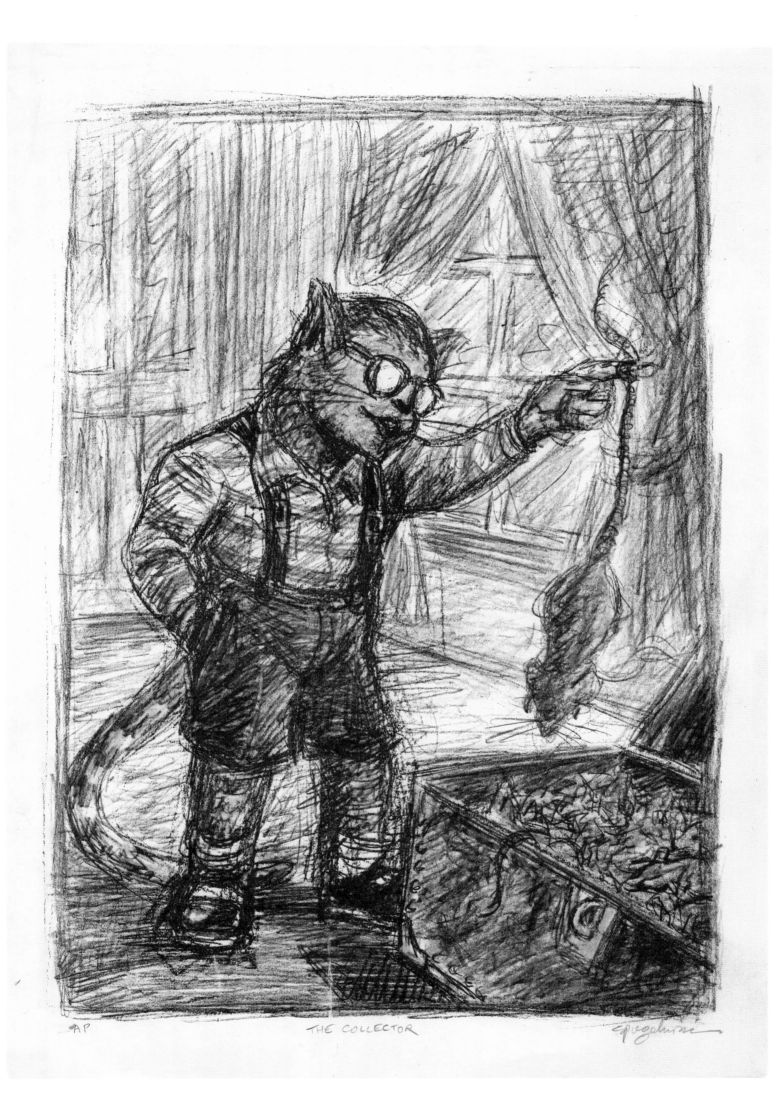

AP THE COLLECTOR

The Collector, 1979. Non-editioned lithograph, hand-tinted with colored pencils.

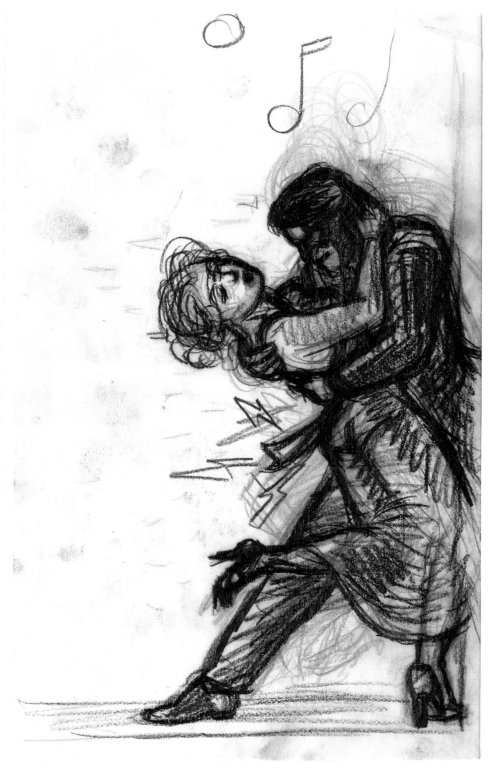

Joseph Moncure March's *The Wild Party* is a narrative poem that Art Spiegelman discovered by chance one day while browsing in a used bookstore. It had been a *succès de scandale* when first published in 1928. Spiegelman was at first seduced by the beauty of the book's design. He was then gripped by the evocative power and steamy nature of the story—a story that the great Beat writer William Burroughs said had made him want to become a writer. Having just released the second volume of *Maus*, Spiegelman was eager to do a book that was sexy, stylized, and decorative—all qualities that the narrative of *Maus* didn't allow him to explore. Illustrated with more than fifty drawings, Spiegelman's edition of *The Wild Party* allowed the artist to flex his muscles as a draftsman while also playing with a new way of merging words with pictures.

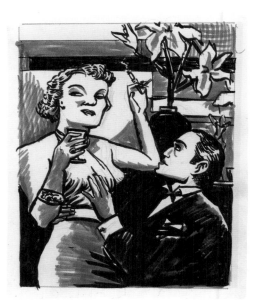

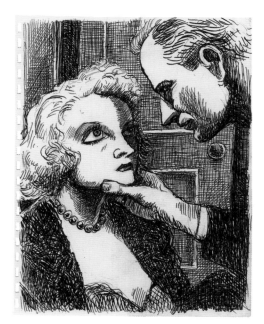

THIS PAGE AND FACING PAGE: Studies and illustrations, 1992–93.

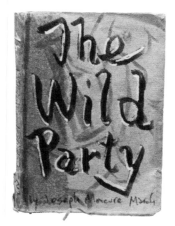

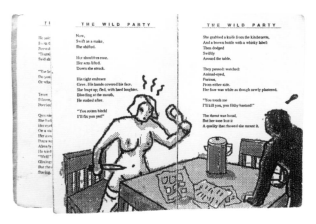

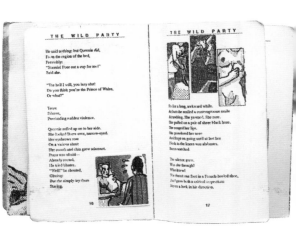

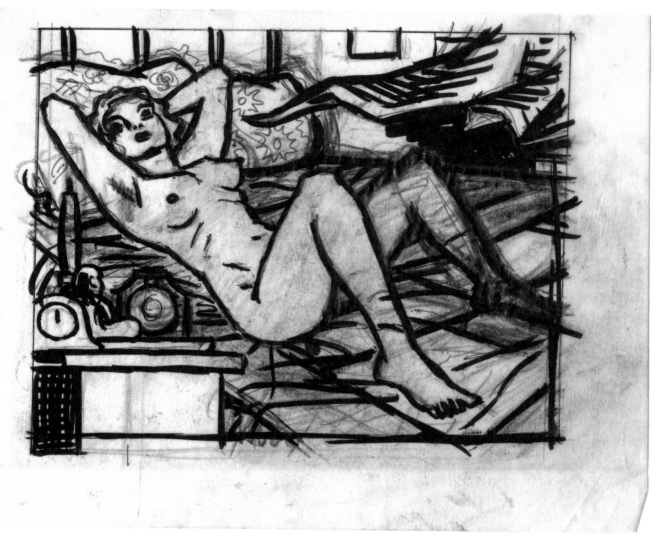

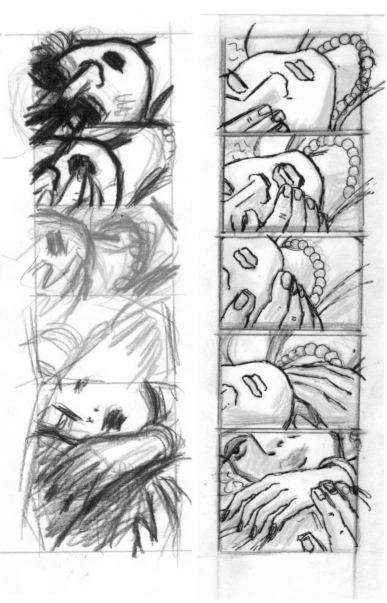

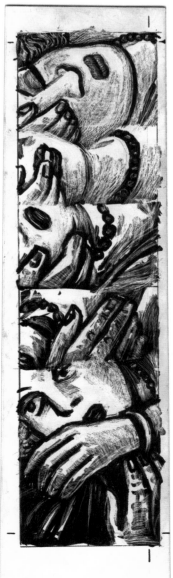

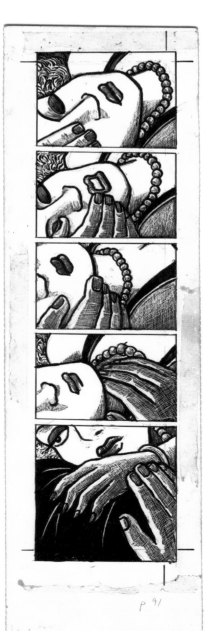

p 91

As with all of Spiegelman's works, each final drawing used in *The Wild Party* was the result of a lengthy process of complex studies and rough drafts. Spiegelman used varying materials and approaches leading up to each scratchboard drawing, including wax crayon, ink washes, colored pencil, pen and ink, and even digital layouts drawn directly on his computer.

THIS PAGE AND FACING PAGE: Studies and illustrations, 1992–93.

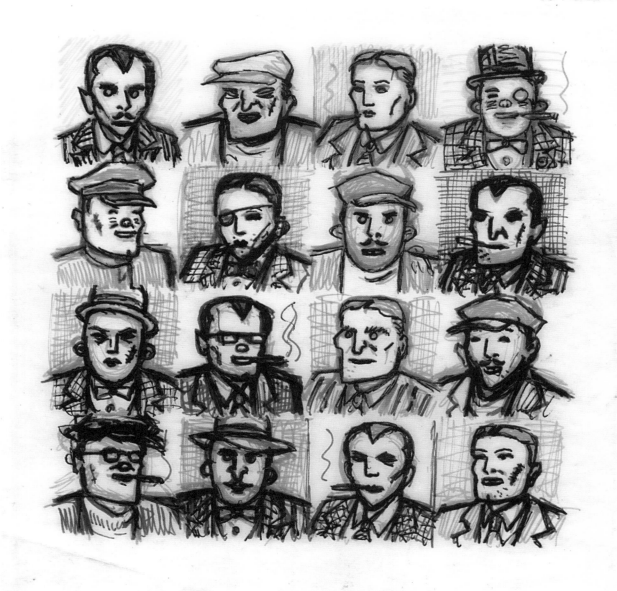

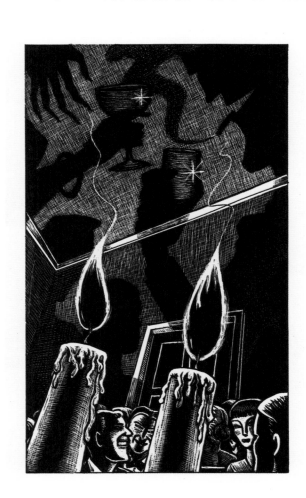

After Spiegelman's version was published in 1994 by Pantheon, March's obscure poem found a renewed audience. It was published for the first time in French, German, Spanish, and Swedish, and two competing large-scale musicals were staged, inspired by the illustrations and March's catchy rhymes and rhythms.

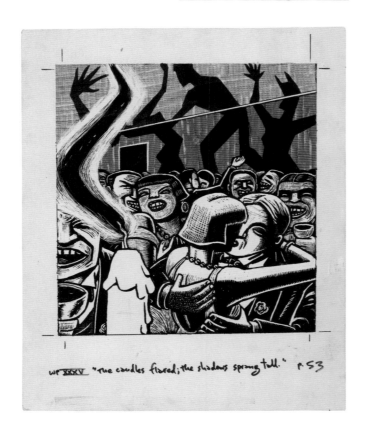

WP XXXV "The candles flared; the shadows sprang tall." p.53

NOV 0 5 1993

THIS PAGE AND FACING PAGE: Studies and illustrations, 1992–93.

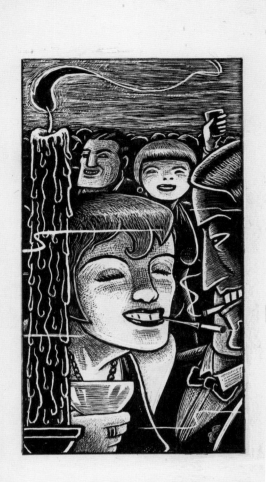

WP XXIX "The candles sputtered; their flames were g

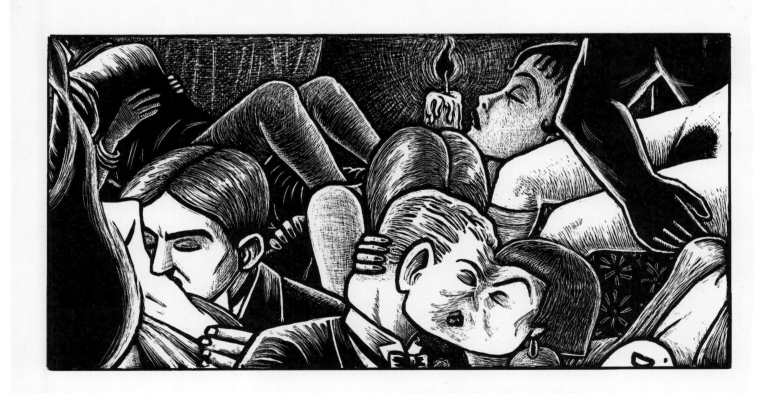

WP XLII "And the party began to reek of sex."

pps 68-69

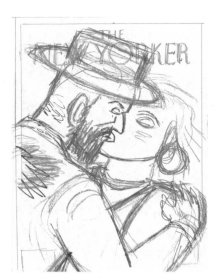

Sketch for "Valentine's Day" cover.

In 1992, Tina Brown was made editor of the *New Yorker* and given a mandate to shake up the venerable but staid literary weekly so as to make it more edgy and current. She brought Spiegelman on board as a regular cover artist and several months later hired Françoise Mouly as art editor, best known at the time for her visionary design work on *RAW* and other publications. Spiegelman's gift for hot-button imagery was evident in his first cover—a Valentine's Day theme—which dealt with the tensions between Blacks and Jews in Crown Heights, Brooklyn, by showing a Hasidic Jew and a Black woman locked in a passionate embrace. This was the first of many Spiegelman covers that would cause an outcry. Some proposed covers never made it to the newsstand because they were deemed "too outrageous" by the editors. In 2003, after more than ten years as a contributor, Spiegelman drifted away from the magazine to concentrate on a more personal project, his rumination on the 9/11 attacks, *In the Shadow of No Towers*.

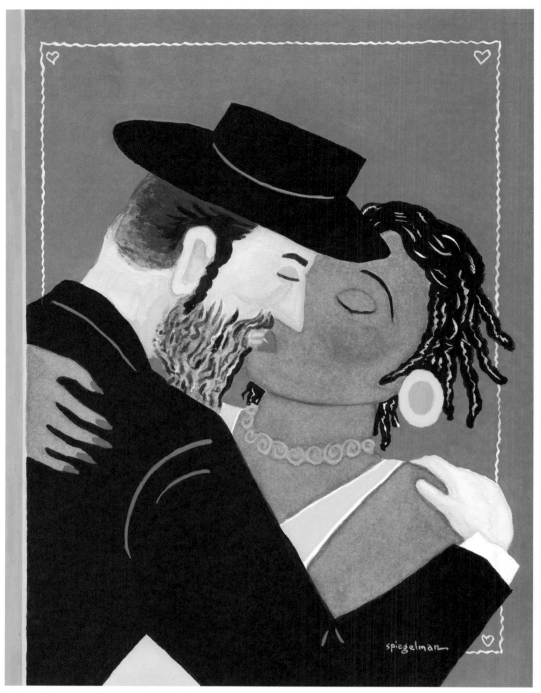

"Valentine's Day." Gouache. Cover for the *New Yorker*, February 15, 1993.

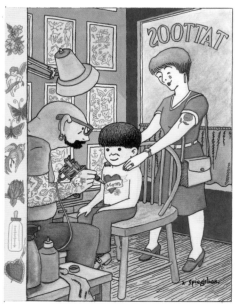

"M is for the Many Things She Gave Me..." Ink and watercolor. Cover for the *New Yorker*, May 19, 1993.

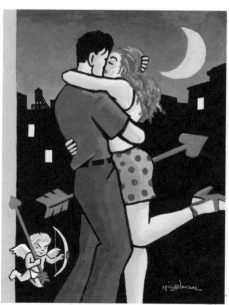

"Beau and Eros." Gouache. Cover for the *New Yorker*, August 25–September 1, 1997.

"Lunch Break." Gouache. Cover for the *New Yorker*, May 11, 1998.

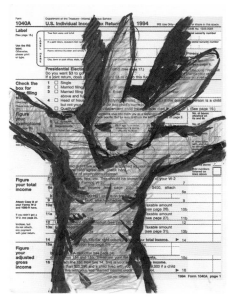
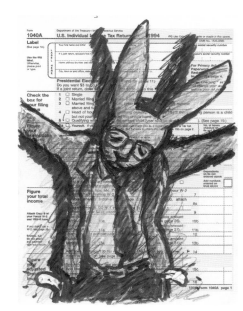

Sketches for the *New Yorker* Easter cover, 1995. Ink and colored pencil on tax form.

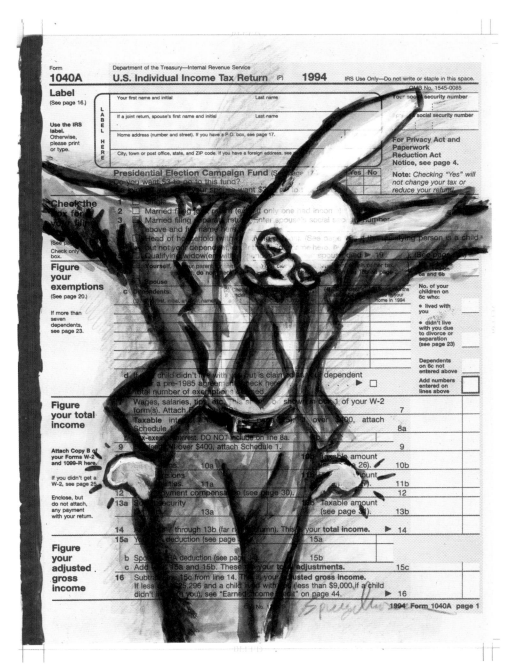

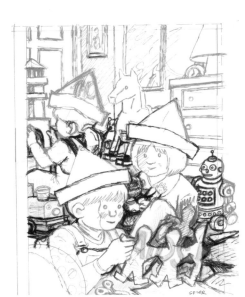

Sketch for the *New Yorker* cover. Marker on tracing paper, 1995.

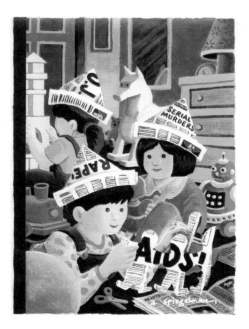

"Taxed to Death?" Ink, watercolor, and colored pencil on tax form. Cover for the *New Yorker*, April 17, 1995.

"News R Us." Gouache. Cover for the *New Yorker*, September 11, 1995.

Spiegelman's eye-catching images were groundbreaking, and inspired an era of controversial topical covers. Notable amongst these were the back-to-school "Guns of September," the sexually suggestive Clinton cover that appeared as the Monica Lewinsky scandal broke, and the infamous "41 Shots, 10 Cents" about the shooting of immigrant worker Amadou Diallo by four New York City police officers. Spiegelman's work helped set a brasher tone for the legendary magazine.

Sketch for "Guns of September." Pen and ink. Cover for the *New Yorker*, September 13, 1993. Final gouache illustration below left.

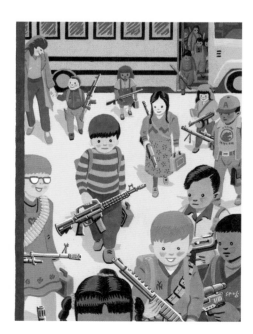

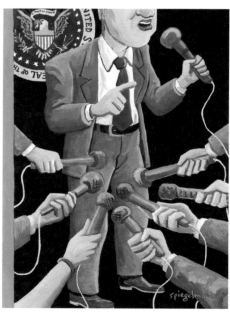

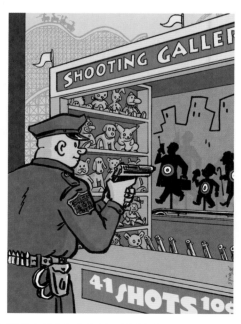

"The Low Road." Gouache. Cover for the *New Yorker*, February 16, 1998.

"41 Shots, 10 Cents." India ink and digital color. Cover for the *New Yorker*, March 8, 1999.

Rejected cover idea, 1993. After its rejection this image was repurposed as Spiegelman and Mouly's holiday card that year.

Rejected cover idea, 1996.

Rejected cover idea, 1999.

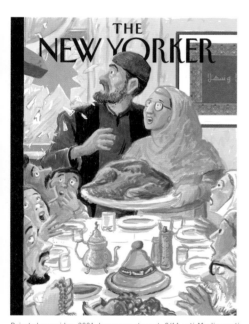

Rejected cover idea, 2001. In response to post–9/11 anti-Muslim sentiment, Spiegelman offered a reworked version of Norman Rockwell's painting "Freedom from Want."

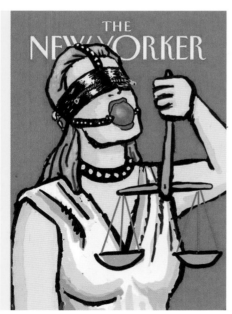

Rejected cover idea, 1998. Spiegelman's proposed cover in reference to the Ken Starr report on the Bill Clinton/Monica Lewinsky affair.

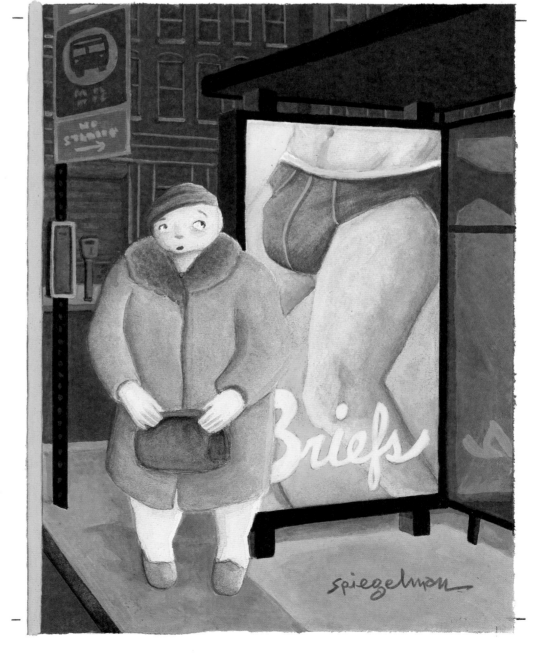

"Brief Encounter." Gouache. Cover for the New Yorker, September 26, 1994.

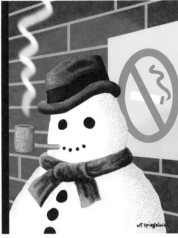

"Snow Smoking." Digital art.
Cover for the *New Yorker*, January 15, 1996.

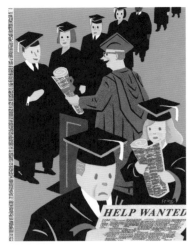

"Classifieds of 1996." Acrylic Gouache.
Cover for the *New Yorker*, May 20, 1996.

"Summer Buzz." Ink and watercolor.
Cover for the *New Yorker*, August 19, 1996.

"Dick Tilley." Acrylic Gouache.
Cover for the *New Yorker*, February 24, 1997.

"Hardboiled Egg Hunt." Acrylic Gouache.
Cover for the *New Yorker*, March 31, 1997.

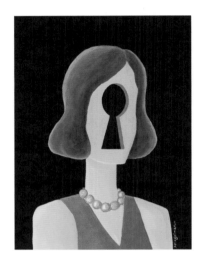

"Private Lives." Acrylic Gouache.
Cover for the *New Yorker*, August 24, 1998.

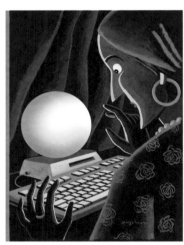

"What's Next." Acrylic Gouache.
Cover for the *New Yorker*, October 26, 1998.

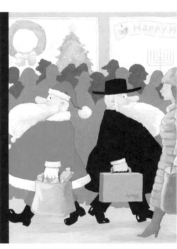

"'Twas The Night Before Hanukkah." Acrylic Gouache.
Cover for the *New Yorker*, December 18, 2000.

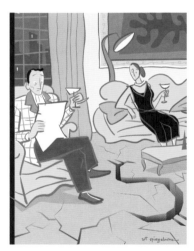

"Is The Bottom Falling Out, Dear?" Digital art.
Cover for the *New Yorker*, April 23, 2001.

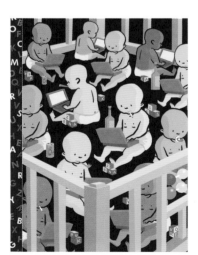

"The Writing Pen." Digital art.
Cover for the *New Yorker*, June 18, 2001.

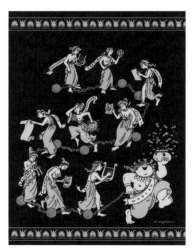

"The Tenth Muse." Pen and ink with digital color.
Cover for the *New Yorker*, October 15, 2001.

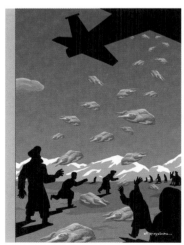

"Enduring Freedom." Digital art.
Cover for the *New Yorker*, November 26, 2001.

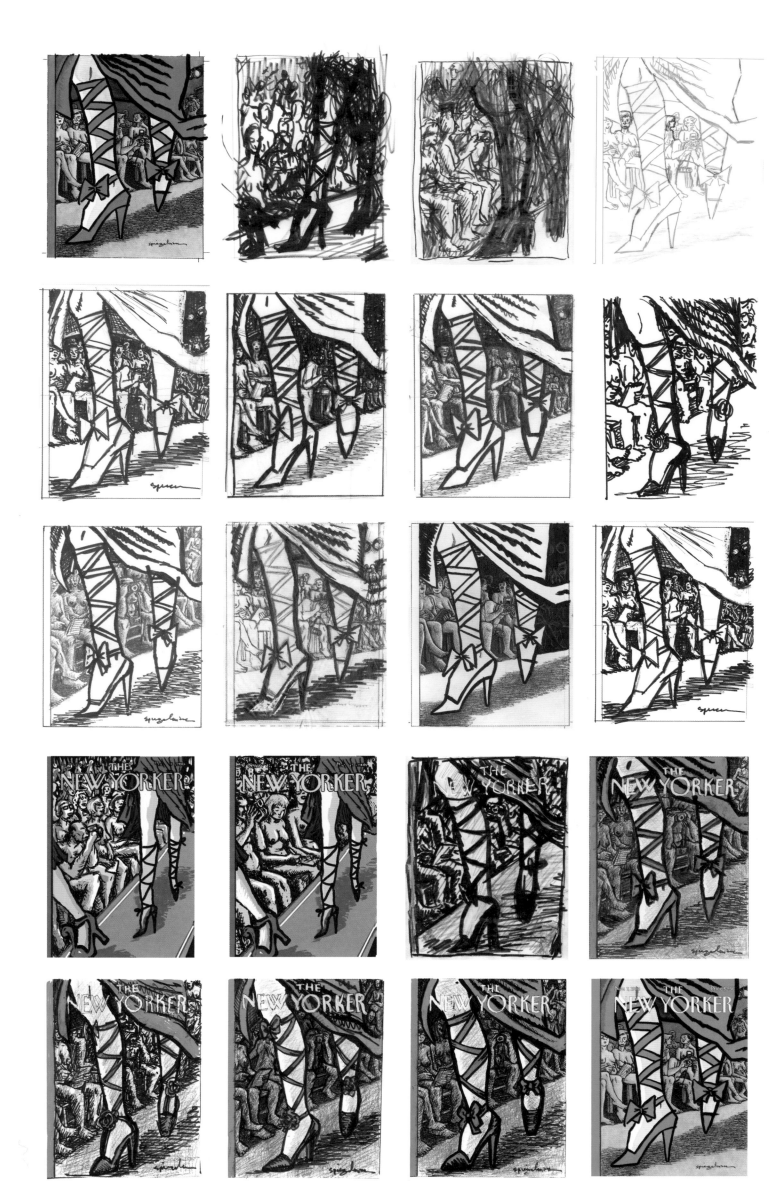

Sketches for "Unveiled." Various mediums. Cover for the *New Yorker*, November 7, 1994.

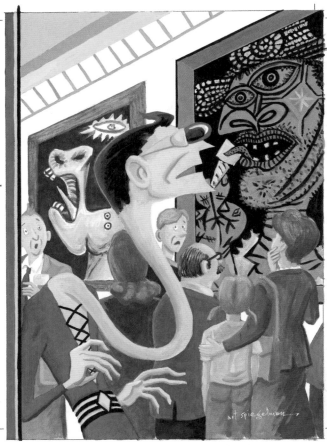

"The Plastic Arts." Acrylic Gouache. Cover for the *New Yorker*, April 19, 1999.

"In Their Own Image." Ink and watercolor. Cover for the *New Yorker*, June 16–24, 2002.

"Family Values." Watercolor. Cover for the *New Yorker*, April 26, 1996.

"Open-Minded Mayor." Acrylic Gouache. Cover for the *New Yorker*, October 11, 1999.

On September 11, 2001, Mouly and Spiegelman witnessed the first plane crash into the World Trade Center and rushed to their daughter Nadja's Ground Zero adjacent school. As art editor of the *New Yorker*, Mouly had to search for a cover appropriate to the event even before she had a chance to assimilate the tragedy. Spiegelman, her fellow witness and long-time collaborator, responded with a somber, austere cover idea: black skyscrapers against an almost equally black sky, a funereal image that evoked the mournful, shocked mood experienced by both New Yorkers and the wider world. As Spiegelman observed, "Though the towers were gone, they lingered like an amputee's phantom limb."

THE NEW YORKER

PRICE $3.50

SEPT. 24, 2001

"Ground Zero." Cover for the *New Yorker*, September 24, 2001.

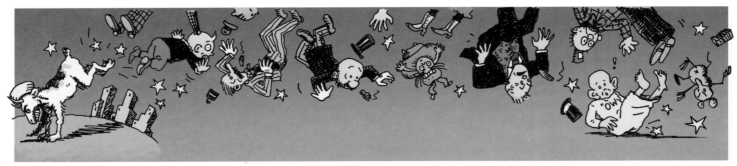

In The Shadow of No Towers, 2004. Cover detail.

Sketch for *In the Shadow of No Towers* no. 2. Ballpoint pen and felt-tip.

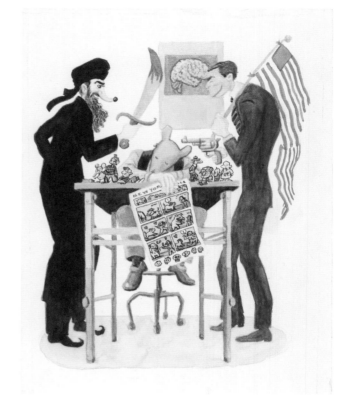

Gouache and ink drawing for splash panel of *In the Shadow of No Towers* no. 2.

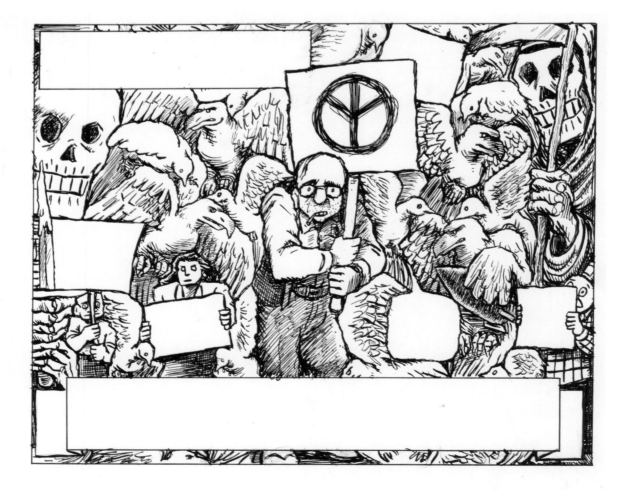

Marker with colored pencil sketch and final ink drawing for *In the Shadow of No Towers* no. 4.

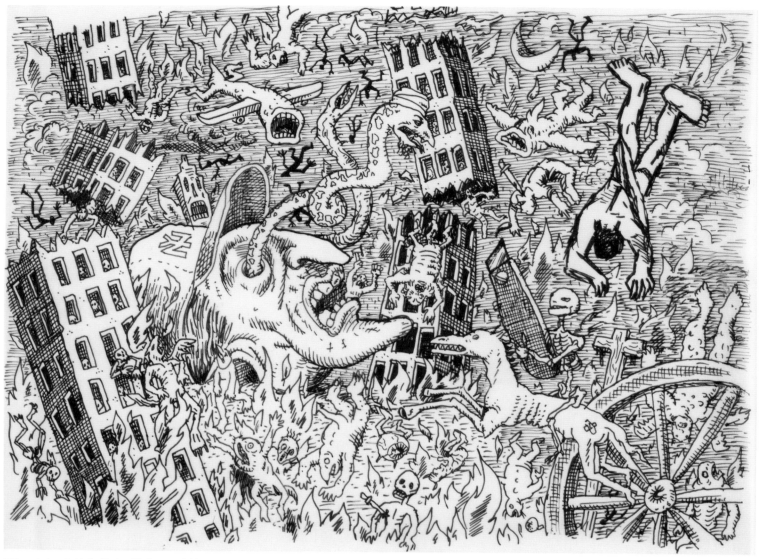

Art for central panel of *In the Shadow of No Towers* no. 6. Ink on paper.

Traumatized by both 9/11 and the political fallout after the terrorist attacks, Spiegelman returned to comics in 2002 and 2003, recording his experiences and reactions in a series of broadsheets, initially serialized in a variety of publications in Germany, France, Italy, and the Netherlands. Eventually gathered together in the 2004 book *In the Shadow of No Towers*, this project allowed Spiegelman to bring together several strands of his career: the political and polemical engagement of his *New Yorker* covers, the use of autobiographical material pioneered in *Maus*, the use of oversized formats from *Breakdowns* and *RAW*, and the pervasive concern with the history of comics that permeates his entire oeuvre.

In a daring move, Spiegelman processed the shock of 9/11 by placing it in the context of New York's rich tradition of newspaper cartooning born in the late nineteenth century on Newspaper Row right near the blown up towers. Throughout the book he uses classic comic strip characters like the Yellow Kid and Happy Hooligan to provide an ironic comment on contemporary events. The classic comic strip characters, Spiegelman said, gave him aesthetic solace because they represented "vital, unpretentious ephemera from the optimistic dawn of the twentieth century...That they were never intended to last past the day they appeared in the newspaper gave them poignancy; they were just right."

Studies for *In the Shadow of No Towers* no. 9. Ink on paper.

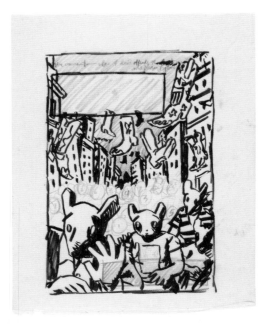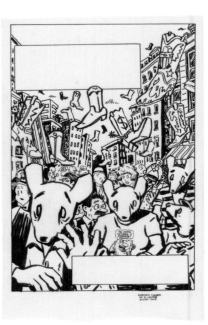

Sketches and final art for *In the Shadow of No Towers* no. 10.
Marker and colored pencils, ink on paper.

Using the full newspaper page as a canvas, Spiegelman returned to his longstanding formalist interest in comics as a type of collage where incongruous images could be juxtaposed. The splintered and fragmented pages of *In the Shadow of No Towers* both look back to classic newspaper strips but also forward to the media overload of cable news and the computer screen. As Spiegelman noted, "The terrorists' hijackings have been hijacked by the Bush regime, and turned into a war recruiting poster. I'd never wanted to be a political cartoonist…Nothing has a shorter shelf-life than angry caricatures of politicians, and I'd often harbored notions of working for posterity, notions that seemed absurd after being reminded how ephemeral even skyscrapers and democratic institutions are."

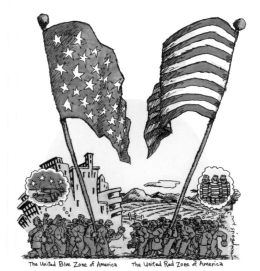

Art for *In the Shadow of No Towers* no. 7. Ink on paper and digital color.

Sketch for *In the Shadow of No Towers* no. 4. Ink on paper.

Art for *In the Shadow of No Towers* no. 1. Ink on paper.

Sketch for *In the Shadow of No Towers* no. 5. Ink on paper.

Sketch for *In the Shadow of No Towers* no. 4. Ink on paper.

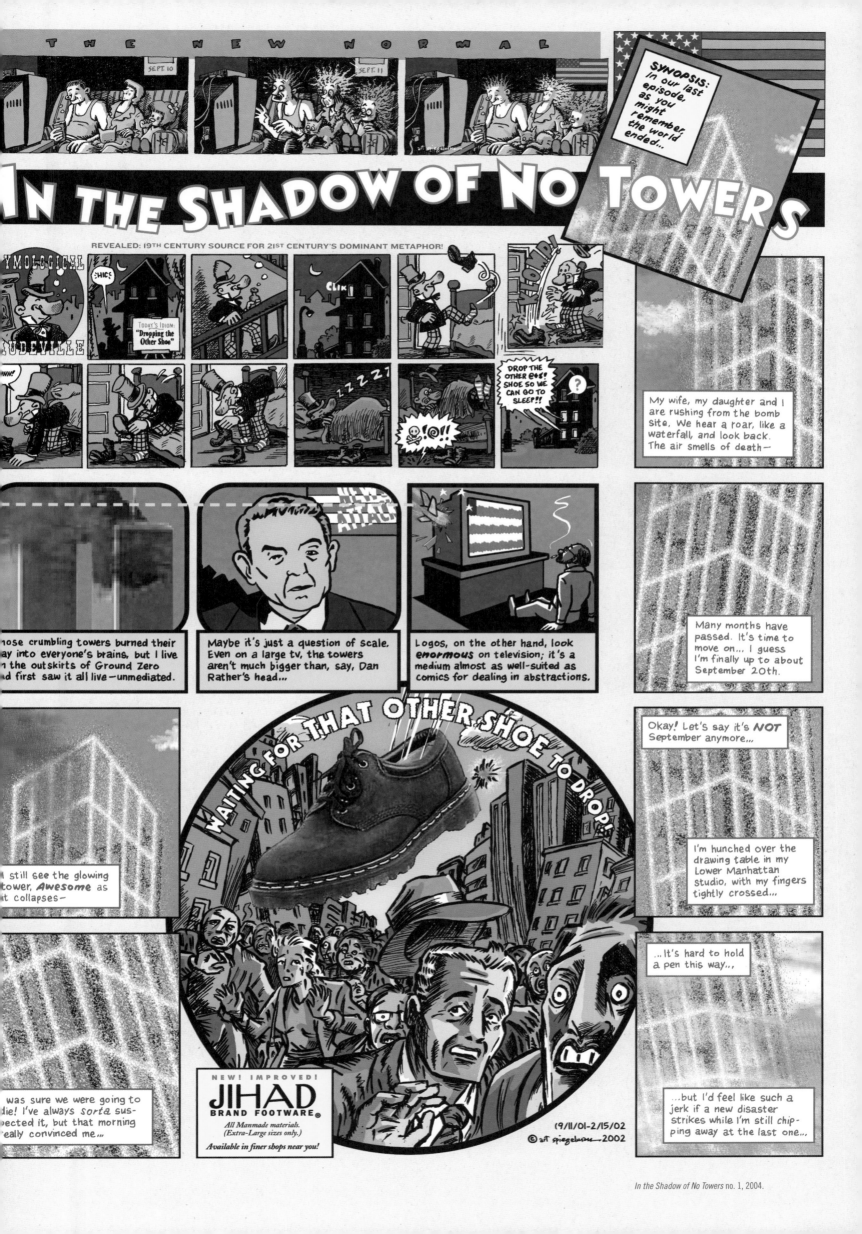

WAIT! Don't put me back on the shelf!
I'll tell you about the wizard's curse.

Just as **Spiegelman** brought formalist experimentation to comics in *Breakdowns*, he crafted an avant-garde kids' book in *Open Me...I'm a Dog!* (HarperCollins, 1997). It tells the story of a dog that has been cursed by a wizard and turned into a book, complete with a leash. In Spiegelman's hands, the book became a version of René Magritte's "This is not a pipe" for young readers.

It started when I was just a pup... A rabbit drove by, so of course I chased it.

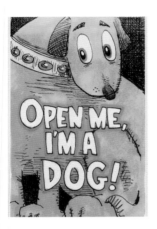

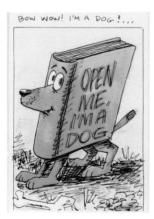

TOP AND CENTER: studies, felt tip markers.
Very early studies for book, circa 1968.

Images from *Open Me...I'm a Dog!* Gouache, ink, and watercolor. 1997.

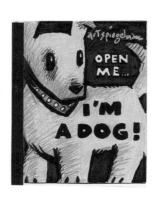

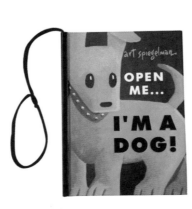

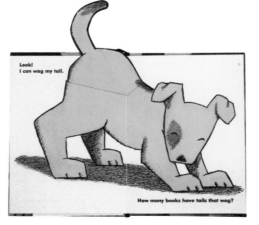

Study, ink and colored pencil. 1996.

Open Me...I'm a Dog! Cover, interior, and back cover. 1997.

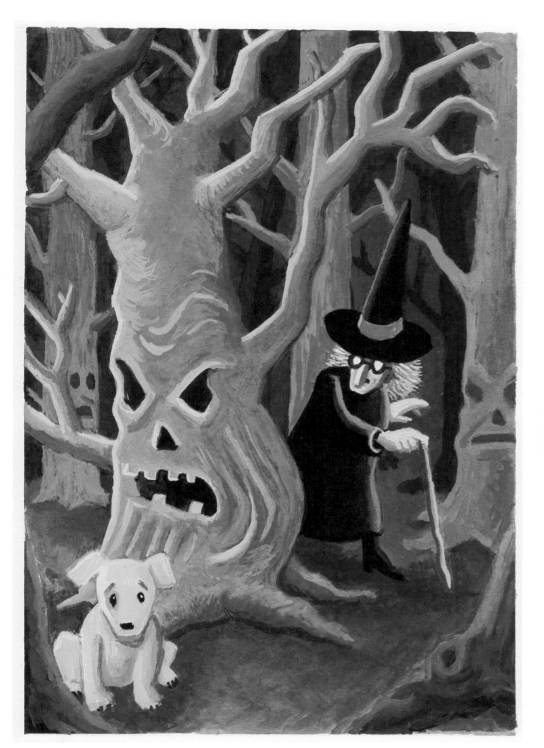

Spiegelman says, "the book was first conceived in 1968, during the early stages of a mental breakdown that led to my incarceration in a mental hospital. I was thinking too hard about the differences between language and 'reality.'" The eventual book was published nearly three decades after Spiegelman's first sketches, at left on facing page.

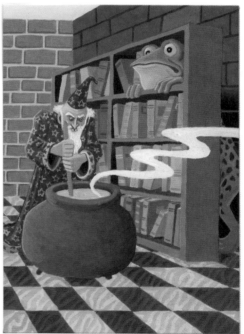

THIS PAGE: Images from *Open Me…I'm a Dog!* Gouache. 1997.

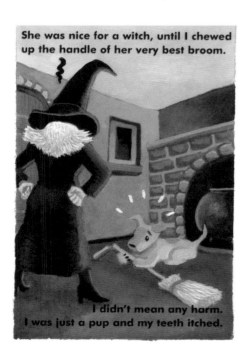

She was nice for a witch, until I chewed up the handle of her very best broom.

I didn't mean any harm. I was just a pup and my teeth itched.

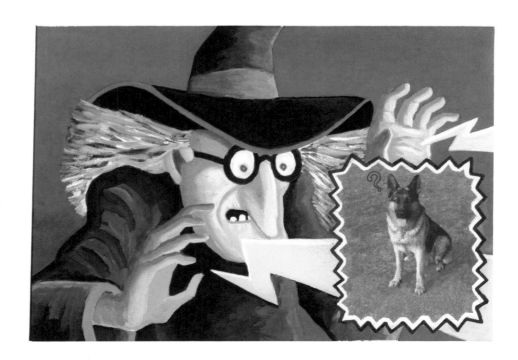

After proving in *RAW* that comics could be for adults, Spiegelman and Mouly, now parents with two kids, turned their attention to the dire state of children's comics, a once thriving genre that had virtually disappeared by the end of the twentieth century. With their *Little Lit* anthologies, published from 2000 to 2003, they recruited both cartoonists and children's book creators to reinvigorate kids' comics. The books included *RAW* alumni such as Mattotti, Loustal, Ware, and Burns as well as stars from the world of children's books, such as Ponti and Sendak.

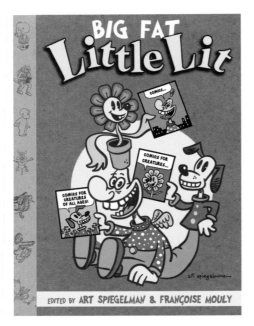

Cover for *Big Fat Little Lit*, a compendium volume collecting the three books in the series. Digital drawing. 2006.

RIGHT: Cover art for *Little Lit: Folklore and Fairy Tale Funnies*, gouache. 2000.

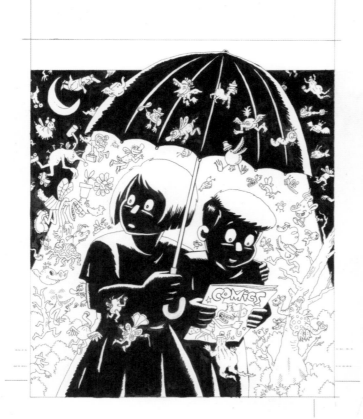

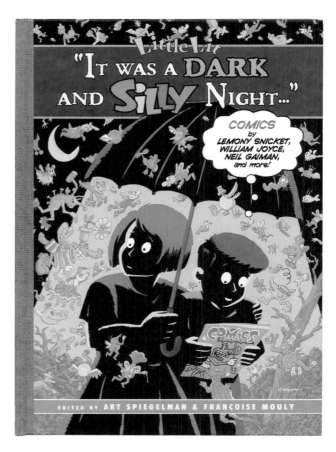

Line art for cover of *Little Lit: It Was A Dark and Silly Night*…2003.

Printed cover for *Little Lit: It Was A Dark and Silly Night*…2003.

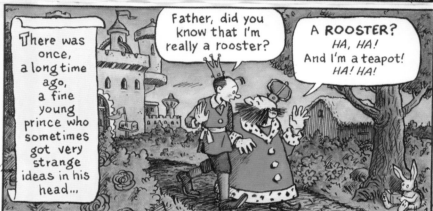

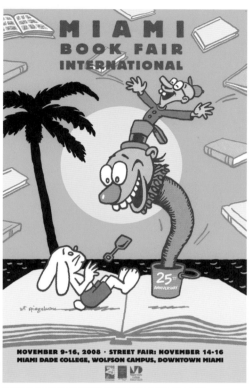

KIDS' COMICS

Poster for Miami Book Fair. Pen and ink with digital color. 2000.

LEFT: "Prince Rooster." Splash page for a story in *Little Lit: Folklore and Fairy Tale Funnies*. India ink and watercolor. 2000.

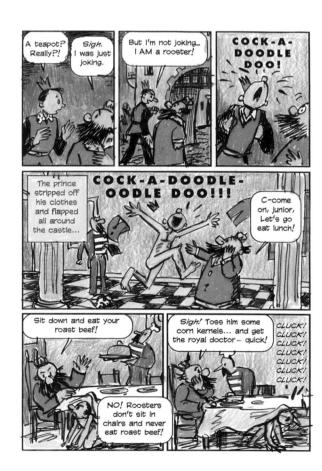

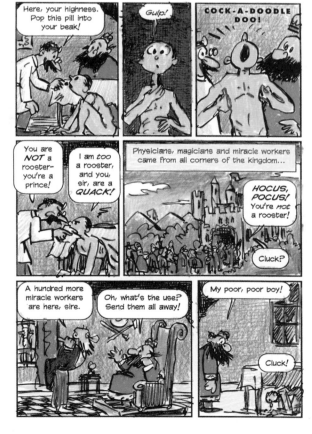

Studies for "Prince Rooster." *Little Lit: Folklore and Fairy Tale Funnies*. India ink, colored pencil, and digital elements. 2000.

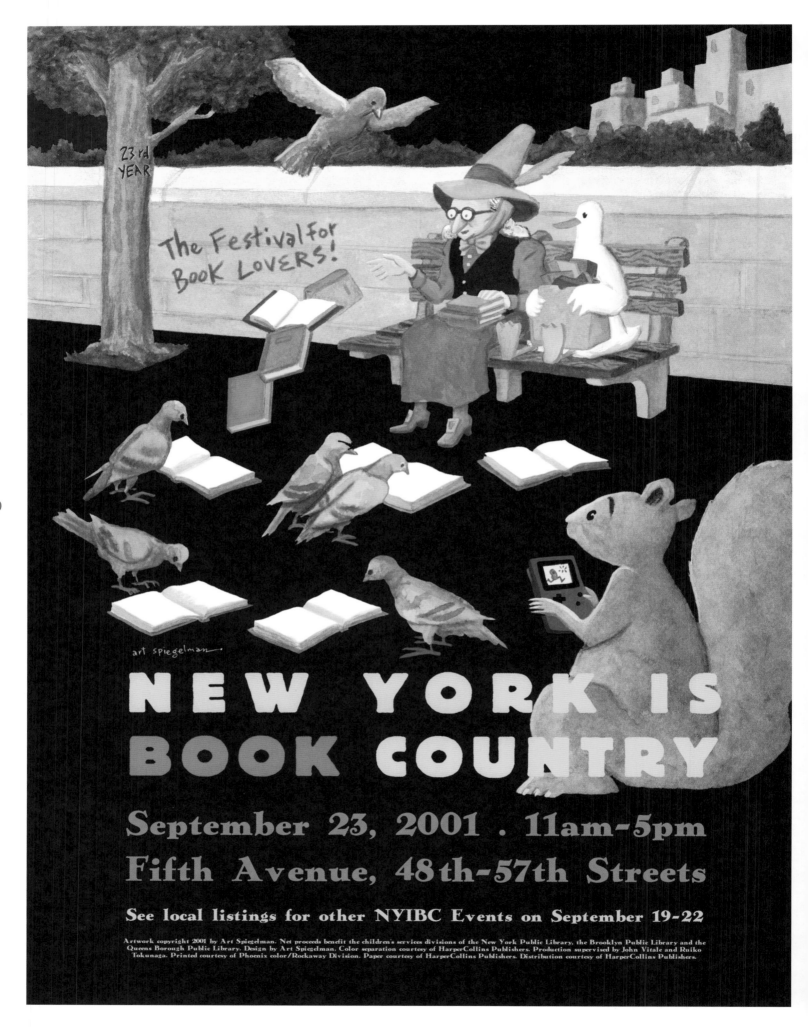

Poster for New York Is Book Country, 2001. Gouache. The festival was canceled as a result of the 9/11 terrorist attacks earlier that month. This image was later reissued for the 2002 edition of the festival.

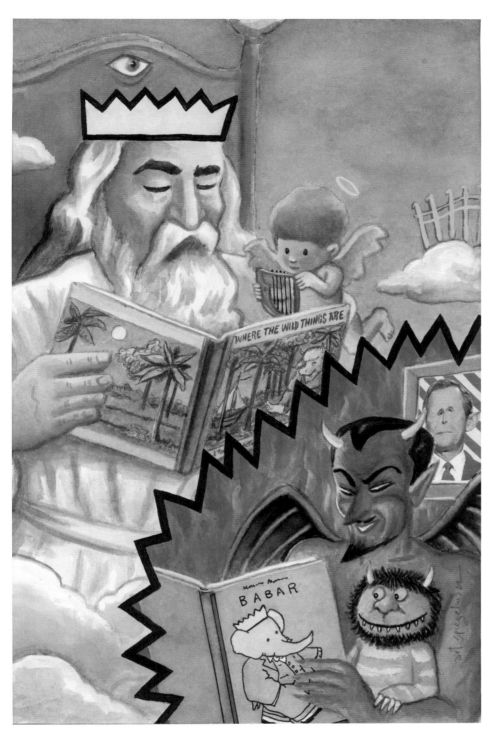

Cover for *Horn Book* magazine, November 2001. Acrylic gouache. Special issue on religion and politics in children's books.

Study for *Jack and The Box*, 2008. Colored marker.

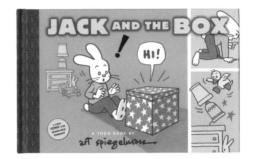

Cover for *Jack and The Box*, 2008. Digital drawing.

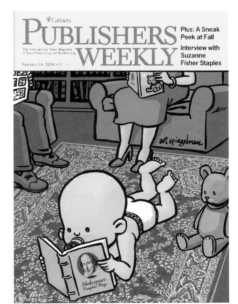

Cover for *Publishers Weekly*, July 16, 2001. Digital drawing.

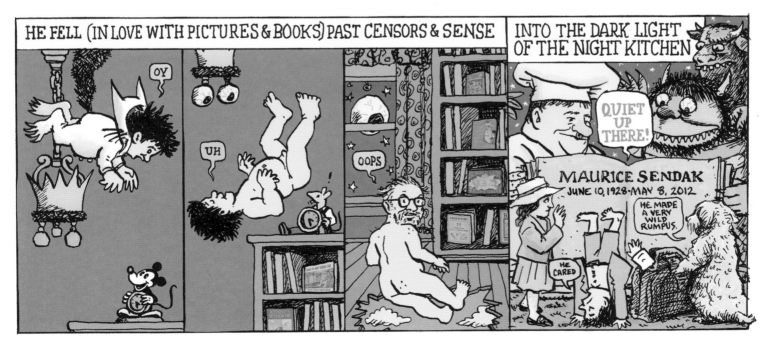

Homage to Maurice Sendak, the *New York Times*, May 13, 2012. Pen and ink with digital color.

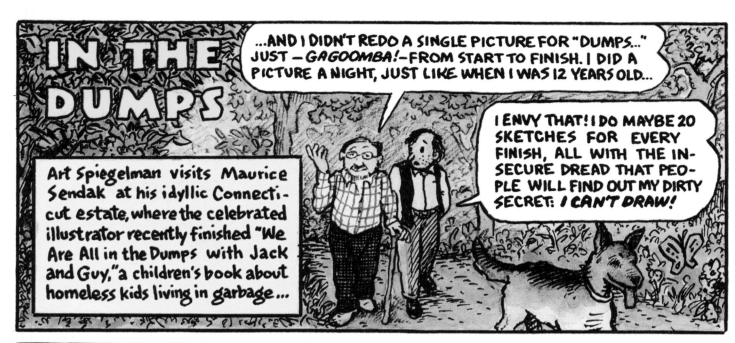

IN THE DUMPS

...AND I DIDN'T REDO A SINGLE PICTURE FOR "DUMPS..." JUST — *GAGOOMBA!* — FROM START TO FINISH. I DID A PICTURE A NIGHT, JUST LIKE WHEN I WAS 12 YEARS OLD...

Art Spiegelman visits Maurice Sendak at his idyllic Connecti- cut estate, where the celebrated illustrator recently finished "We Are All in the Dumps with Jack and Guy," a children's book about homeless kids living in garbage...

I ENVY THAT! I DO MAYBE 20 SKETCHES FOR EVERY FINISH, ALL WITH THE IN- SECURE DREAD THAT PEO- PLE WILL FIND OUT MY DIRTY SECRET: *I CAN'T DRAW!*

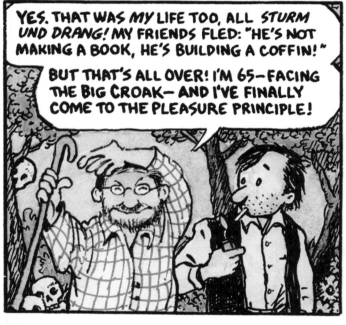

YES. THAT WAS *MY* LIFE TOO, ALL *STURM UND DRANG!* MY FRIENDS FLED: "HE'S NOT MAKING A BOOK, HE'S BUILDING A COFFIN!"

BUT THAT'S ALL OVER! I'M 65 — FACING THE BIG CROAK — AND I'VE FINALLY COME TO THE PLEASURE PRINCIPLE!

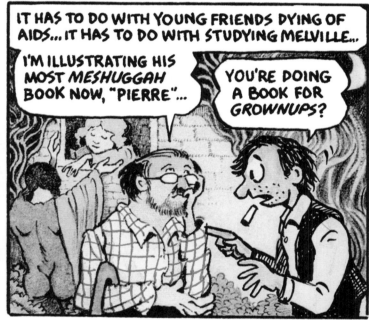

IT HAS TO DO WITH YOUNG FRIENDS DYING OF AIDS... IT HAS TO DO WITH STUDYING MELVILLE...

I'M ILLUSTRATING HIS MOST *MESHUGGAH* BOOK NOW, "PIERRE"...

YOU'RE DOING A BOOK FOR GROWNUPS?

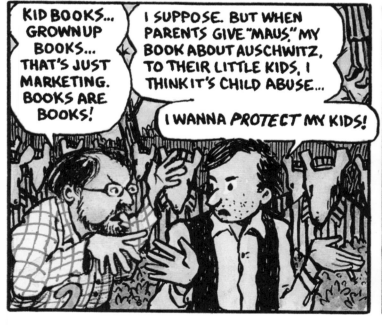

KID BOOKS... GROWN UP BOOKS... THAT'S JUST MARKETING. BOOKS ARE BOOKS!

I SUPPOSE. BUT WHEN PARENTS GIVE "MAUS," MY BOOK ABOUT AUSCHWITZ, TO THEIR LITTLE KIDS, I THINK IT'S CHILD ABUSE...

I WANNA *PROTECT* MY KIDS!

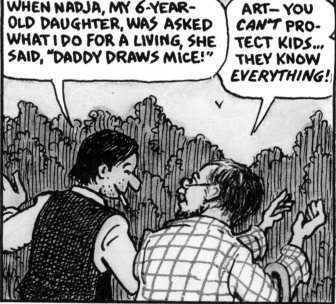

WHEN NADJA, MY 6-YEAR- OLD DAUGHTER, WAS ASKED WHAT I DO FOR A LIVING, SHE SAID, "DADDY DRAWS MICE!"

ART — YOU *CAN'T* PRO- TECT KIDS... THEY KNOW EVERYTHING!

"In The Dumps." Pen and ink and watercolor. Drawn in collaboration with Maurice Sendak. The *New Yorker*, September 27, 1993.

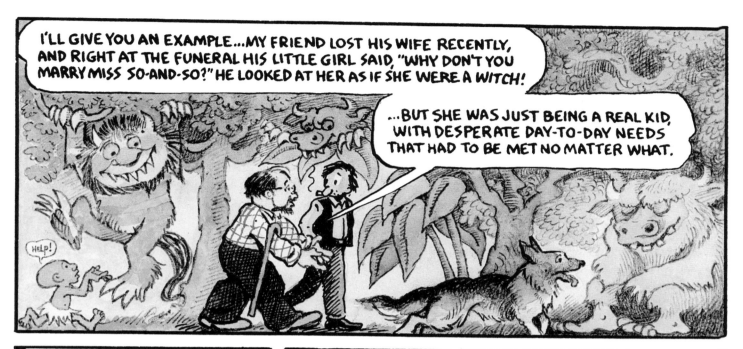

I'LL GIVE YOU AN EXAMPLE...MY FRIEND LOST HIS WIFE RECENTLY, AND RIGHT AT THE FUNERAL HIS LITTLE GIRL SAID, "WHY DON'T YOU MARRY MISS SO-AND-SO?" HE LOOKED AT HER AS IF SHE WERE A *WITCH!*

...BUT SHE WAS JUST BEING A REAL KID, WITH DESPERATE DAY-TO-DAY NEEDS THAT HAD TO BE MET NO MATTER WHAT.

HELP!

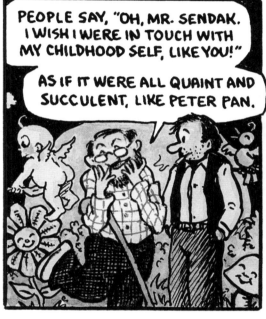

PEOPLE SAY, "OH, MR. SENDAK. I WISH I WERE IN TOUCH WITH MY CHILDHOOD SELF, LIKE YOU!"

AS IF IT WERE ALL QUAINT AND SUCCULENT, LIKE PETER PAN.

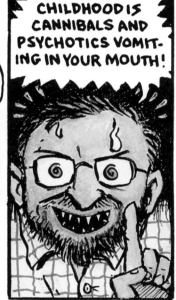

CHILDHOOD IS CANNIBALS AND PSYCHOTICS VOMITING IN YOUR MOUTH!

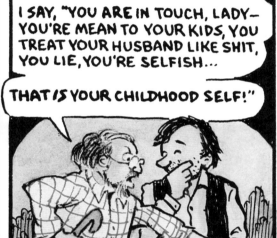

I SAY, "YOU ARE IN TOUCH, LADY— YOU'RE MEAN TO YOUR KIDS, YOU TREAT YOUR HUSBAND LIKE SHIT, YOU LIE, YOU'RE SELFISH...

THAT *IS* YOUR CHILDHOOD SELF!"

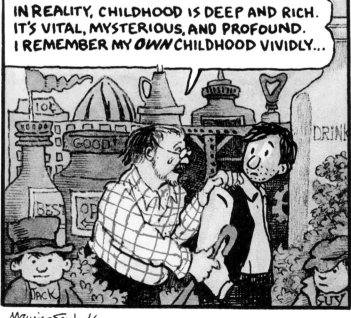

IN REALITY, CHILDHOOD IS DEEP AND RICH. IT'S VITAL, MYSTERIOUS, AND PROFOUND. I REMEMBER MY *OWN* CHILDHOOD VIVIDLY...

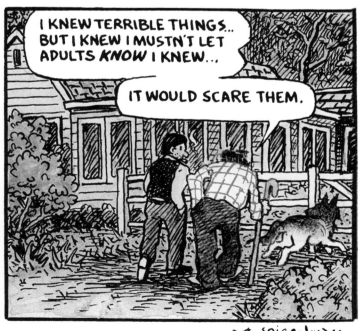

I KNEW TERRIBLE THINGS... BUT I KNEW I MUSTN'T LET ADULTS *KNOW* I KNEW...

IT WOULD SCARE THEM.

Maurice Sendak

art spiegelman

COMICS SUPPLEMENT

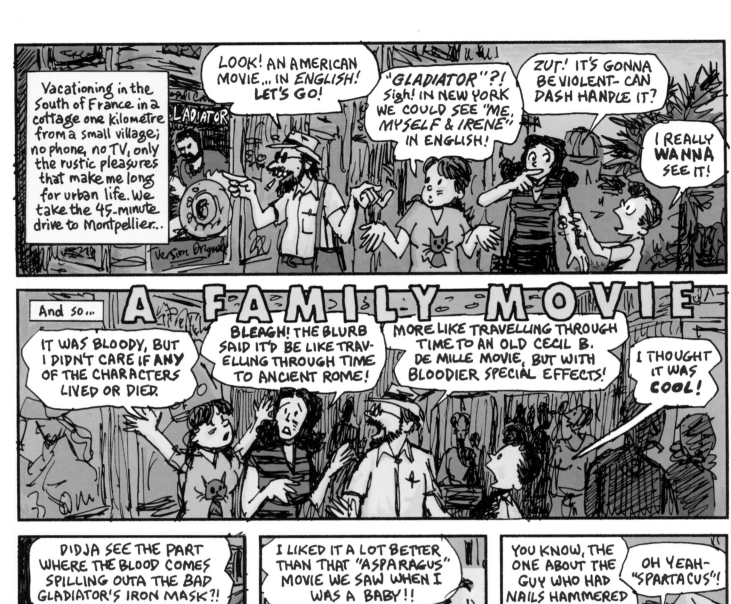

Vacationing in the South of France in a cottage one kilomètre from a small village; no phone, no TV, only the rustic pleasures that make me long for urban life. We take the 45-minute drive to Montpellier...

LOOK! AN AMERICAN MOVIE... IN ENGLISH! LET'S GO!

"GLADIATOR"?! Sigh! IN NEW YORK WE COULD SEE "ME, MYSELF & IRENE" IN ENGLISH!

ZUT! IT'S GONNA BE VIOLENT— CAN DASH HANDLE IT?

I REALLY WANNA SEE IT!

A FAMILY MOVIE

And so...

IT WAS BLOODY, BUT I DIDN'T CARE IF ANY OF THE CHARACTERS LIVED OR DIED.

BLEAGH! THE BLURB SAID IT'D BE LIKE TRAVELLING THROUGH TIME TO ANCIENT ROME!

MORE LIKE TRAVELLING THROUGH TIME TO AN OLD CECIL B. DE MILLE MOVIE, BUT WITH BLOODIER SPECIAL EFFECTS!

I THOUGHT IT WAS COOL!

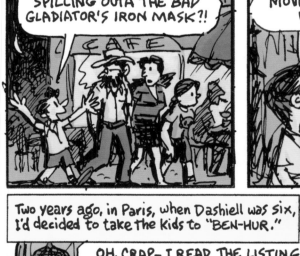

DIDJA SEE THE PART WHERE THE BLOOD COMES SPILLING OUTA THE BAD GLADIATOR'S IRON MASK?!

I LIKED IT A LOT BETTER THAN THAT "ASPARAGUS" MOVIE WE SAW WHEN I WAS A BABY!!

"ASPARAGUS"?

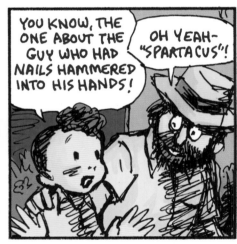

YOU KNOW, THE ONE ABOUT THE GUY WHO HAD NAILS HAMMERED INTO HIS HANDS!

OH YEAH— "SPARTACUS"!

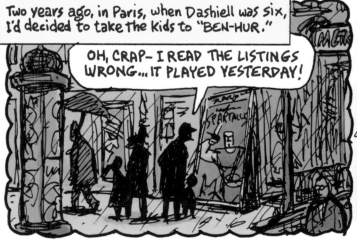

Two years ago, in Paris, when Dashiell was six, I'd decided to take the kids to "BEN-HUR."

OH, CRAP— I READ THE LISTINGS WRONG... IT PLAYED YESTERDAY!

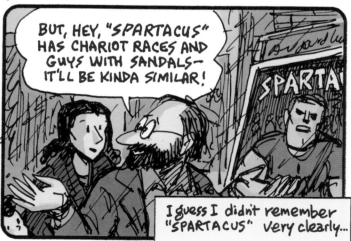

BUT, HEY, "SPARTACUS" HAS CHARIOT RACES AND GUYS WITH SANDALS— IT'LL BE KINDA SIMILAR!

I guess I didn't remember "SPARTACUS" very clearly...

"A Family Movie." Pen and ink and digital color. The *New Yorker*, September 4, 2000.

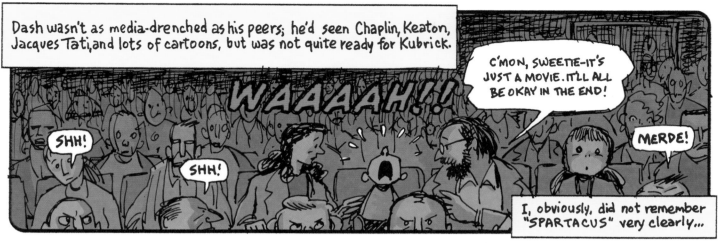

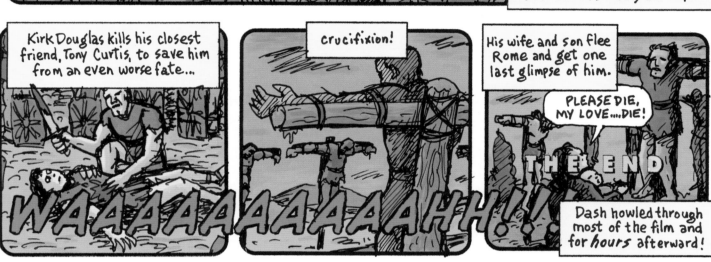

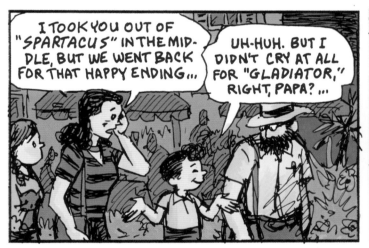

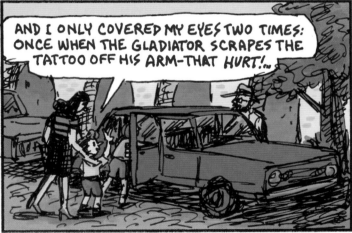

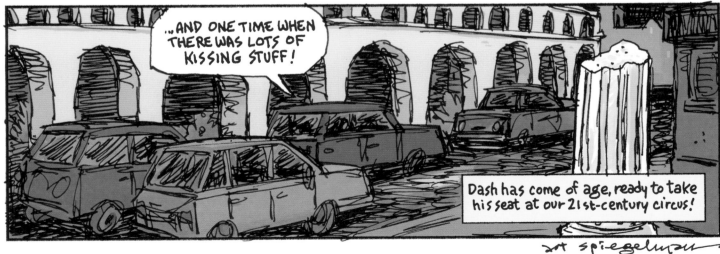

Nature vs. Nurture

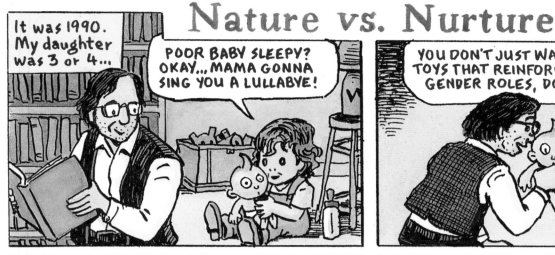

It was 1990. My daughter was 3 or 4...

POOR BABY SLEEPY? OKAY... MAMA GONNA SING YOU A LULLABYE!

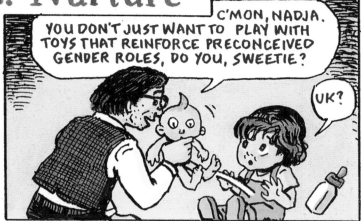

C'MON, NADJA. YOU DON'T JUST WANT TO PLAY WITH TOYS THAT REINFORCE PRECONCEIVED GENDER ROLES, DO YOU, SWEETIE?

UK?

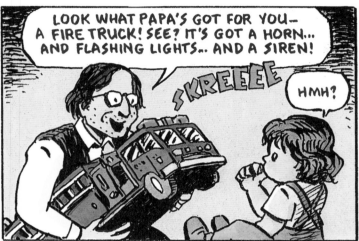

LOOK WHAT PAPA'S GOT FOR YOU— A FIRE TRUCK! SEE? IT'S GOT A HORN... AND FLASHING LIGHTS... AND A SIREN!

SKREEEE

HMH?

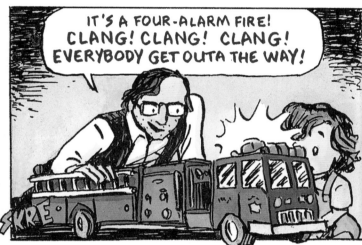

IT'S A FOUR-ALARM FIRE! CLANG! CLANG! CLANG! EVERYBODY GET OUTA THE WAY!

SKRE

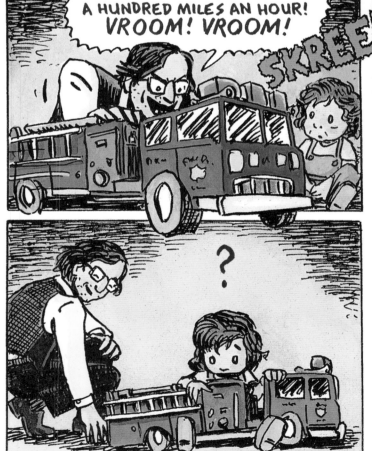

HERE COME THE FIREMEN AT A HUNDRED MILES AN HOUR! VROOM! VROOM!

SKREEEE

?

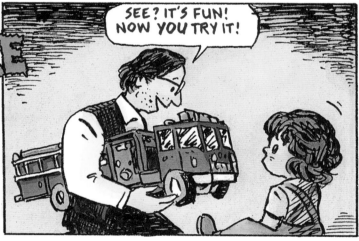

SEE? IT'S FUN! NOW YOU TRY IT!

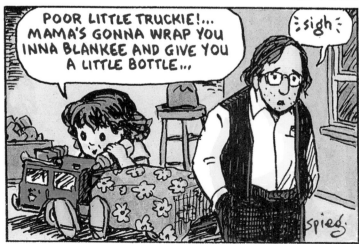

POOR LITTLE TRUCKIE!... MAMA'S GONNA WRAP YOU INNA BLANKEE AND GIVE YOU A LITTLE BOTTLE...

:sigh:

spieg.

"Nature vs. Nurture." Pen and ink and watercolor. The *New Yorker*, September 8, 1997.

※ SIGH ※

The news that Charles (Sparky) Schulz, the 77-year-old creator of "Peanuts," was retiring his almost 50-year-old strip to fight cancer was recognized as a genuine Millennial Event. The end of the most popular comic strip ever was greeted by an outpouring of grief and affection not seen since Paris buried Victor Hugo.

ABSTRACT THOUGHT is a WARM PUPPY
by art spiegelman

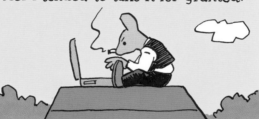

I liked "Peanuts" as much as the next 355 million readers, but confess I tended to take it for granted.

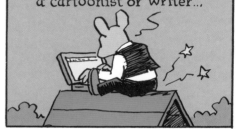

I never acknowledged it as an influence on me as a cartoonist or writer...

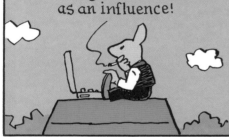

It would have been sort of like citing RICE KRISPIES as an influence!

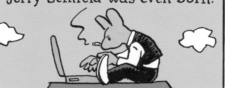

Yet it's astounding how much it did influence all that came after. I mean, "Peanuts" was "about nothing" years before Jerry Seinfeld was even born.

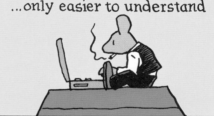

At its best, which was often, the strip had the simplicity and depth charge of a haiku ...only easier to understand

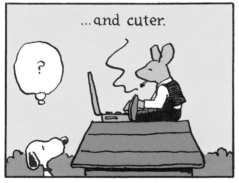

...and cuter.

OKAY! EVERYBODY OUT OF THE PLANE!

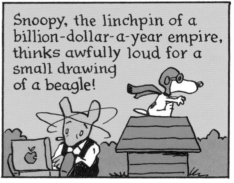

Snoopy, the linchpin of a billion-dollar-a-year empire, thinks awfully loud for a small drawing of a beagle!

I pulled a pile of books off the shelves to research this piece, and soon my 8-year-old son was hooked.

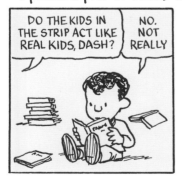

DO THE KIDS IN THE STRIP ACT LIKE REAL KIDS, DASH?

NO. NOT REALLY

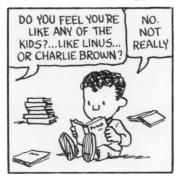

DO YOU FEEL YOU'RE LIKE ANY OF THE KIDS?...LIKE LINUS... OR CHARLIE BROWN?

NO. NOT REALLY

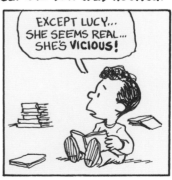

EXCEPT LUCY... SHE SEEMS REAL... SHE'S **VICIOUS!**

"Abstract Thought Is A Warm Puppy." Pen and ink with acrylic gouache and digital color. The *New Yorker*, February 14, 2000.
Although cover dated February 14, the issue with this comic strip appeared on newsstands on February 7, five days before Charles Schulz's death.

Out of the blue, I got a friendly letter from Charles Schulz inviting me to meet him sometime. Determining that it wasn't a hoax, I visited #1 Snoopy Place, in Santa Rosa, last August and was soon engaged in a theological conversation.

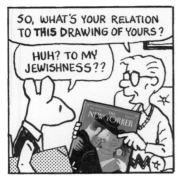

SO, WHAT'S YOUR RELATION TO **THIS** DRAWING OF YOURS?

HUH? TO MY JEWISHNESS??

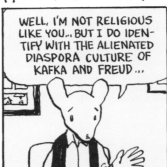

WELL, I'M NOT RELIGIOUS LIKE YOU... BUT I DO IDENTIFY WITH THE ALIENATED DIASPORA CULTURE OF KAFKA AND FREUD...

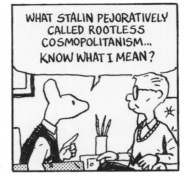

WHAT STALIN PEJORATIVELY CALLED ROOTLESS COSMOPOLITANISM... KNOW WHAT I MEAN?

NO, NOT REALLY... BUT I'M *TRYIN'!*

GOOD GRIEF

FOR BETTER OR WORSE, CHARLES (SPARKY) SCHULZ'S

PEANUTS

PERMANENTLY CHANGED THE POSTWAR NEWSPAPER STRIP, A MEDIUM ONCE DOMINATED BY VAUDEVILLE AND MELODRAMA. HE PRAGMATICALLY ACQUIESCED TO THE SHRINKING SPACE AVAILABLE IN PAPERS AND TO READERS' CHANGING HABITS BY CREATING A SPARE LITTLE STRIP THAT DIDN'T NEED TO BE FOLLOWED DAILY.

AESTHETIC ANALYSIS 5¢
The Comics Historian is IN

SCHULZ STUDIED THE BEST OF THE EARLIER STRIPS... FROM SEGAR'S "THIMBLE THEATER" (WHICH HE CALLED "A PERFECT COMIC STRIP") HE LEARNED THE VALUE OF SLOWLY PACED TIMING AND OF HIGHLY DEFINED CHARACTERS...

LOOKING AT "KRAZY KAT" TAUGHT HIM THE PROFOUND IMPLICATIONS OF VARYING A FEW BASIC THEMES... AND, LIKE THAT KAT WHO WAS NEITHER MALE NOR FEMALE, SCHULZ'S "KIDS" ARE NEITHER CHILDREN NOR ADULTS!

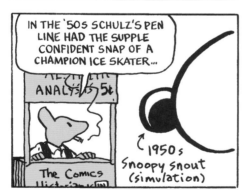

UMBERTO ECO SNAPPILY SAID OF SCHULZ'S CHARACTERS, "THEY ARE THE MONSTROUS INFANTILE REDUCTIONS OF ALL THE NEUROSES OF A MODERN CITIZEN OF THE INDUSTRIAL CIVILIZATION!"

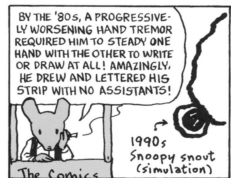

IN ANY CASE, SCHULZ'S KIDS ARE HARDLY KATZENJAMMER KIDS... THEY'RE CLOSER TO PERCY CROSBY'S FORGOTTEN CURBSIDE PHILOSOPHER, SKIPPY, OR CROCKETT JOHNSON'S GRAPHICALLY AUSTERE BARNABY!

IN THE '50S SCHULZ'S PEN LINE HAD THE SUPPLE CONFIDENT SNAP OF A CHAMPION ICE SKATER...

1950s Snoopy snout (simulation)

BY THE '80S, A PROGRESSIVELY WORSENING HAND TREMOR REQUIRED HIM TO STEADY ONE HAND WITH THE OTHER TO WRITE OR DRAW AT ALL! AMAZINGLY, HE DREW AND LETTERED HIS STRIP WITH NO ASSISTANTS!

1990s Snoopy snout (simulation)

HIS NERVOUS LINE—SO APPROPRIATE TO THE STRIP'S THEMES—WAS ACHIEVED THROUGH SHEER FORCE OF WILL! IT'S POIGNANT... AND A *LITERAL* MARK OF SCHULZ'S DEDICATION TO HIS CRAFT!

UNFORTUNATELY, HIS DECEPTIVELY SIMPLE APPROACH HAS BEEN WIDELY EMULATED BY LESSER TALENTS, WHO HAVE BROUGHT ABOUT A DISTRESSING EROSION OF CARTOON CRAFT!

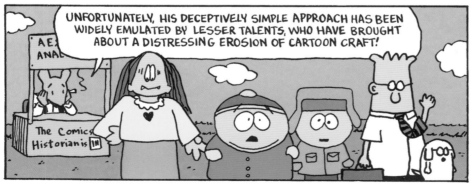

IT'S NOT MY FAULT!

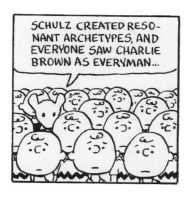

SCHULZ CREATED RESO-
NANT ARCHETYPES, AND
EVERYONE SAW CHARLIE
BROWN AS EVERYMAN...

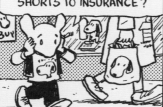

THE STRIP RADIATED
INTEGRITY, BUT **WHY** DID
EVERYDOG HAVE TO FLOG
EVERYTHING FROM BOXER
SHORTS TO INSURANCE?

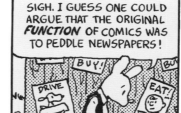

SIGH. I GUESS ONE COULD
ARGUE THAT THE ORIGINAL
FUNCTION OF COMICS WAS
TO PEDDLE NEWSPAPERS!

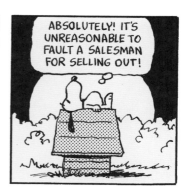

ABSOLUTELY! IT'S
UNREASONABLE TO
FAULT A SALESMAN
FOR SELLING OUT!

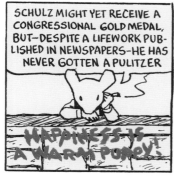

SCHULZ MIGHT YET RECEIVE A
CONGRESSIONAL GOLD MEDAL,
BUT—DESPITE A LIFEWORK PUB-
LISHED IN NEWSPAPERS—HE HAS
NEVER GOTTEN A PULITZER

HAPPINESS IS
A WARM PONY!

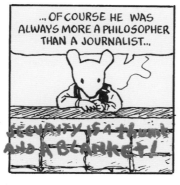

...OF COURSE HE WAS
ALWAYS MORE A PHILOSOPHER
THAN A JOURNALIST...

SECURITY IS A THUMB
AND A BLANKET!

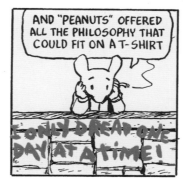

AND "PEANUTS" OFFERED
ALL THE PHILOSOPHY THAT
COULD FIT ON A T-SHIRT

I ONLY DREAD ONE
DAY AT A TIME!

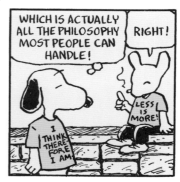

WHICH IS ACTUALLY
ALL THE PHILOSOPHY
MOST PEOPLE CAN
HANDLE!

RIGHT!

LESS
IS
MORE!

I
THINK
THERE
FORE
I AM

Talking with Sparky was, fittingly enough, a bit
like finding oneself inside a "Peanuts" episode.

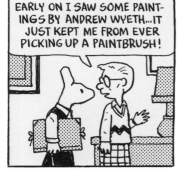

EARLY ON I SAW SOME PAINT-
INGS BY ANDREW WYETH...IT
JUST KEPT ME FROM EVER
PICKING UP A PAINTBRUSH!

I HAVE VERY
LIMITED TALENTS

...BUT AT LEAST I KNOW
I'VE USED THEM TO THE
BEST OF MY ABILITY!

...YOU KNOW, I SOMETIMES
FEEL THAT I'M GETTING SMALL-
ER WHILE THE UNIVERSE
IS GETTING BIGGER!

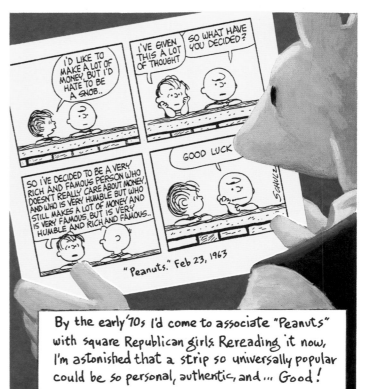

"Peanuts." Feb 23, 1963

By the early '70s I'd come to associate "Peanuts"
with square Republican girls. Rereading it now,
I'm astonished that a strip so universally popular
could be so personal, authentic, and ... Good!

Millions of readers are
as concerned about the
artist's health as they
are about their own
immediate families'.

If Art that's beloved
could bring immortality,
the artist, like his alter
ego, would **never** kick
the -um-

...bucket!

...HOW **DID** "PEANUTS" CON-
SISTENTLY DEPICT GENUINE
PAIN AND LOSS AND STILL
KEEP EVERYTHING SO
WARM AND FUZZY?!

※ SIGH ※

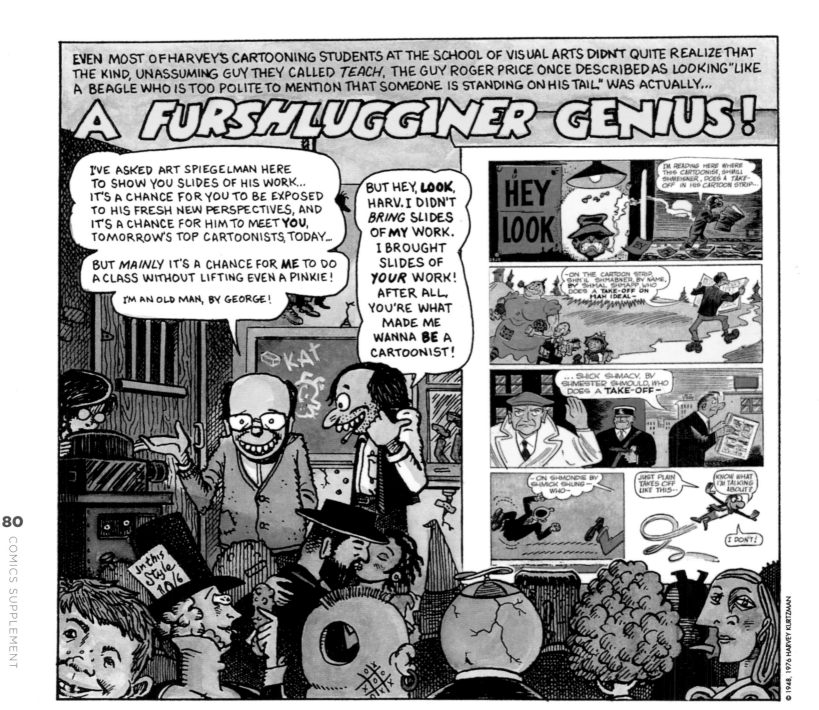

EVEN MOST OF HARVEY'S CARTOONING STUDENTS AT THE SCHOOL OF VISUAL ARTS DIDN'T QUITE REALIZE THAT THE KIND, UNASSUMING GUY THEY CALLED *TEACH*, THE GUY ROGER PRICE ONCE DESCRIBED AS LOOKING "LIKE A BEAGLE WHO IS TOO POLITE TO MENTION THAT SOMEONE IS STANDING ON HIS TAIL," WAS ACTUALLY...

A FURSHLUGGINER GENIUS!

I'VE ASKED ART SPIEGELMAN HERE TO SHOW YOU SLIDES OF HIS WORK... IT'S A CHANCE FOR YOU TO BE EXPOSED TO HIS FRESH NEW PERSPECTIVES, AND IT'S A CHANCE FOR HIM TO MEET **YOU**, TOMORROW'S TOP CARTOONISTS, TODAY...

BUT *MAINLY* IT'S A CHANCE FOR **ME** TO DO A CLASS WITHOUT LIFTING EVEN A PINKIE!

I'M AN OLD MAN, BY GEORGE!

BUT HEY, **LOOK**, HARV. I DIDN'T *BRING* SLIDES OF *MY* WORK. I BROUGHT SLIDES OF *YOUR* WORK! AFTER ALL, YOU'RE WHAT MADE ME WANNA **BE** A CARTOONIST!

IT WAS 1988. I SHOWED HIS CLASS THE RIGOROUS STRUCTURING AND JAZZY RHYTHMS THAT HARVEY BROUGHT TO HIS EARLY "HEY LOOK" PAGES, AND I TALKED ABOUT **MAD.**

SELF-REFLEXIVE AND CHEERFULLY VULGAR, HARVEY'S EARLY **MAD** COMIC BOOK WAS LIVELIER AND MORE SUBVERSIVELY ANARCHISTIC THAN THE LATER MAGAZINE.

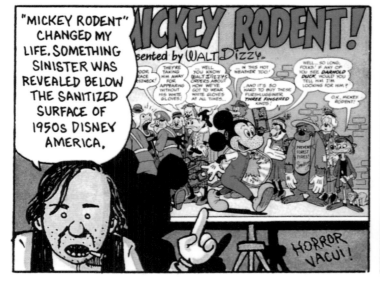

"MICKEY RODENT" CHANGED MY LIFE. SOMETHING SINISTER WAS REVEALED BELOW THE SANITIZED SURFACE OF 1950s DISNEY AMERICA.

HORROR VACUI!

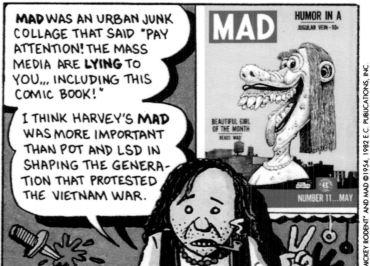

MAD WAS AN URBAN JUNK COLLAGE THAT SAID "PAY ATTENTION! THE MASS MEDIA ARE **LYING** TO YOU... INCLUDING THIS COMIC BOOK!"

I THINK HARVEY'S **MAD** WAS MORE IMPORTANT THAN POT AND LSD IN SHAPING THE GENERATION THAT PROTESTED THE VIETNAM WAR.

"A Furshlugginer Genius!" Pen and ink and gouache. *The New Yorker*, March 29, 1993.

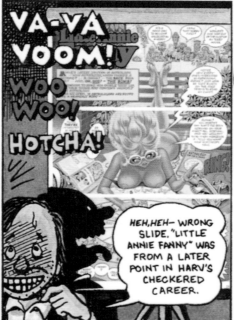

HARV DIDN'T CHANGE THE CULTURE ONLY BY CREATING A NEW MODE OF SATIRE. AT THE HEIGHT OF THE KOREAN WAR HE EDITED, WROTE, AND DREW WAR COMICS—NOT JINGOISTIC TRASH BUT THOROUGHLY RESEARCHED NARRATIVES WITH GREAT MORAL PURPOSE.

NEXT SLIDE, PLEASE.

NO SMOKI

VA-VA VOOM! WOO WOO! HOTCHA!

HEH, HEH— WRONG SLIDE. "LITTLE ANNIE FANNY" WAS FROM A LATER POINT IN HARV'S CHECKERED CAREER.

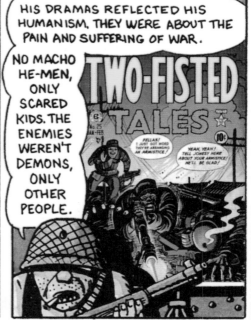

HIS DRAMAS REFLECTED HIS HUMANISM. THEY WERE ABOUT THE PAIN AND SUFFERING OF WAR.

NO MACHO HE-MEN, ONLY SCARED KIDS. THE ENEMIES WEREN'T DEMONS, ONLY OTHER PEOPLE.

TWO-FISTED TALES

I ANALYZED HARVEY'S VISUAL STORYTELLING STRUCTURE TO SHOW HOW HE CREATED A PRECISE FORMAL "GRAMMAR" OF COMICS.

I MENTIONED HIS IMPORTANCE AS AN INNOVATOR OF EDITORIAL FORMATS, AND CONCLUDED BY TALKING ABOUT HIS SKILLS AS AN EDITOR WHO NURTURED THE TALENTS OF OTHERS.

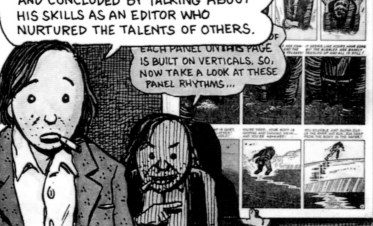

EACH PANEL ON THIS PAGE IS BUILT ON VERTICALS. SO, NOW TAKE A LOOK AT THESE PANEL RHYTHMS...

THE CLASS SAT IN AWE. SARAH DOWNS, HARVEY'S ASSISTANT, WAS WEEPING SOFTLY. ONLY HARVEY'S SWEET, FRAIL VOICE, TREMBLING WITH THE PARKINSON'S DISEASE THAT RAVAGED HIM, BROKE THE SILENCE.

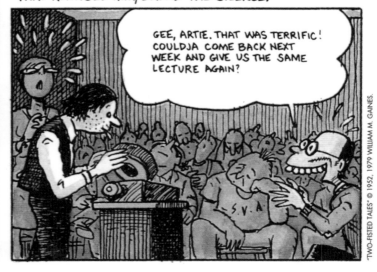

GEE, ARTIE. THAT WAS TERRIFIC! COULDJA COME BACK NEXT WEEK AND GIVE US THE SAME LECTURE AGAIN?

AFTERWARDS HARVEY GLOWED WITH PLEASURE. HE WARMLY CLASPED MY HAND.

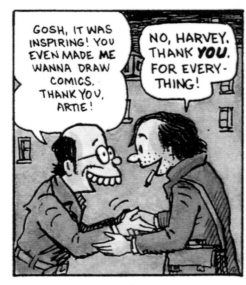

GOSH, IT WAS INSPIRING! YOU EVEN MADE ME WANNA DRAW COMICS. THANK YOU, ARTIE!

NO, HARVEY. THANK YOU. FOR EVERYTHING!

I LOOKED LOVINGLY AT MY ROLE MODEL, AND FOR A LONG MOMENT WE EMBRACED...

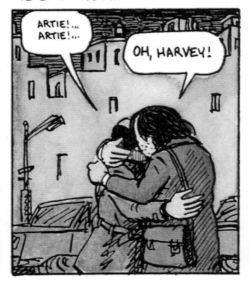

ARTIE!... ARTIE!...

OH, HARVEY!

MY MENTOR WAS WHISPERING SOMETHING TO ME. HE WAS BARELY AUDIBLE:

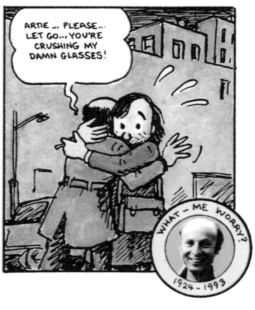

ARTIE... PLEASE... LET GO... YOU'RE CRUSHING MY DAMN GLASSES!

WHAT — ME WORRY?
1924 - 1993

WORDS, Worth a Thousand

see also: IMAGES, Unique Circulating Archives of, and NEW YORK CITY, Public Library Picture Collection.

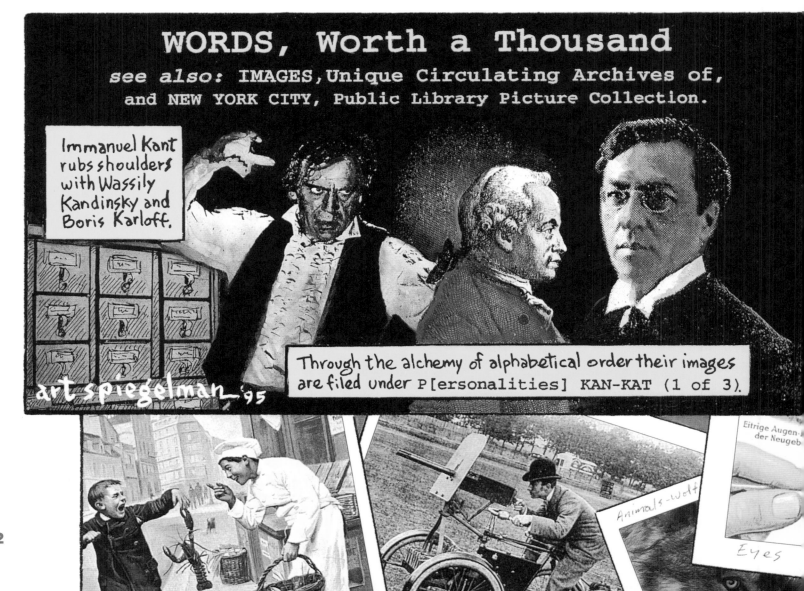

Immanuel Kant rubs shoulders with Wassily Kandinsky and Boris Karloff.

art spiegelman '95

Through the alchemy of alphabetical order their images are filed under P[ersonalities] KAN–KAT (1 of 3).

Pain

Inventions

Eitrige Augen der Neugeb

Animals—Wolf

Eyes

In the 1930s a visionary library clerk, Romana Javitz, took over a paltry picture collection started in 1915.

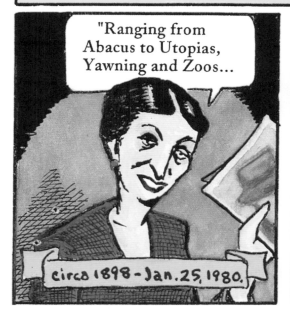

"Ranging from Abacus to Utopias, Yawning and Zoos...

circa 1898 – Jan. 25, 1980.

"by way of Murders, Noses and Oysters...

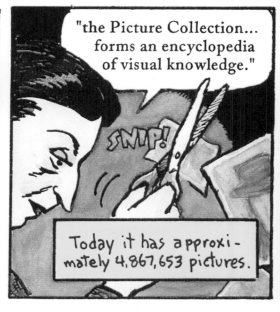

"the Picture Collection... forms an encyclopedia of visual knowledge."

SNIP!

Today it has approximately 4,867,653 pictures.

"Words, Worth a Thousand." Pen and ink and watercolor. The *New Yorker*, February 20, 1995.

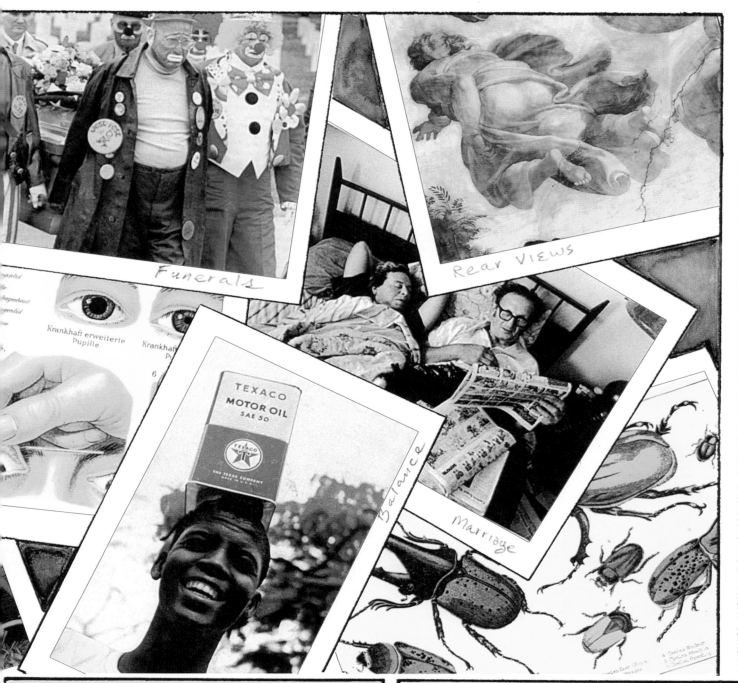

MARRIAGE: "MARILYN AND SAMUEL LEIBOVITZ, SILVER SPRING, MARYLAND, 1975." BY ANNIE LEIBOVITZ, REPRINTED WITH PERMISSION. FUNERALS: JOE ROSSI/SAINT PAUL PIONEER PRESS. ANIMALS—WOLF: STEPHEN HOMER/FIRST LIGHT.

Artists are the collection's heaviest users, but in the 1940s Army Intelligence found thousands of photos of Japan invaluable.

In 1982, when the collection moved from 42nd Street to larger quarters at the Mid-Manhattan Library, Charles Addams said:

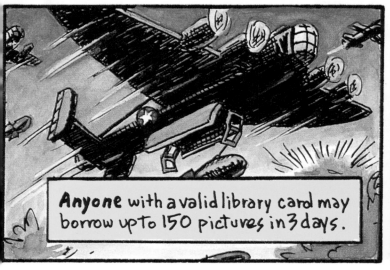

Anyone with a valid library card may borrow up to 150 pictures in 3 days.

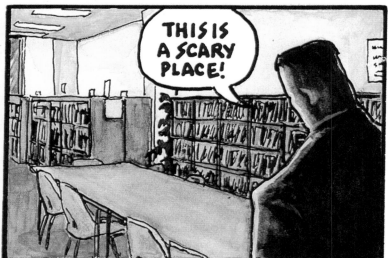

THIS IS A SCARY PLACE!

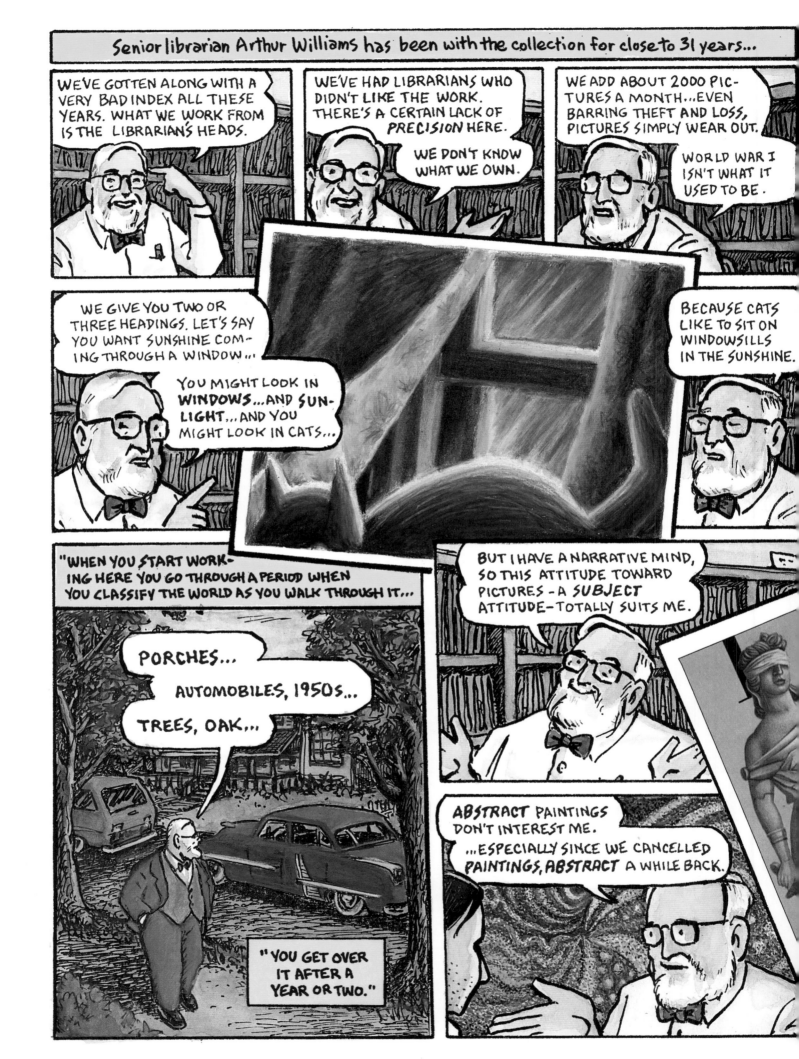

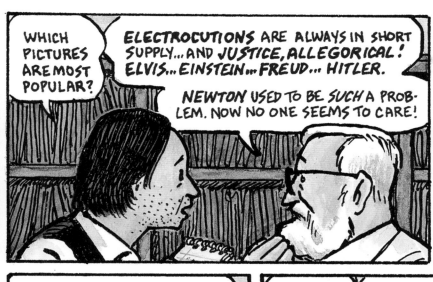
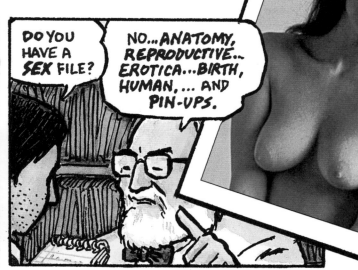
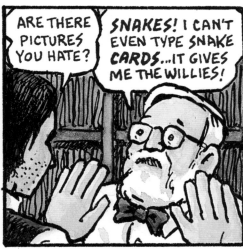
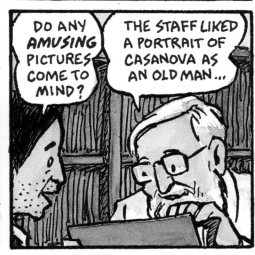
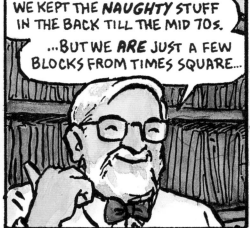
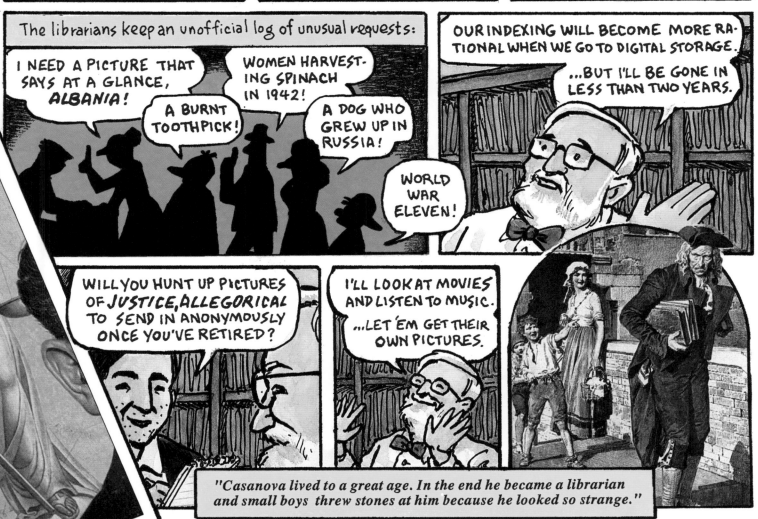

IT WAS WEIRD BEING A JEW IN ROSTOCK ON YOM KIPPUR...

I VISITED THE BUILDING OF GYPSY ASYLUM-SEEKERS FIREBOMBED BY SKINHEADS IN AUGUST.

THOUSANDS OF LOCALS FROM THE NEIGHBORING BUILDINGS CHEERED.

THEY GAVE THE HITLER SALUTE: "FOREIGNERS OUT! GERMANY FOR GERMANS!"

AFTER WWII MAYBE THE JEWS SHOULD HAVE INHERITED GERMANY...

THE GERMANS COULD'VE RESETTLED IN PALESTINE.

TWO YEARS OF WEST GERMAN MARKS HAVE MADE DOWNTOWN ROSTOCK QUAINT, PRETTY, AND PLUSH.

BUT THE WORKERS' LIVING UNITS ARE STORAGE LOCKERS WHICH STRETCH FOR MILES, DULL AND DEHUMANIZING.

UP TILL NOW GERMANY HAS BEEN A GENEROUS HOST TO ATONE FOR ITS GENOCIDAL PAST, IT HAS LET IN ANYONE SEEKING ASYLUM.

BUT EAST GERMANS DON'T IDENTIFY WITH THE NEW BEGGARS FROM THE REST OF THE CRUMBLED EMPIRE.

A SLIGHTLY DRUNK OUT-OF-WORK WORKER SAW US...

IT'S SAD. ROSTOCK IS NOW WORLD-FAMOUS,...

GYPSIES WERE LIVING NOT ONLY INSIDE THE BUILDING BUT IN THE BUSHES, WITH NO SANITATION. IT WAS A PIGSTY!

WE COMPLAINED, BUT THE MAYOR DID NOTHING. HE'D JUST GET **MORE** GYPSIES. NO ONE LIKED WALKING IN SHIT TO GET TO THE MARKET.

HEY. I LIVE IN SOHO AND I REMEMBER HOW ANGRY WE GOT ABOUT PLANS TO DOCK A PRISON BARGE NEARBY.

I READ IN THE "TIMES" THAT GERMANY IS DEPORTING GYPSIES BACK TO ROMANIA. THAT'S NOT THE WHOLE STORY.

THEY ARE PAYING OFF ROMANIA TO TAKE BACK REJECTED ASYLUM-SEEKERS AND IMPROVE GYPSY LIVING CONDITIONS INSIDE ROMANIA, BUT GYPSIES SEEKING ASYLUM STILL GET FOOD, SHELTER, MONEY, AND THE RIGHT TO APPEAL. HARDLY CATTLE CARS EAST.

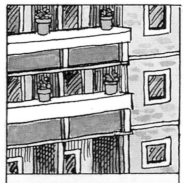

OF COURSE, THE NAZIS DID MURDER ABOUT 500,000 GYPSIES.... IT MAKES FOR AN EMBARRASSING P.R. PROBLEM.

"A Jew in Rostock." Pen and ink and watercolor. The *New Yorker*, December 7, 1992.

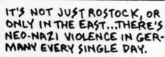

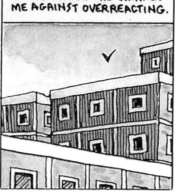
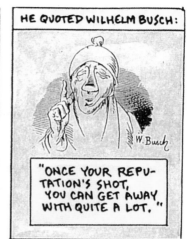
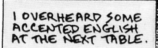
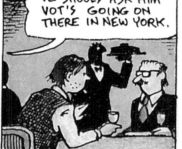
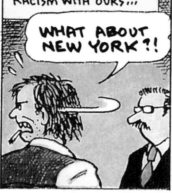
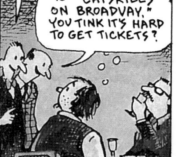

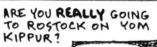

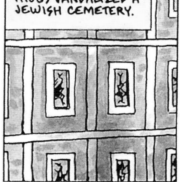
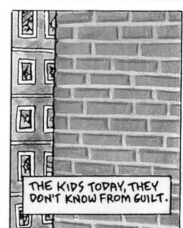
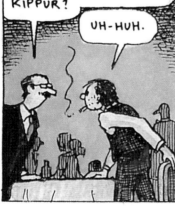
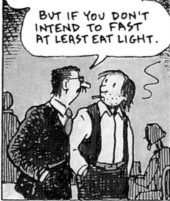

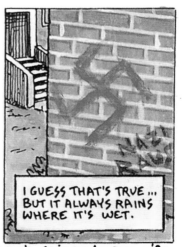

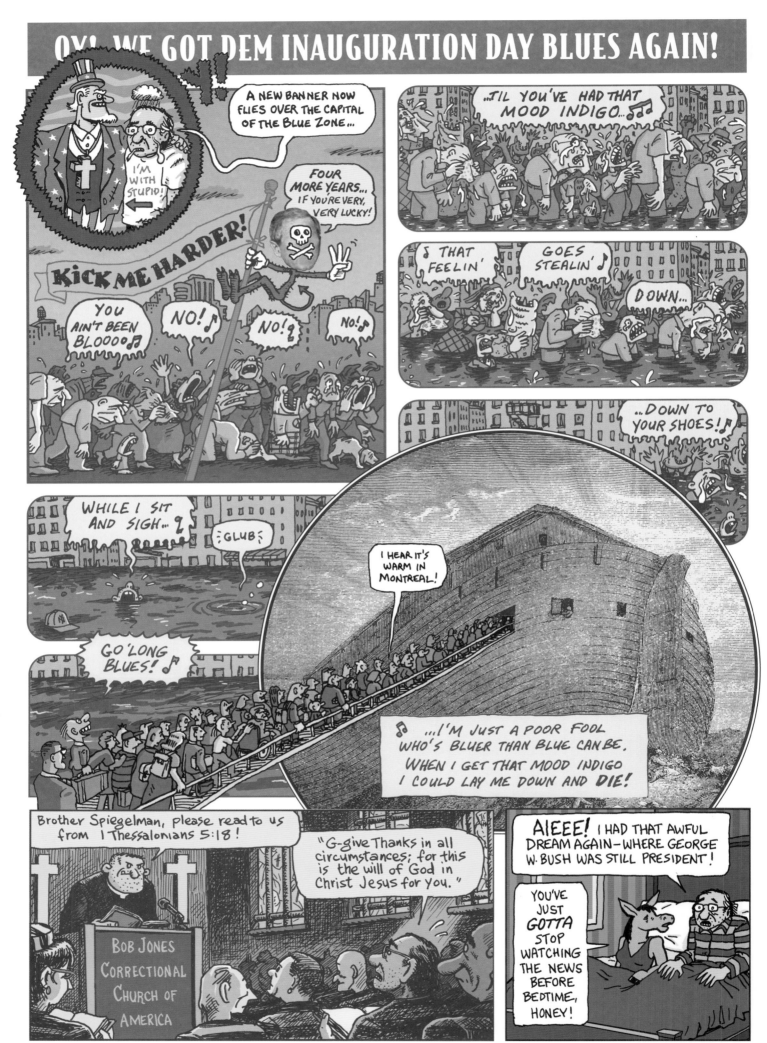

"Mood Indigo: Oy! We Got Dem Inauguration Day Blues Again!" Pen and ink, collage, and digital color. The *New Yorker*, January 17, 2005.

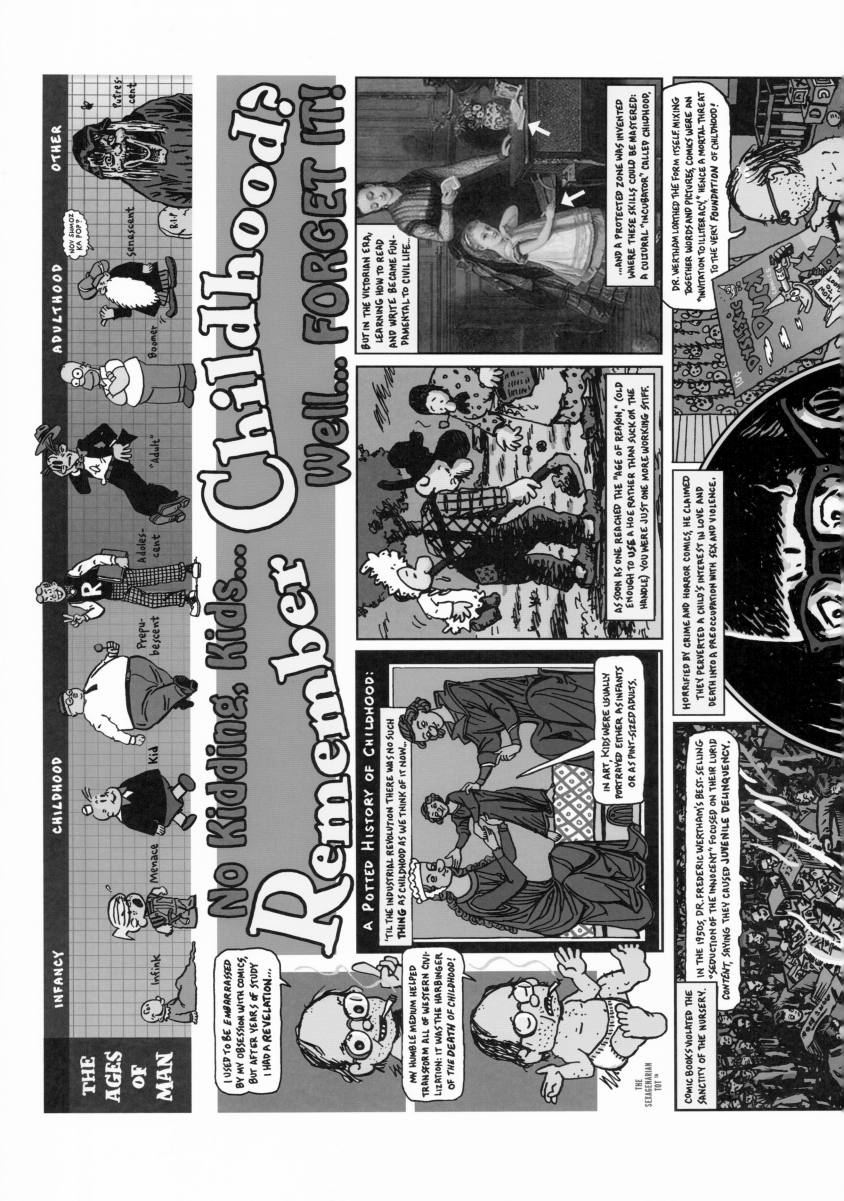

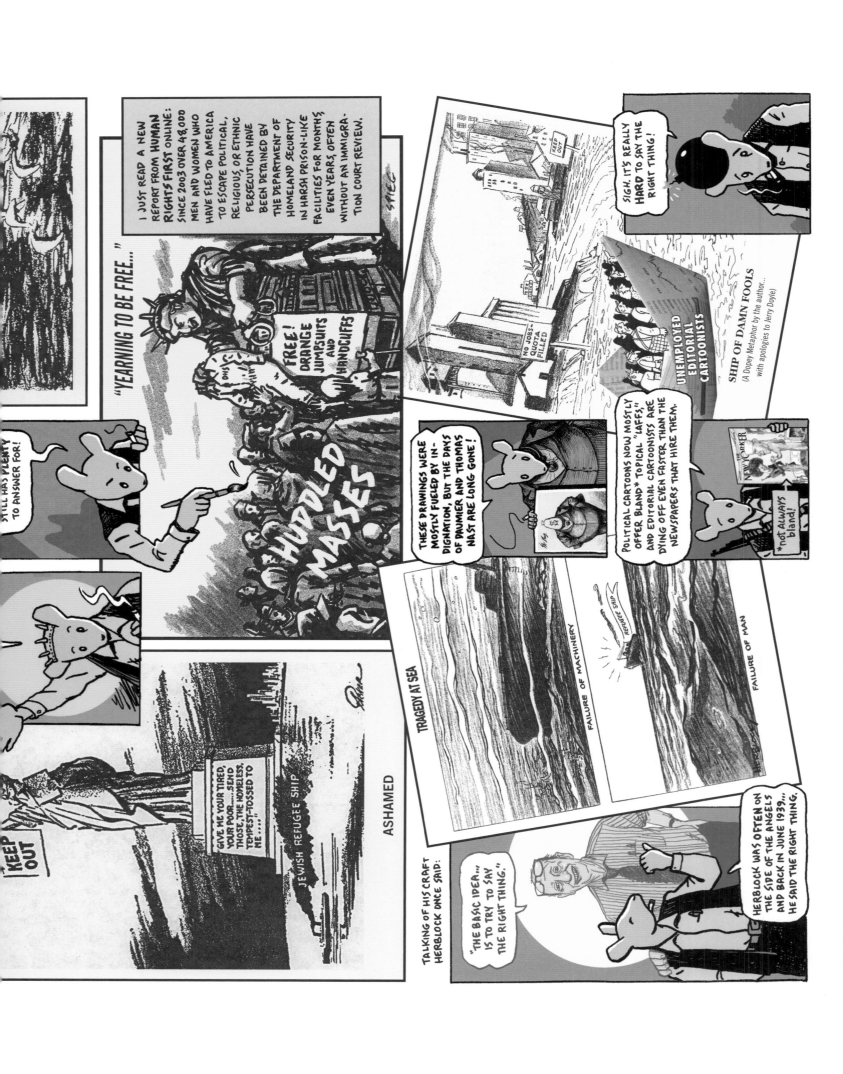

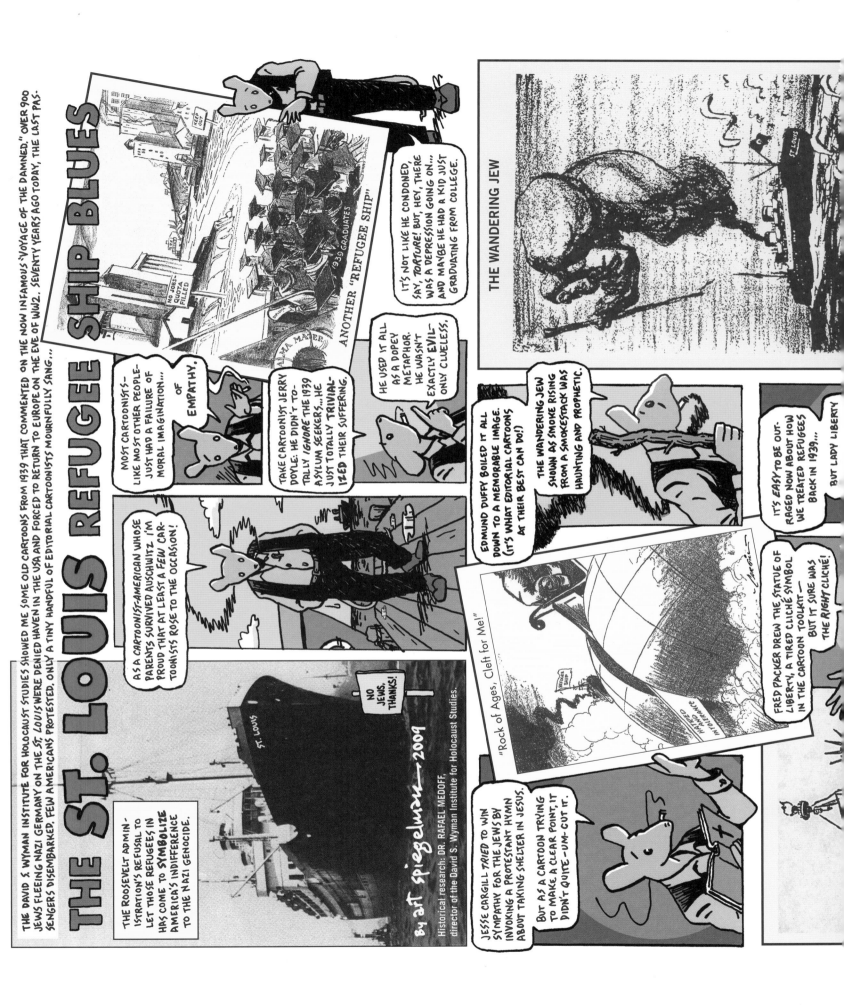

THE ST. LOUIS REFUGEE SHIP BLUES

The David S. Wyman Institute for Holocaust Studies showed me some old cartoons from 1939 that commented on the now infamous "Voyage of the Damned." Over 900 Jews fleeing Nazi Germany on the *St. Louis* were denied haven in the USA and forced to return to Europe on the eve of WW2. Seventy years ago today, the last passengers disembarked. Few Americans protested, only a tiny handful of editorial cartoonists mournfully sang...

The Roosevelt Administration's refusal to let those refugees in has come to *symbolize* America's indifference to the Nazi genocide.

ST. LOUIS

NO JEWS, THANKS!

By art spiegelman—2009

Historical research: Dr. Rafael Medoff, director of the David S. Wyman Institute for Holocaust Studies.

As a cartoonist-American whose parents survived Auschwitz, I'm proud that at least a few cartoonists rose to the occasion!

Most cartoonists—like most other people—just had a failure of moral imagination... of empathy.

ANOTHER "REFUGEE SHIP"

Take cartoonist Jerry Doyle: he didn't totally *ignore* the 1939 asylum seekers...he just totally trivialized their suffering.

He used it all as a dopey metaphor. He wasn't exactly *evil*—only clueless.

THE WANDERING JEW

Edmund Duffy boiled it all down to a memorable image. (It's what editorial cartoons at their best can do!)

The Wandering Jew shown as smoke rising from a smokestack was haunting and prophetic.

"Rock of Ages, Cleft for Me!"

Jesse Cargill *tried* to win sympathy for the Jews by invoking a Protestant hymn about taking shelter in Jesus.

But as a cartoon trying to make a clear point, it didn't quite-um-cut it.

It's *easy* to be outraged now about how we treated refugees back in 1939...

Fred Packer drew the Statue of Liberty, a tired cliché symbol in the cartoon toolkit—but it sure was the *right* cliché!

But Lady Liberty

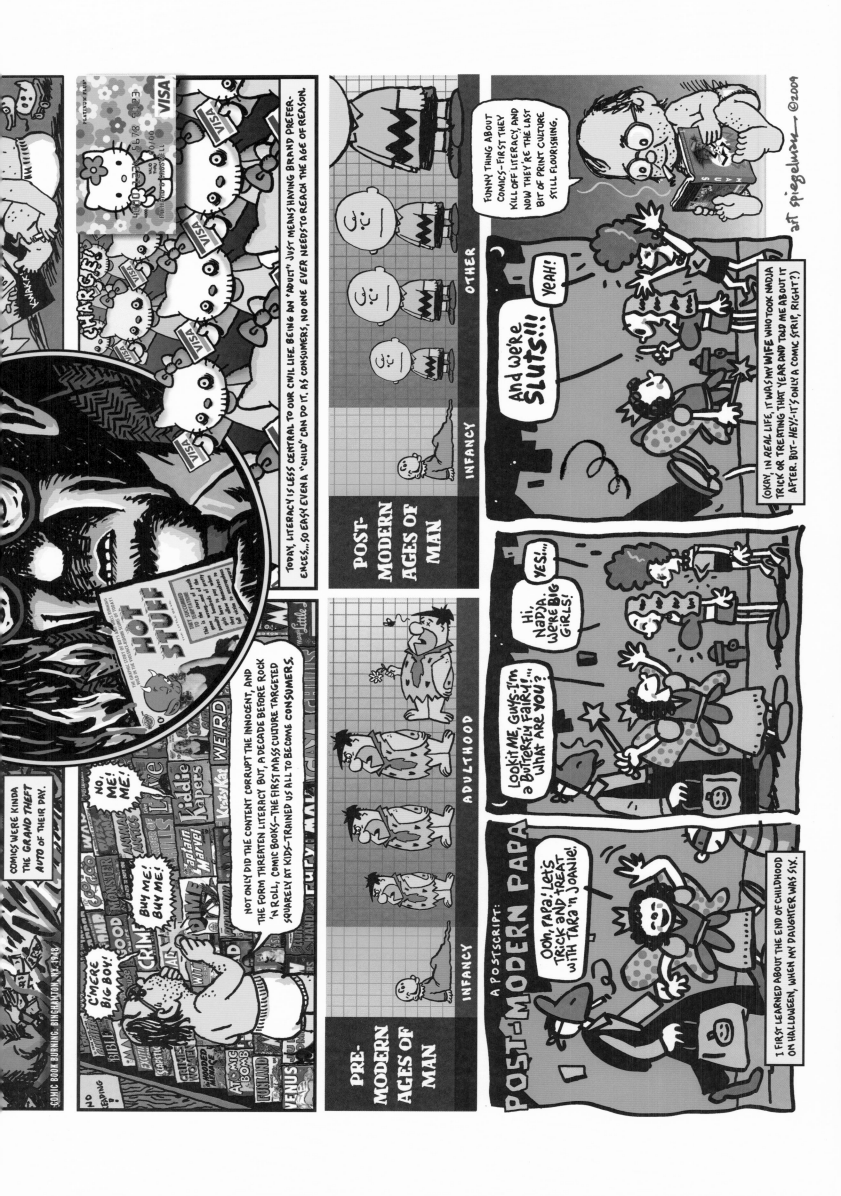

In 2008, Spiegelman published a re-edition of his 1977 *Breakdowns* with Pantheon. But rather than simply reissue the earlier book, Spiegelman encased it in an elaborate new structure by adding an introduction titled "Portrait of the Artist as a Young %@?*!" Done in comics form (and almost as long as the material being reprinted), this introduction juxtaposed autobiographical sequences that shaped many of the stories in the collection with sequences that illuminate the artist's interest in the formal aspects of comics. In effect, Spiegelman turned the book into an elaborate memory box, using recurring images to mirror the different stages of his life from youth to young adulthood to maturity.

Self portrait from *Breakdowns: Portrait of the Artist as a Young %@?*!*, 2008.

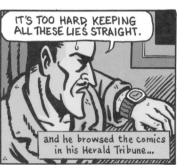

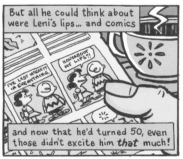

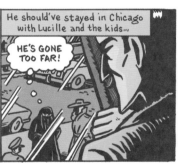

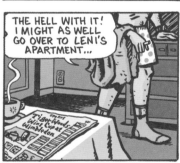

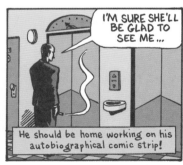

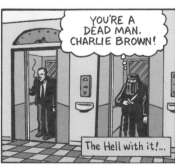

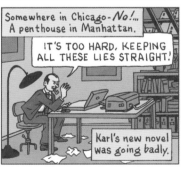

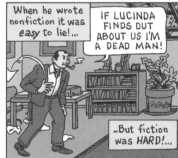

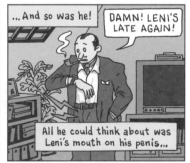

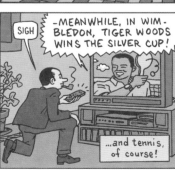

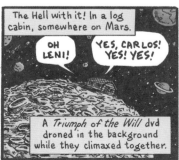

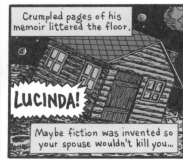

Excerpt from the introduction. *Breakdowns: Portrait of the Artist as a Young %@?*!*, 2008. Pen and ink and digital elements.

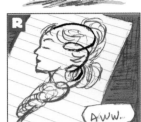

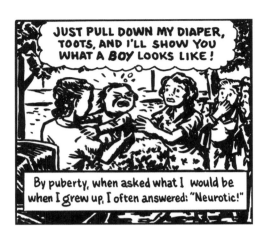
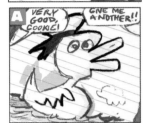
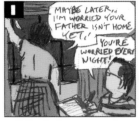
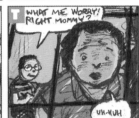
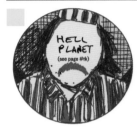

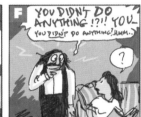

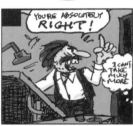

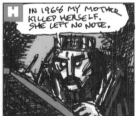
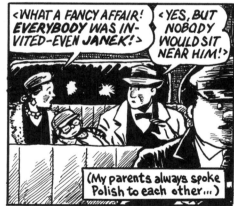

ABOVE AND BELOW: Final art, pen and ink. *Breakdowns: Portrait of the Artist as a Young %@?*!*, 2008.

Early draft of the introduction, digital drawing. *Breakdowns: Portrait of the Artist as a Young %@?*!*, 2008.

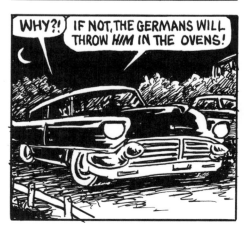
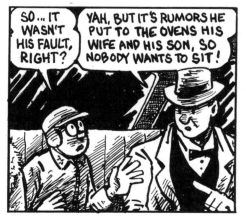
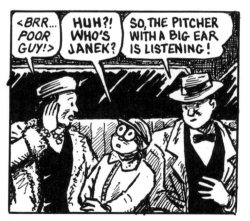
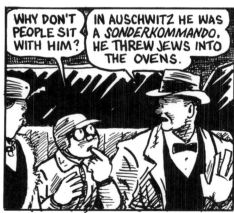
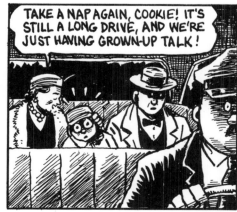

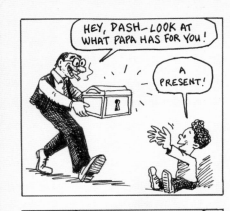

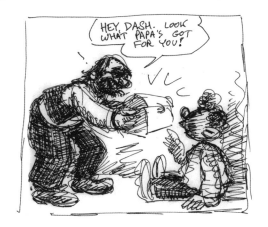

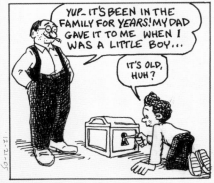

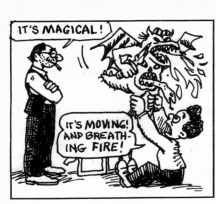

Studies and panels of final art for the introduction. *Breakdowns: Portrait of the Artist as a Young %@?*!*, 2008. Ink wash, marker, pen, and ink.

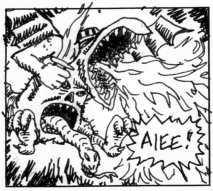

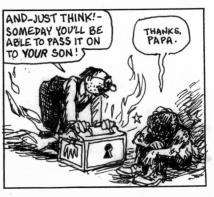

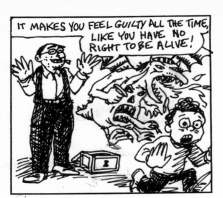

Cover for *Virginia Quarterly Review,* Fall 2006. The magazine regularly published portions of the introduction as a work in progress.

Spiegelman has also cut a distinctive figure in the world of cover design. When working on covers for author friends such as Tom De Haven and Paul Auster, he often fuses the exuberance of the pulp magazine tradition with the elegance of modernist poster-making, an especially appropriate style for novels that themselves borrow from popular culture.

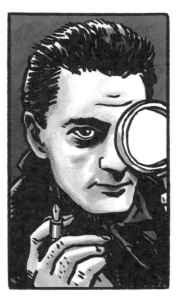

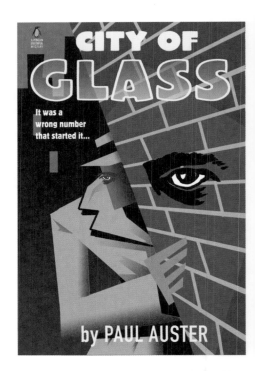

Portrait of Paul Auster. India ink on layout paper. For dust jacket flap of the Penguin Deluxe Graphic Edition of *The New York Trilogy*, 2006.

ILLUSTRATION & VARIOUS SCRAPS

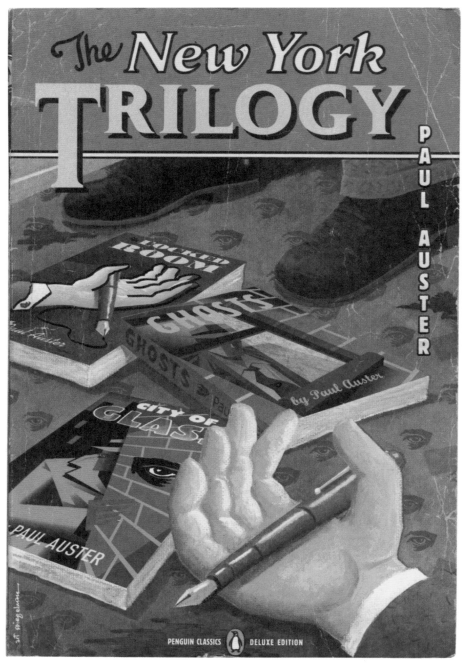

Cover for Paul Auster's *The New York Trilogy*. Gouache and digital art. Published by Penguin Classics Deluxe Graphic Editions, 2006.

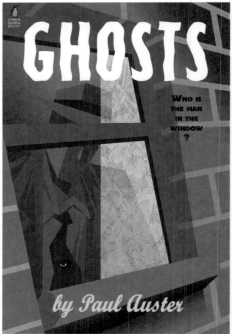

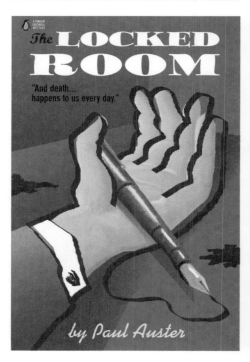

The New York Trilogy. Duotone chapter titles. Digital drawings. Published by Penguin Classics Deluxe Graphic Editions, 2006.

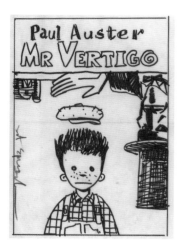

Studies for the cover of Paul Auster's *Mr. Vertigo*, 1994. Pencil and marker on layout paper.

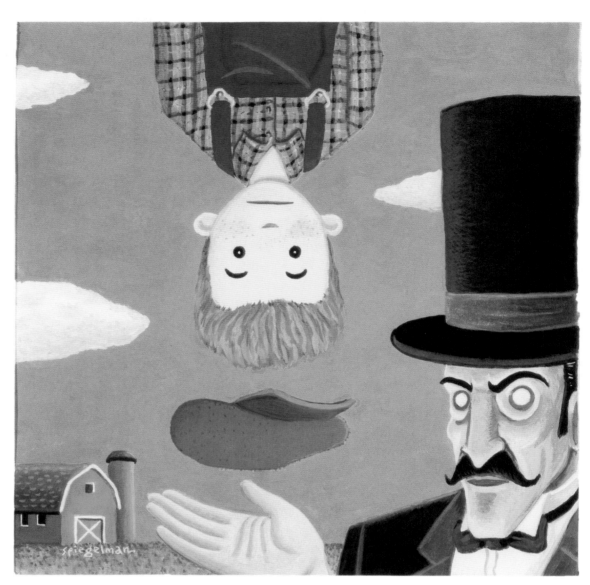

Cover for Paul Auster's *Mr. Vertigo*. Gouache. Viking Penguin, 1994.

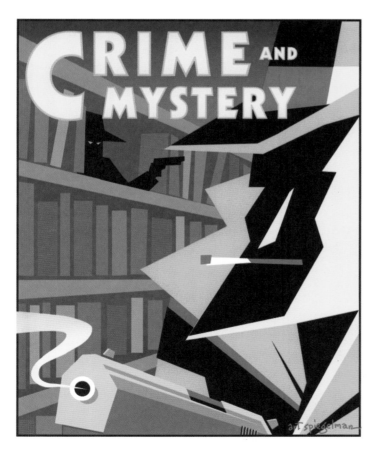

New York Times Book Review, "Crime and Mystery" supplement cover, 1995. Digital drawing.

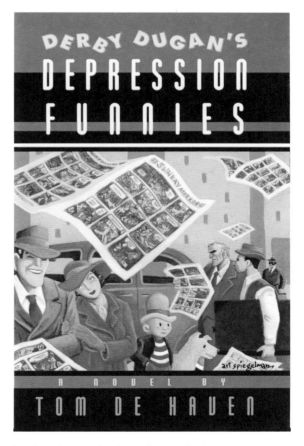

Cover for Tom De Haven's *Derby Dugan's Depression Funnies*. Gouache on paper. Metropolitan Books, 1994.

Comics turned out to be an ideal training ground for the allied field of graphic design. Moonlighting as an editorial illustrator, poster artist, and print maker, Spiegelman brought to these forms a cartooning aesthetic rooted in eye-catching imagery, quick communication of information, and deployment of familiar iconic characters.

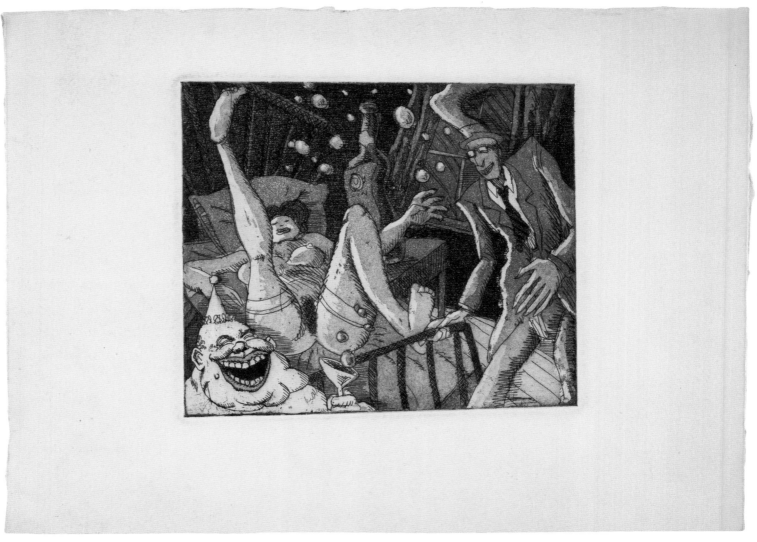

Uneditioned aquatint etching, circa 1974.

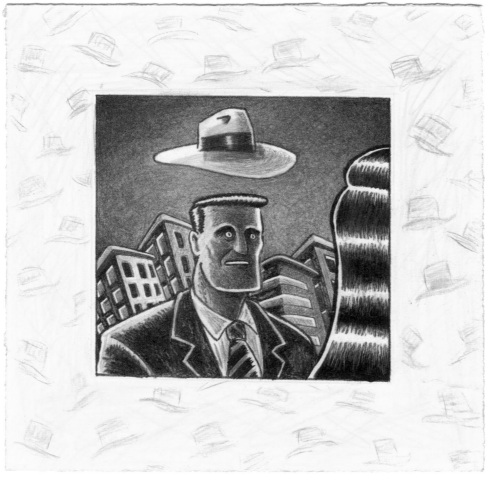

"Hats Off." Uneditioned stone lithograph with hand colored pencil embellishment, circa 1982–83.

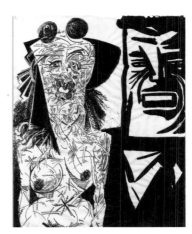

"Couple." Unpublished. Crowquill pen, brush, and india ink. 1982.

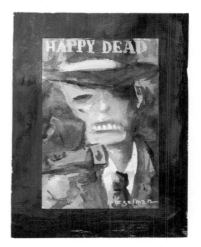

Unpublished sketch, watercolor and gouache. 1974.

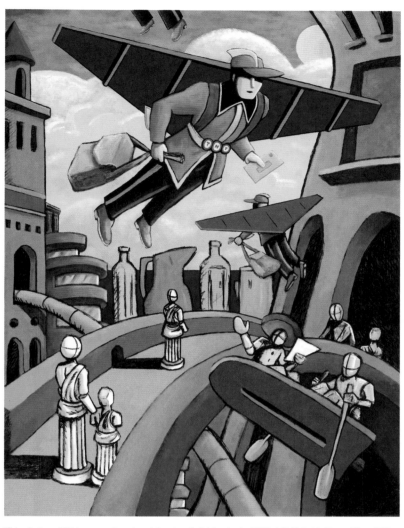

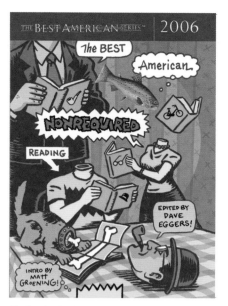

The Best American Non-Required Reading, 2006. Book cover, Houghton Mifflin Harcourt. Pen and ink plus digital color.

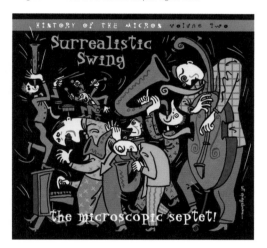

"Flying Postman." Thirty-seven color serigraph based on digital drawing for TNT Post. Published by Nuage, Milan, 2007.

Surrealistic Swing. CD cover for the Microscopic Septet. India ink and digital color. Cuneiform Records, 2006.

"Drawing Blood." Cover for *Harper's* magazine to accompany an article by Spiegelman on the Muhammad cartoon controversy and forbidden images, June 2006.

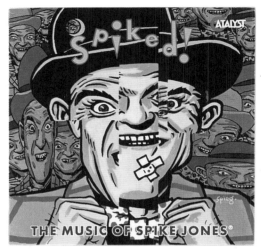

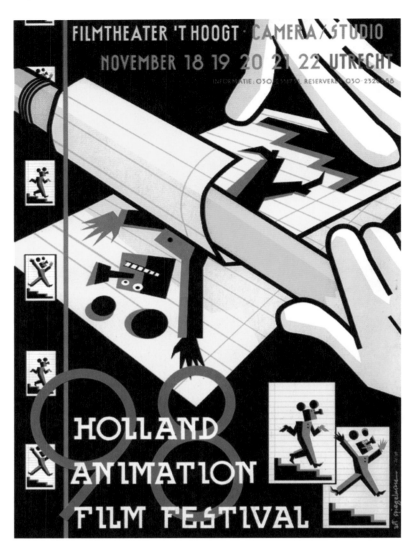

Poster for Holland Animation Film Festival, 1998.

Spiked! Spike Jones CD cover, 1994.

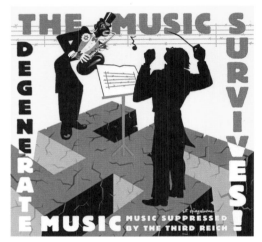

The Music Survives: Degenerate Music, CD cover, 1996.

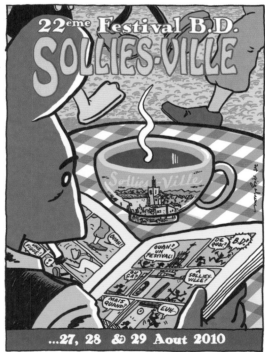

Poster for Sollies-Ville Comics Festival in France, 2010.

Spiegelman's posters and album covers showcase his characteristic gift for redeploying iconic images. In the poster for the Holland Animation Film Festival, the familiar ears of Mickey Mouse are fused with a stick-figure drawing, showing the range of animated cartooning styles. The cover for *Degenerate Music* juxtaposes three discordant icons: the minstrel saxophonist, the highbrow European conductor, and the swastika, suggesting the meeting ground between popular culture, high art, and political tyranny (all of which Spiegelman also brought together in *Maus*).

Discover magazine cover, September 2004.

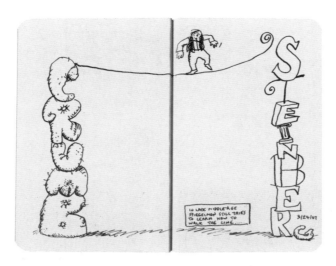

Although Spiegelman is not a compulsive sketchbook artist like, say, Robert Crumb or Chris Ware, he has made sporadic attempts at using sketchbooks as a laboratory for ideas. In 2009 McSweeney's published a collection of three of those sketchbooks as a set called *Be A Nose!* A rare early sketchbook anthology featuring some of Spiegelman's sketches, called *Four Sketchbooks and a Table of Useful Information,* was published by Apex Novelties in 1973. (It also included selections from sketchbooks by Bill Griffith, Spain, and Justin Green.)

....The MetaMetamorphosis

Sketchbook page, pen and ink. November 29, 2012.

Spiegelman has used sketchbooks as an important venue for creative exploration, describing them as "exercises in style" and "stray thought idea drawings," which often incorporate images from beloved comic strips (like *Little Orphan Annie, Dick Tracy,* and *Krazy Kat*) and fine artists (such as Philip Guston and Pablo Picasso).

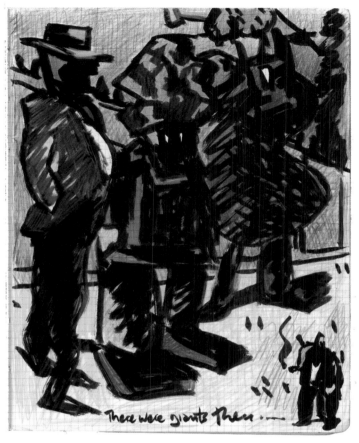

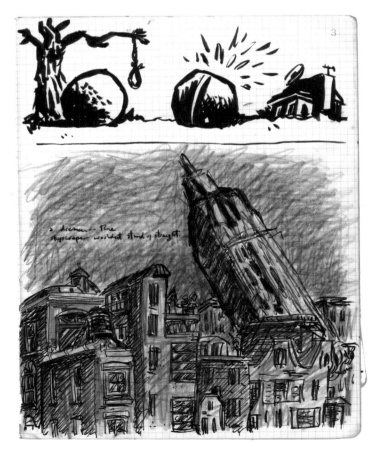

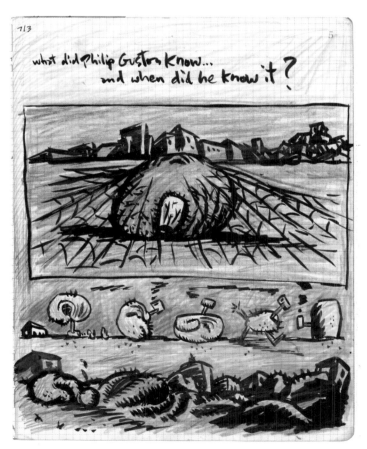

Drawings from a 1995–1996 sketchbook. Colored pencil, pen, brush, and ink.

3/25/98 The State of Anomie (Anomie of the State.) Eyes glaze over as you fall inside yourself...or rather yourselves. This plummet recaps an early page "Grain of Sand" for East Village Other, wherein Quentin Fester plummets down a toilet bowl in a series of vertical Winsor McCay panels, and lands in Festoria.

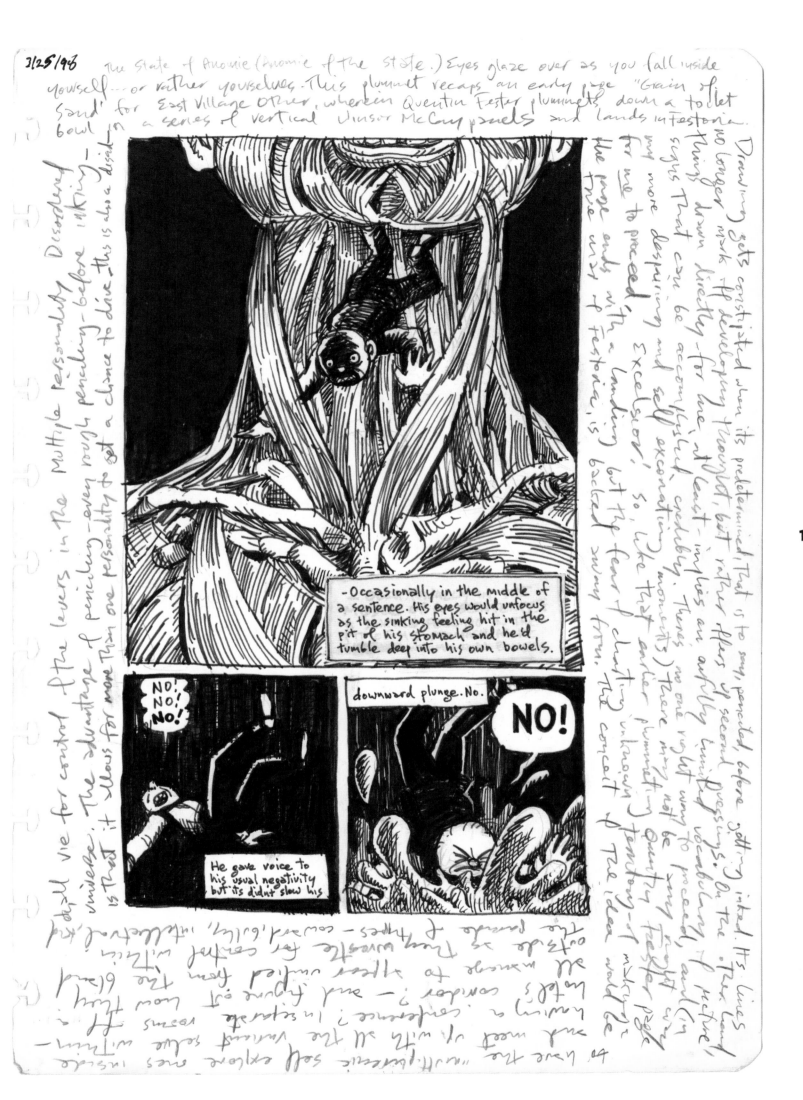

- Occasionally in the middle of a sentence, his eyes would unfocus as the sinking feeling hit in the pit of his stomach and he'd tumble deep into his own bowels.

NO! NO! NO!

He gave voice to his usual negativity but it's didn't slow his

downward plunge. No.

NO!

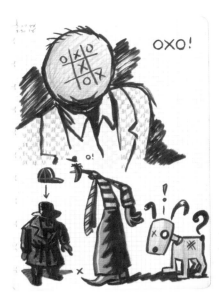

Drawings, October 27 and 30, 2008. Colored pencil, pen, and ink.

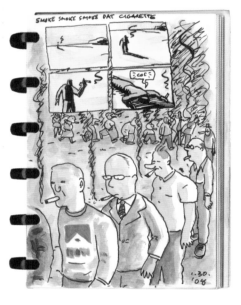

Drawings, 2008. Watercolor, pen, and ink.

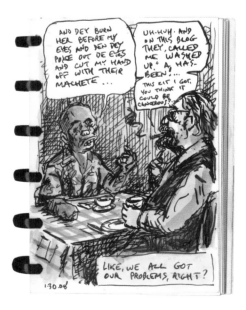

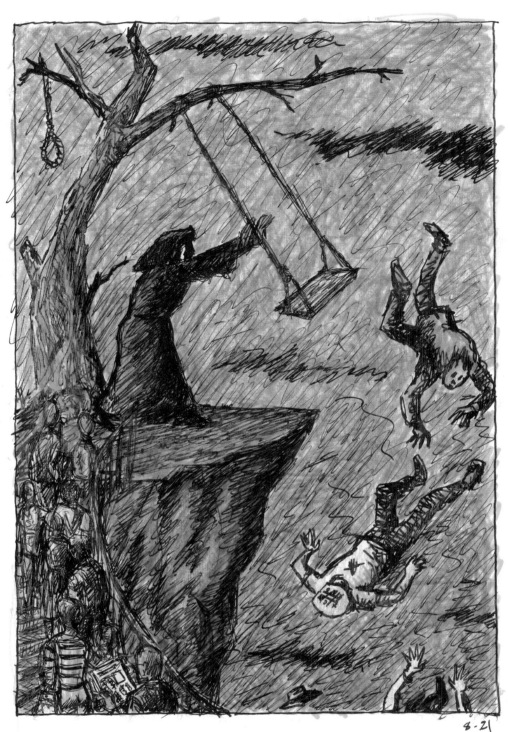

Drawings, 2012. Colored pencil, pen, and ink. It should be noted that Spiegelman was awaiting a serious operation at this time and clearly his own mortality was on his mind. Hence, the repeat appearances of the Grim Reaper.

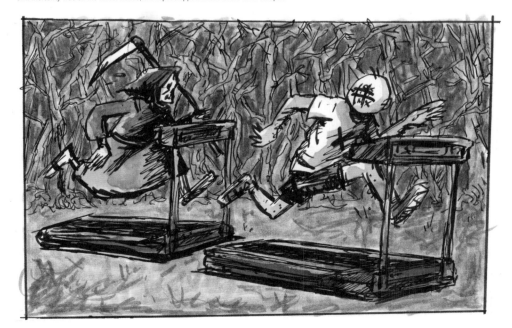

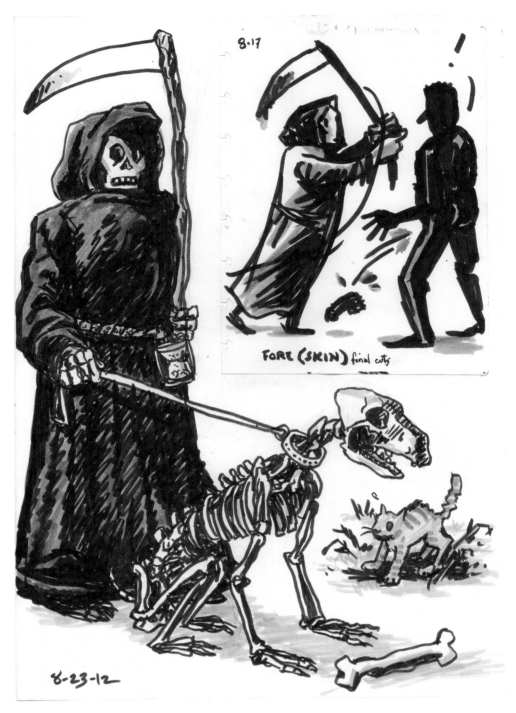

FORE (SKIN) final cuts

SPACE BETWEEN the EARS! and ON THE PAGE!!!

Drawings, 2012. Color markers, pen, and ink.

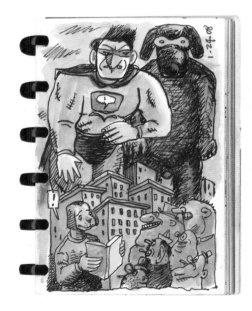

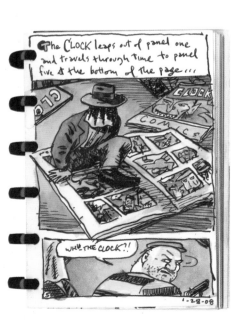

The CLOCK leaps out of panel one and travels through time to panel five & the bottom of the page...

WHY THE CLOCK?!

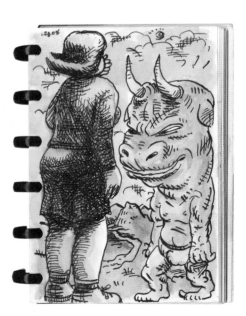

RIGHT AND BOTTOM ROWS: Drawings, 2008. Watercolor, pen, and ink.

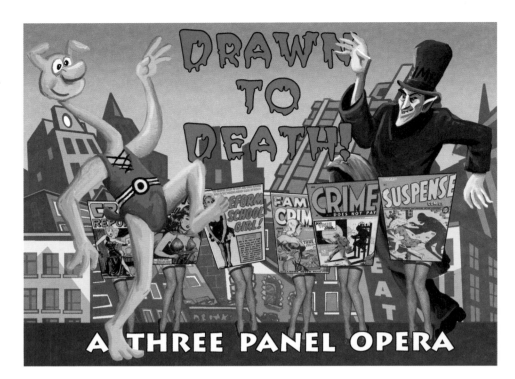

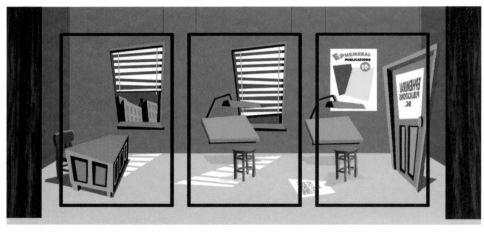

Drawn to Death, a Three Panel Opera, is a music-theater piece Spiegelman collaborated on with jazz musician Phillip Johnston. The project was conceived in the late 1990s, and has had several workshops over the years (in Cambridge, Dartmouth, and New York City) but still remains a work in progress. It is a pageant about the rise and fall of the comic book, centered on the 1954 US Senate Hearings on comic books and juvenile delinquency that resulted in the near death of the medium. The piece revisits themes Spiegelman has explored in various essays on comics history, notably his 2001 monograph on Jack Cole, the tragic creator of *Plastic Man,* who committed suicide in 1958.

In 2010, avoiding work on his *MetaMaus* book, Spiegelman accepted a commission to collaborate on a dance performance with Pilobolus, a renowned contemporary dance company. The result was *Hapless Hooligan in "Still Moving."* Like *In the Shadow of No Towers*, the dance performance is an outgrowth of Spiegelman's fascination with early twentieth century comic strips, notably Frederick Opper's *Happy Hooligan*. In a June 2010 review of the premiere, the *New York Times* dance critic wrote: "It's as if we're being given a fleeting glimpse of the inner workings of the universe."

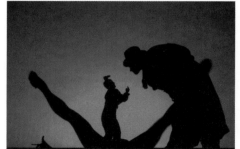

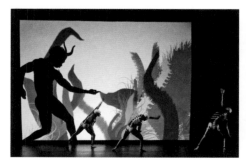

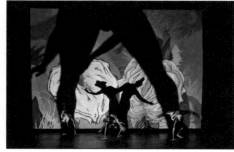

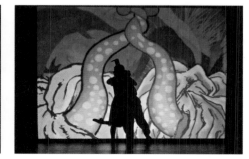

Dancers, shadows, and animated drawings co-mingle in *Hapless Hooligan*. Dartmouth, NH, 2010.

DANCIN' IN THE DARK!

SOME NOTES ON THE ART OF COLLABORATION
art spiegelman

IT'S A LONELY BUSINESS, MAKING COMICS...

SO CARTOONISTS ARE EASY PREY FOR ANY BOZOS WHO OFFER A DISTRACTION...

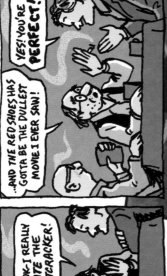

WE'RE PILOBOLUS, A DANCE COMPANY— HOW'D YOU LIKE TO WORK WITH US?

I DON'T COLLABORATE, AND I CAN'T DANCE. SO WHAT'S A PILOBOLUS?

TURNS OUT IT'S A FUNGUS THAT GROWS ON COW DUNG...SO I INVITED THEM OVER.

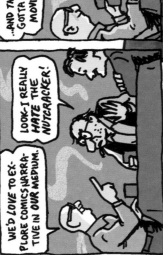

WE'D LOVE TO EX-PLORE COMICS NARRA-TIVE IN OUR MEDIUM.

LOOK—I REALLY HATE THE NUTCRACKER!

PILOBOLUS GREW ON ME...LIKE A FUNGUS!

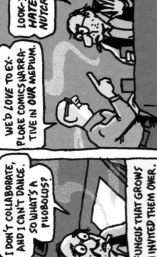

...AND THE RED SHOES HAS GOTTA BE THE DULLEST MOVIE I EVER SAW!

YES! YOU'RE PERFECT!

WELL...ABSOLUTELY NO MICE!

MICE? WHY MICE?!

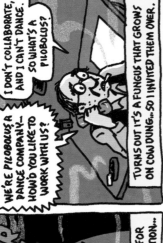

MICHAEL TRACY, THE ARTISTIC DIRECTOR, AND I HAD TO LEARN TO MERGE OUR DREAM-SCAPES.

CLASSICAL CAR-TOONS AND COMICS

CLASSICAL MYTHOLOGY

BIOMORPHIC SURREALISM

SORDID TALES

GENRE FICTION

FREUD?

JUNG!

SOPHOMORIC SMUT!

DANCERS EXPRESS EMOTION IN TIME...CARTOONISTS FREEZE TIME AND STUFF IT INTO BOXES.

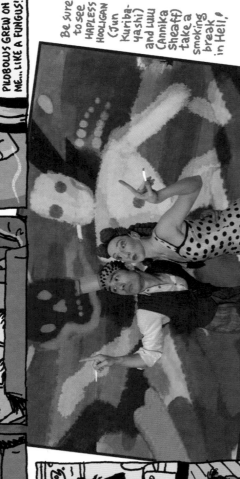

ARRGHH!!

WHAT'S THE MATTER NOW, ART?

THEIR SHADOWS ARE STANDING OUTSIDE MY PANEL BORDERS AGAIN!

NOT BEING ABLE TO SMOKE IN THIS STUDIO IS DRIVING ME CRAZY, BUT, STILL...

BUT LULU! IT'S OVER, HAP!

UNLIT

COULD YOU PLEASE GET YOUR G#%?! DANCERS TO STOP MOVING!!

Be sure to see HAPLESS HOOLIGAN (Jun Kuribayashi) and LULU (Annika Sheaff) take a smoking break in Hell!

COSTUMES, LIGHTING, SOUND AND EVEN ANIMA-TION... IT JUST TAKES INK TO MAKE A COMIC STRIP, BUT IT TAKES A TROUPE TO TANGO!

YOUR ANIMATION IS GREAT, GUYS— BUT CAN YOU GET IT TO QUIT MOVING AROUND SO MUCH?!!

Hapless Hooligan

STILL MOVING

I'M WAY TOO HIGH-STRUNG TO COLLABO-RATE EASILY BUT, STILL, I FOUND THE WHOLE EXPERIENCE STRANGELY...MOVING.

The use of narrative images in sequence in medieval stained glass windows, some art critics have argued, can be seen as a precursor to comics. Given his predilection for historical and formal exploration, it's not surprising that when Spiegelman was commissioned to do an art project for New York's High School of Art and Design, a vocational school he graduated from in 1965, he experimented with the medium of painted glass windows. *It Was Today, Only Yesterday*, a large (approximately 8 × 50 ft.) painted glass window offers a wry science fictional reflection on the evolution of an artist from youth to maturity. Manufactured by Franz Mayer of Munich under the aegis of Public Art for Public Schools, the work was installed in the school's new building in September 2012.

Everything I know I learned from comics. They were my window onto the world from the time they first imprinted on me as a pre-literate five-year-old. My obsessive interest in cartooning was nurtured at the High School of Art and Design (class of 1965) and when a chance came to return the favor for new generations of students I leaped at it through this window. Stained glass windows, after all, were among the very first comics in the centuries before they invented newsprint. Usually they told the story of some superhero who could walk on water, and turn it into wine. Though my interest in theology and superheroes per se is quite limited, I remain inspired by the idea that comics are a way to turn Time into Space.
— Excerpt from the artist statement, 2012.

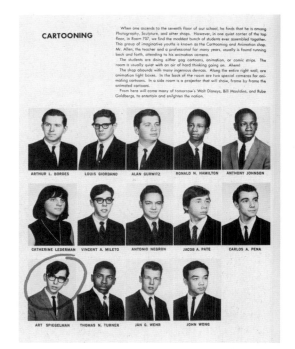

Page from the High School of Art and Design yearbook, 1965.

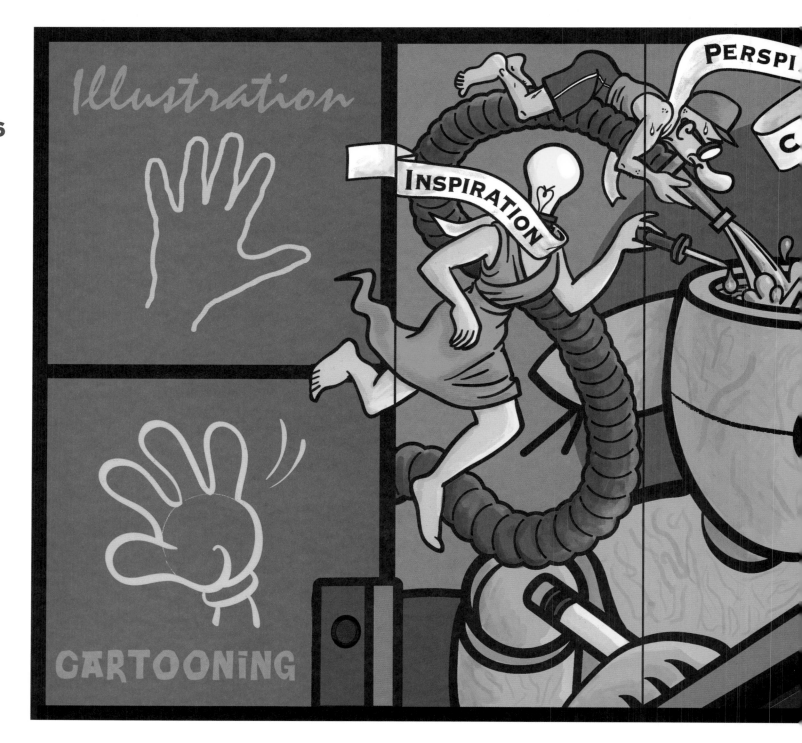

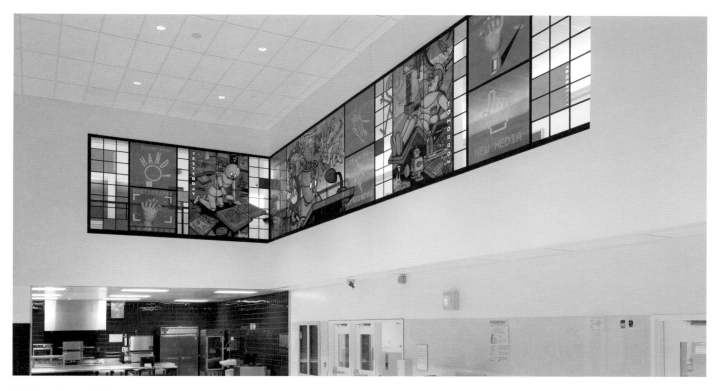

Installation photo, cafeteria view.

Digital art for the central panel.
Photos of the installation by Etienne Frossard, with additional photography on these pages by Grace R. Gaston, Nadja Spiegelman, and John Carlin.

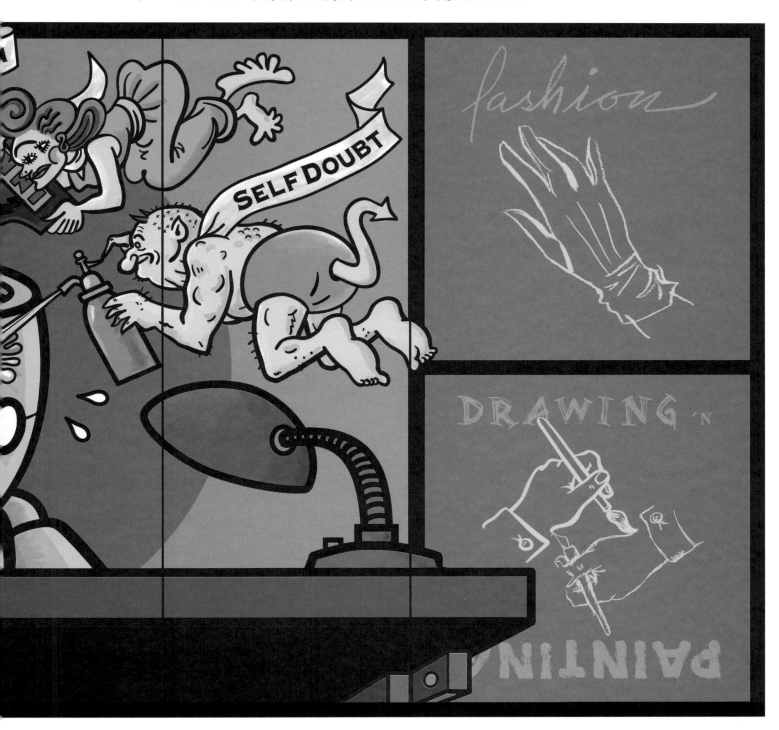

"Allegory of the Family," a mural for Brooklyn Family Court painted in the 1950s by Works Progress Administration (WPA) artist Abraham Tobias (1913–1996), was restored and now hangs in the new High School of Art and Design's lobby. It is visually referenced in the "Yesterday" and "Tomorrow" panels of the painted glass.

As students and faculty walk through the high school corridor that overlooks the cafeteria, they can see and be seen, moving back and forth between Yesterday and Tomorrow in a work about Work. It embeds the institution's history and values—as well as my own—in the stories of this building, and embodies the idea that Art—like a school cafeteria—is a site for Communication as well as Communion.
— Excerpt from the artist statement, 2012.

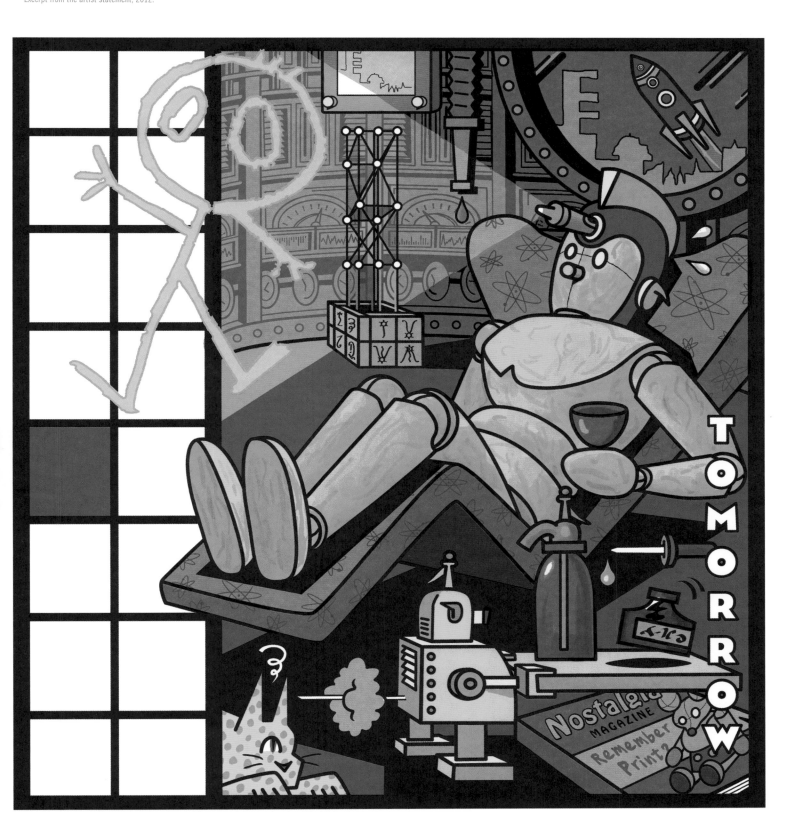

Views of the reverse side of the painted glass windows. These views are from the fifth floor, overlooking the fourth floor cafeteria.

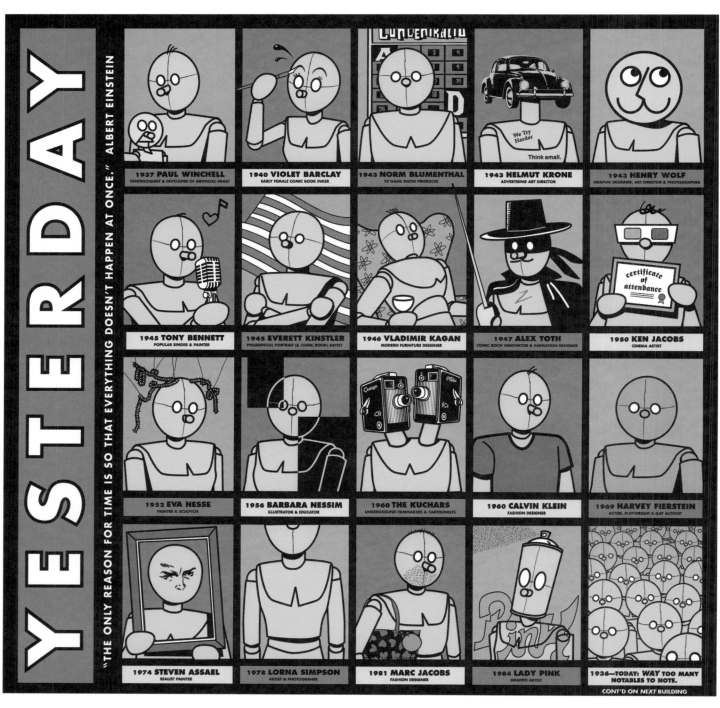

Spiegelman's digital drawings for the two "Grad Grids" (painted on the reverse side of the two yellow Mondrian-like squares seen from the cafeteria) feature notable alumni of the past and future.

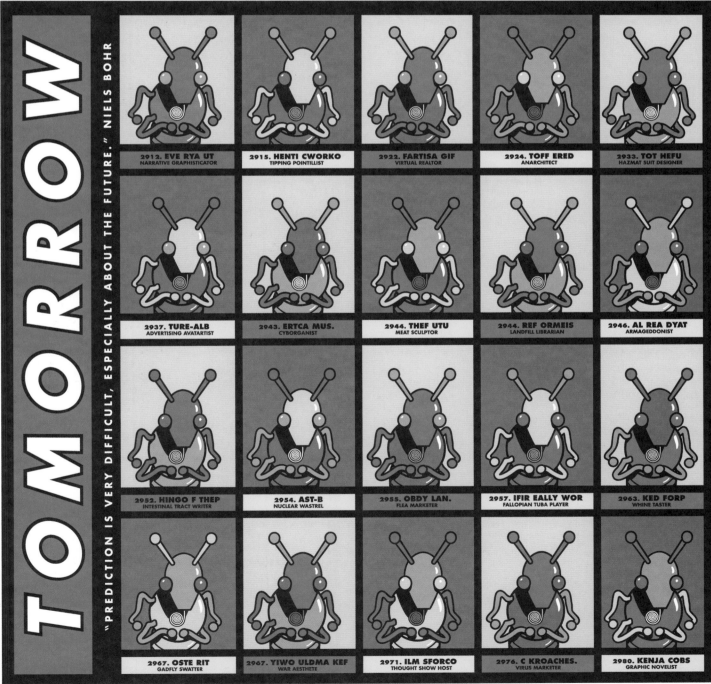

TOMORROW

"PREDICTION IS VERY DIFFICULT, ESPECIALLY ABOUT THE FUTURE." NIELS BOHR

2912. EVE RYA UT NARRATIVE GRAPHISTICATOR	**2915. HENTI CWORKO** TIPPING POINTILLIST	**2922. FARTISA GIF** VIRTUAL REALTOR	**2924. TOFF ERED** ANARCHITECT	**2933. TOT HEFU** HAZMAT SUIT DESIGNER
2937. TURE-ALB ADVERTISING AVATARTIST	**2943. ERTCA MUS.** CYBORGANIST	**2944. THEF UTU** MEAT SCULPTOR	**2944. REF ORMEIS** LANDFILL LIBRARIAN	**2946. AL REA DYAT** ARMAGEDDONIST
2952. HINGO F THEP INTESTINAL TRACT WRITER	**2954. AST-B** NUCLEAR WASTREL	**2955. OBDY LAN.** FLEA MARKETER	**2957. IFIR EALLY WOR** FALLOPIAN TUBA PLAYER	**2963. KED FORP** WHINE TASTER
2967. OSTE RIT GADFLY SWATTER	**2967. YIWO ULDMA KEF** WAR AESTHETE	**2971. ILM SFORCO** THOUGHT SHOW HOST	**2976. C KROACHES.** VIRUS MARKETER	**2980. KENJA COBS** GRAPHIC NOVELIST

If students view the work from the close-up vantage point of the fifth floor corridor, and are inclined to examine the text in the book shown above with a mirror, they can read the following passage relating to Spiegelman's tenure at the school:

SPIEGELMAN: THE EARLY YEARS

...returned from trying to flirt with Andrea at her table, still astonished that she didn't seem put off by how awkward he always became around her. (That came later, when they finally had an actual date. Girls were still a mystery deeper than anything *Archie* comics had prepared him for.) Back at his own lunch table, Rick was guffawing at Tommy who had spilled soda on the English homework he had to finish by next period and, knowing Spiegelman's feelings about Andrea, he turned to flash him a friendly leer. Ronnie was telling Jon about an offer he'd just gotten to draw a weekly strip, *Super Colored Guy,* for some local Harlem newspaper. No money, but a chance to be published regularly! He was having trouble with the scripting and invited Spiegelman to write the thing, though he was adamant about not letting him sign it—his name was too conspicuously Jewish to pass unnoticed in that 1964 Black Power moment. Ronnie did eventually agree to letting him take a credit as Artie X.

Ronnie and Jon were both in his Cartooning class; Rick and Tommy were major-ing in Illustration, which had the advantage of attracting more girl students and allowed them to study with Bernard Krigstein, one of the most innovative comic book artists of the 1950s, who was known to look back on the field with so much scorn that Spiegelman steered well clear of the whole Illustra-tion department. After all, a public high school that taught *cartooning*—and among the school's graduates was a generation of comic book artists: Alex Toth, Gil Kane, and Joe Orlando! Carmine Infantino, Mike Sekowsky, and Sy Barry! John Romita, Dick Giordano, and Neal Adams! All made their careers in the lowly comic books that Krigstein looked down on. What more need be said?

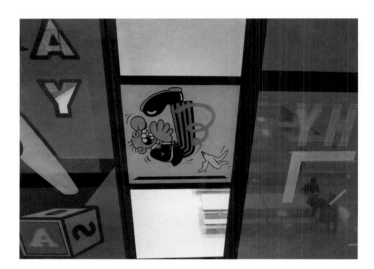

Getting into A&D had rescued Spiegelman from continuing to be quarantined as the nerd he'd been in Junior High School, though he continued to do suspi-ciously well in most of his academic classes. Dragging his large zippered port-folio stuffed with textbooks as well as art supplies and layout pads onto the BMT subway to Manhattan every day—a few short blocks from *MAD* maga-zine's offices!— gave him access to a world grander than Rego Park. Here it seemed that *everybody* had an excuse note for gym class and his clearly visi-ble neuroses were almost a social asset.

The young artist eagerly looked forward to Mr. Allen's cartooning classes almost as much as Mr. Gilman's English class where he could covertly ogle several of the girls he was most interested in. Charles Allen was one of the few Black artists to have ever cracked the virtually all-white world of syndicated comics. At least once a day, when the class got unruly, the affable teacher would raise his hands in mock despair and wail, "It's a plot! It's a plot to drive me mad!" It was a far more benign environment than the one he'd found in Mr. Caval-litto's required modeling and sculpture class. When the students there started talking in class one day, the irascible teacher shouted: "Shut up! Next student to talk, Spiegelman fails!" Conversation eventually welled up again...and a note was sent to his parents that he was failing the course. His mother had to come to the school and plead for mercy: her son had been home with the mumps the whole week that he'd been failed for talking. Almost fifty years later, the cartoonist lifted a small ungainly little glazed bowl that held pen points and razor blades on his drawing table and cusped it in his hands fondly as he told this book's author: "I made this in Cavallitto's class. Y'know, the old reprobate was right, I really *did* deserve to fail sculpture."

The only class Spiegelman actually did fail at A&D was eleventh grade math. As editor-in-chief of *Highlights,* the school's newspaper, he'd gotten a pass from his beautiful and spunky faculty advisor, Priscilla Farmer. It allowed him to leave the building whenever he wanted on "newspaper-related business." Spiegelman just didn't remember ever sitting in that math class. He'd just briskly walk out of the school to the nearby Horn and Hardart cafeteria with Jon, who was also a staff member; or explore Central Park with his co-editor, Marilyn, whose long blond hair reached all the way down to her...

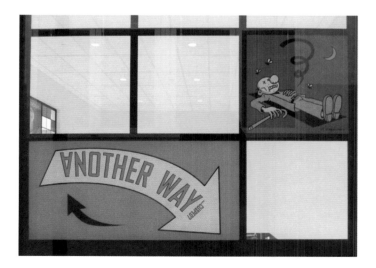
Photo details of corridor view.

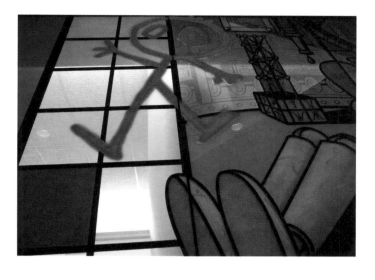

Photo of Lawrence Weiner's large medallion, "One Way & Another Cusped," on the floor of the school's lobby. This medallion is referenced on the reverse sides of the two red Mondrian-like oblongs, visible from the cafeteria.

In 1990, Spiegelman was invited to explore stone lithography with the Print Club of Philadelphia and Corridor Press. The project he developed was a 31 × 22.5 inch double-sided print, *Lead Pipe Sunday*, folded in half to emulate the Sunday newspaper supplements that inspired it. As so often with Spiegelman's work, the project harkened back both in form and content to an earlier moment in the history of comics. Nineteenth century political cartoonists such as Joseph Keppler often worked in lithography and "Lead Pipe Sunday" was a homage to the heavily allegorical political cartoons of this tradition as well as the more vulgar and popular form of the Sunday funnies that emerged at the end of the nineteenth century. In 1997, working with Tandem Press in Madison, Wisconsin, he made a companion piece, "Lead Pipe Sunday" no. 2. The complete prints are reproduced on the two gatefolds that follow.

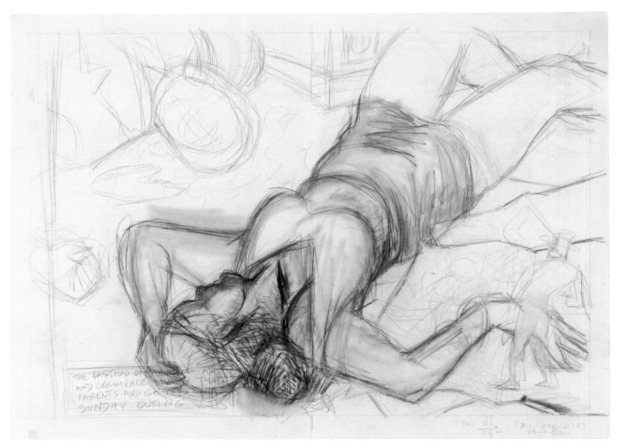

Full-scale pencil study for "Lead Pipe Sunday." 1990.

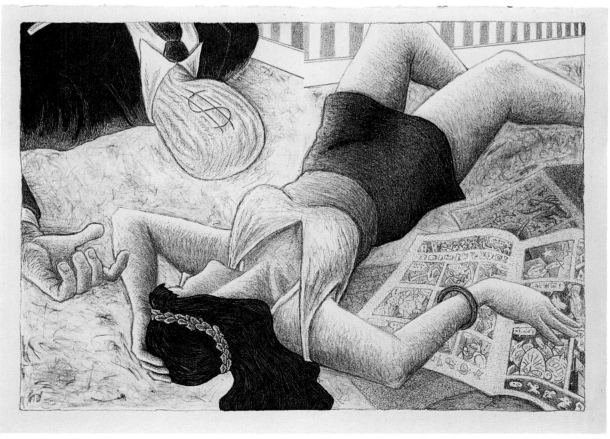

An early state of "Lead Pipe Sunday," before the cartoon characters were added in. 1990.

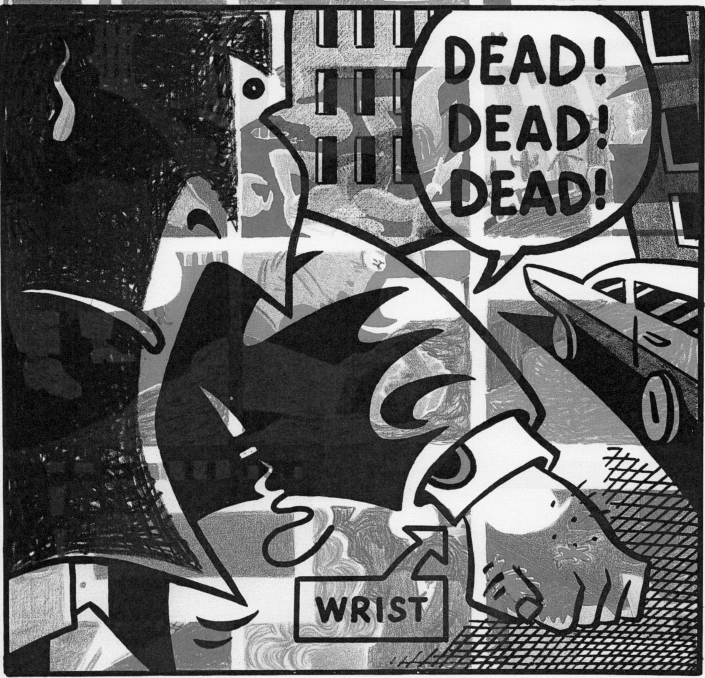

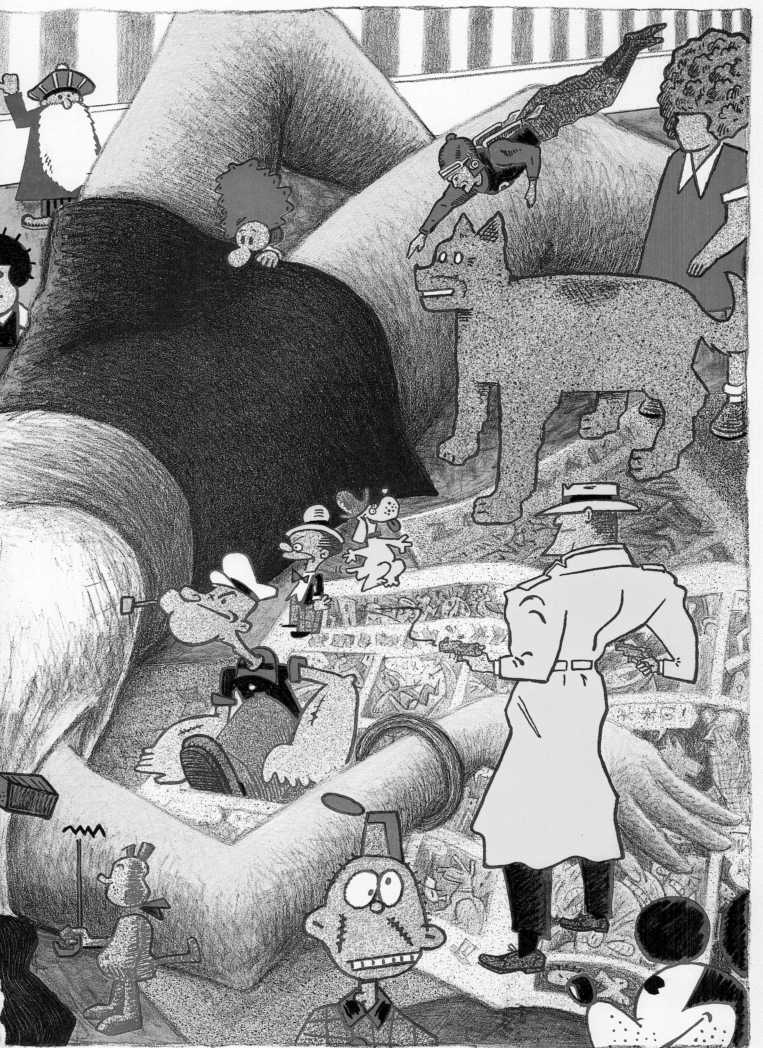

art spiegelman

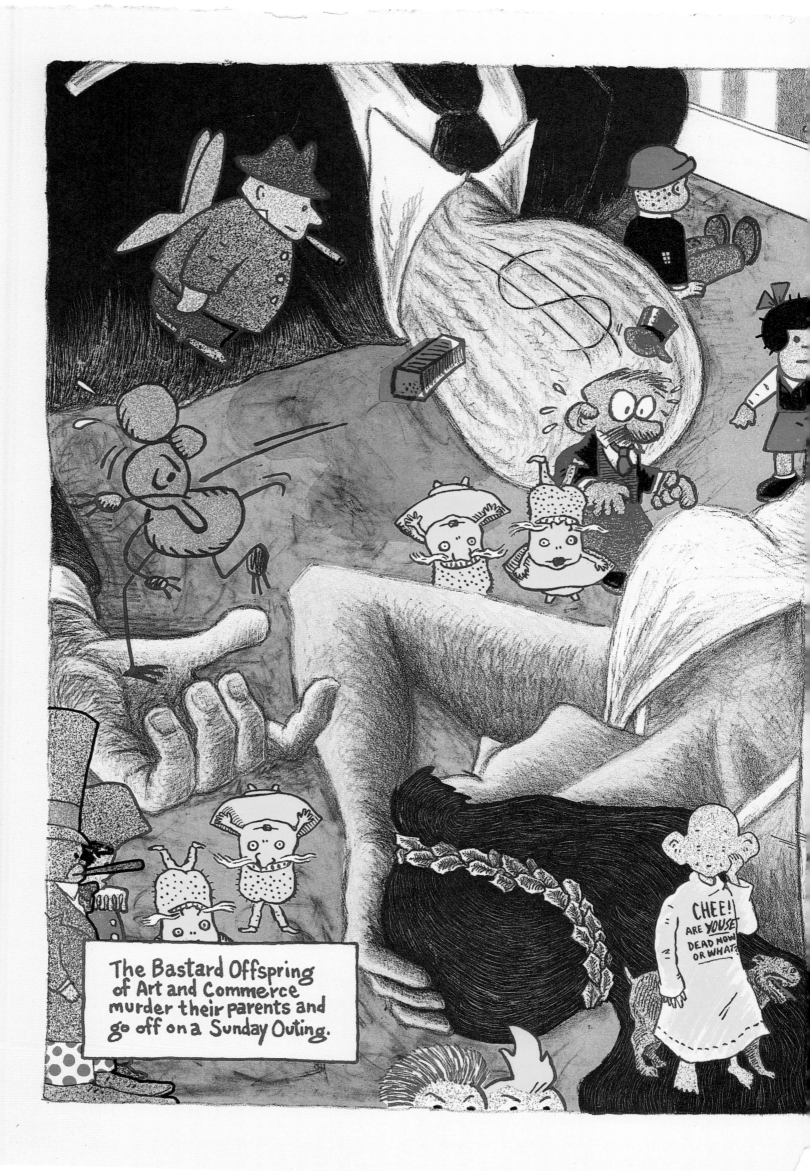

The Bastard Offspring of Art and Commerce murder their parents and go off on a Sunday Outing.

LEAD PIPE Sunday

"The color comics weekly! Ah, there's the dif!...Polychromatic effulgence that makes the rainbow look like a lead pipe." WILLIAM RANDOLPH HEARST. *NY Journal,* 1896.

DEAD DICK

MEANWHILE

FIRE!

CRIMSON SCREAMS LIQUID DEATH.

A GUN. HE'S GOT A GUN!

DEAD!

CHRISTSTABBERS TEXTBOX

TRY, TO BE SURE, HE HASN'T A GUN. FINGERPRINTS? YOU CAN'T BE TOO WARY!

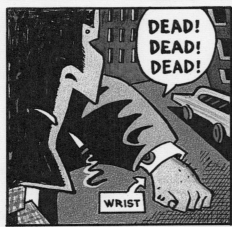

DEAD! DEAD! DEAD!

WRIST

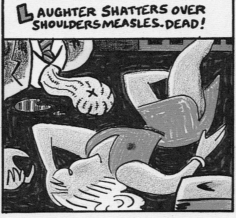

LAUGHTER SHATTERS OVER SHOULDERS MEASLES. DEAD!

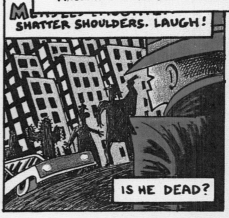

MEASLES LAUGHTER SHATTER SHOULDERS. LAUGH!

IS HE DEAD?

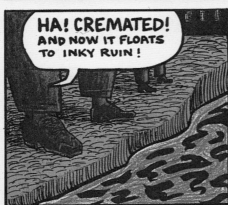

HA! CREMATED! AND NOW IT FLOATS TO INKY RUIN!

BUT LOOK-THE GUN!

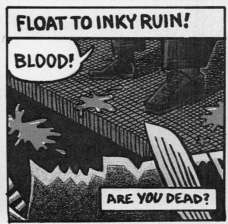

THE GUN SCREAMS FIRE. SADNESS DANCES A LIQUID TANGO. DEAD. DEAD. DEAD!

CREAMEDSPINACH TAXICAB

NEVER NEVER STIPPLE IF YOU CAN HATCH. EVEN BETTER, USE BLACK.

MILLIONS GONE! YET STILL YOU LAUGH?

HA!

FLOAT TO INKY RUIN!

BLOOD!

ARE YOU DEAD?

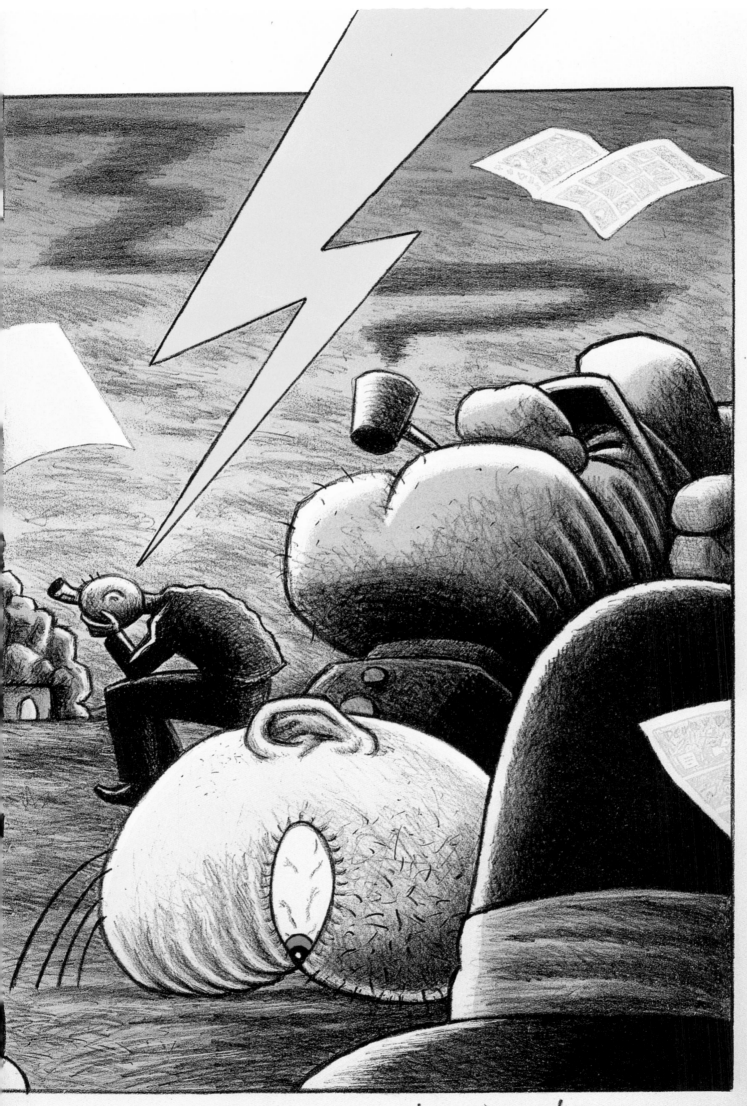

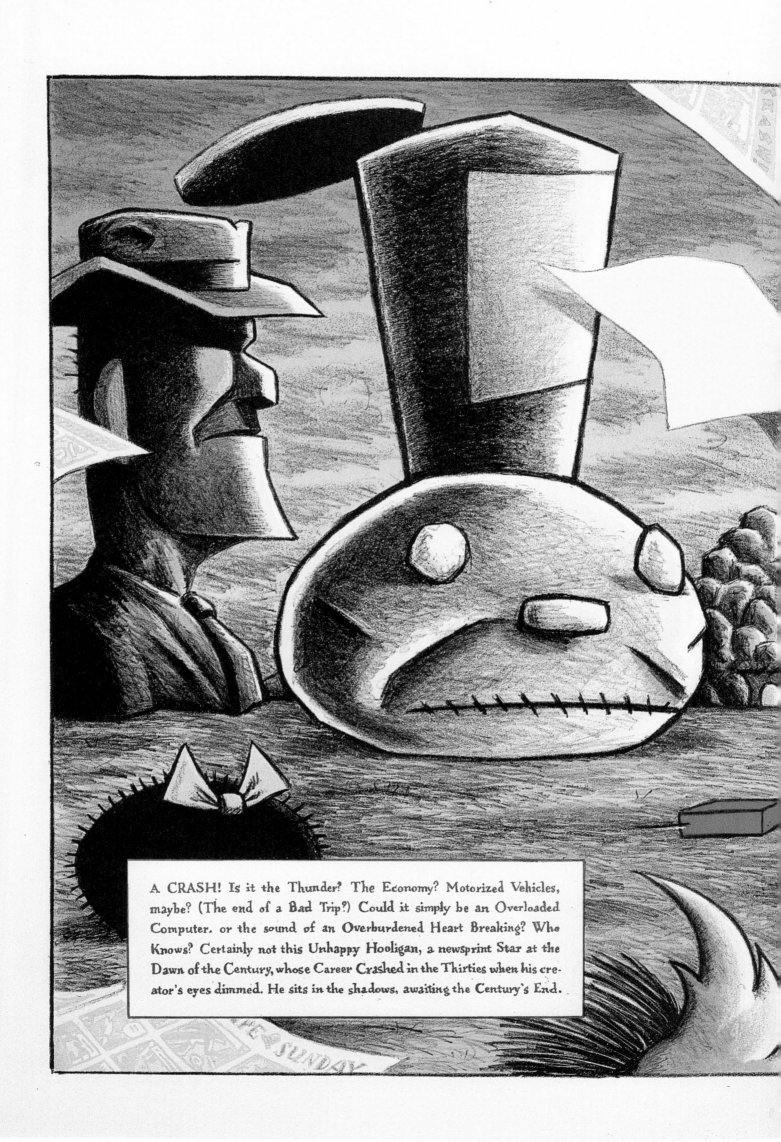

A CRASH! Is it the Thunder? The Economy? Motorized Vehicles, maybe? (The end of a Bad Trip?) Could it simply be an Overloaded Computer, or the sound of an Overburdened Heart Breaking? Who Knows? Certainly not this Unhappy Hooligan, a newsprint Star at the Dawn of the Century, whose Career Crashed in the Thirties when his creator's eyes dimmed. He sits in the shadows, awaiting the Century's End.

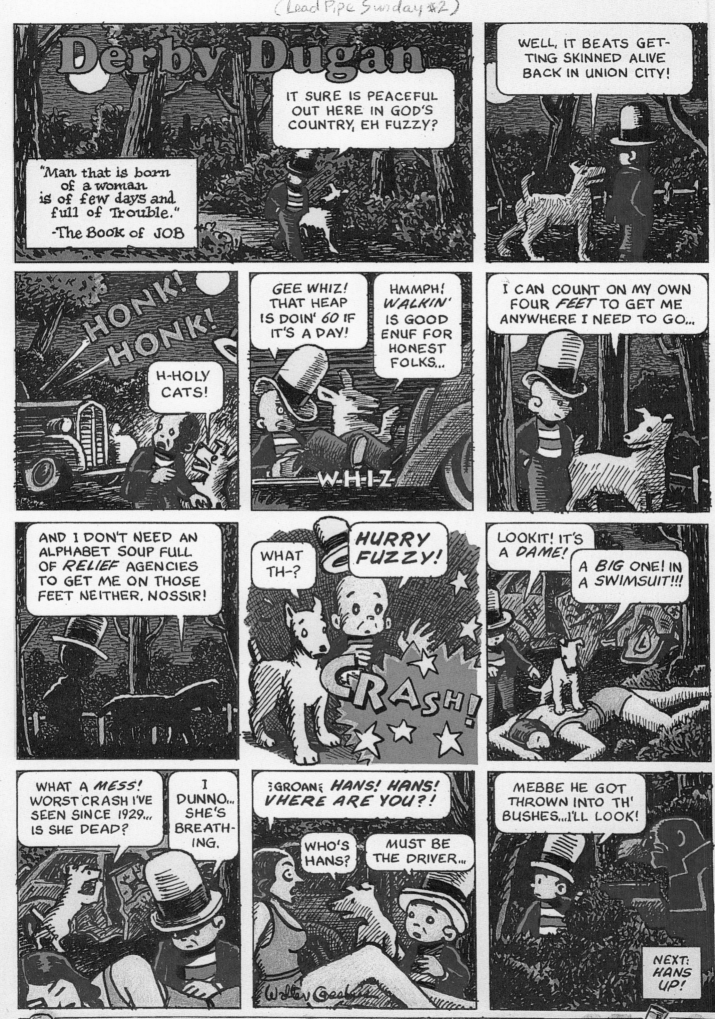

"Crash!" Unused back cover for "Lead Pipe Sunday" no. 2. Litho crayon and spattered tusche on plastic lithography plate. 1990.

contentment pleasant surprise laughter worry sorrow anger determination surprise

AP state II

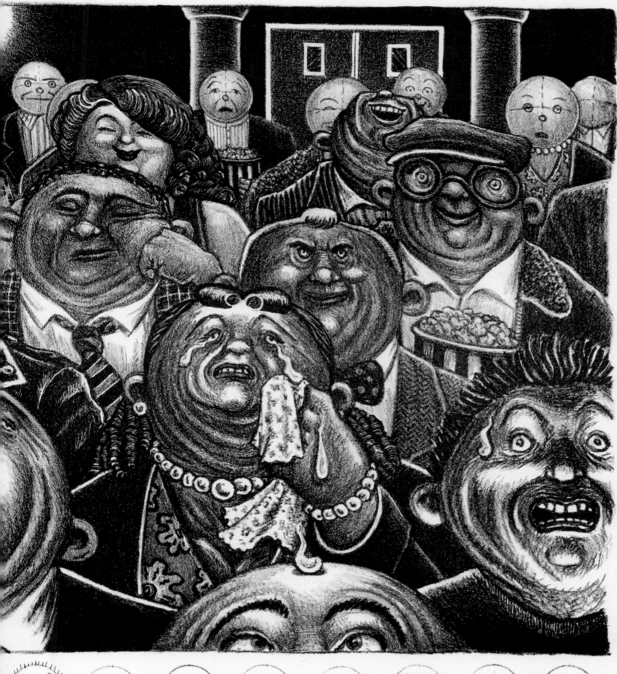

terror stupidity contempt the wink discomfort disdain blank wonder doubt

art spiegelman

Full House, 1992. A stone lithograph printed by Corridor Press as a fundraiser for the Film Forum movie theater.

MetaMaus cover first draft, 2010. Pastel on black paper.

MAKING MAUS

Robert Storr, 1991

"After Auschwitz, to write a poem is barbaric." Although later recanted by its author, Theodor Adorno, this much quoted dictum of 1955 has deep roots in public sentiment. How can a work of art compare to, much less prevail against, such monstrosities? And how can a single lyric voice presume to bespeak such massive suffering? Furthermore, how can art about genocide avoid the insult to the dead implicit in aestheticizing their slaughter? Judged by this standard, the idea of making a comic book about the Holocaust must be an infinitely worse offense. It sounds like a sick joke. That, however, is what Art Spiegelman has been doing for the past thirteen years, and more.

In its entirety a 269-page chronicle, *Maus* is composed of well over 1,500 interlocking drawings. The initial five chapters were published serially between 1980 and 1985 in *RAW*, the experimental "comix" magazine that Spiegelman co-founded and co-edits with Françoise Mouly. With a sixth chapter added to those original installments, the first half of *Maus* was published in book form by Pantheon, New York, in 1986; it was followed five years later by the second and concluding volume, which was issued by Pantheon in November 1991. The completion of *Maus* is the occasion for this exhibition, which consists of all the original pages of the book, plus an extensive display of cover art, preparatory drawings, process-related and research materials, as well as graphic digressions from the central theme. The purpose is to illuminate the final entity—a mass-produced work—by showing its complex genesis in the artist's mind and on the draftsman's page. **Maus centers on the Spiegelman family's** fate at the hand of the Nazis, as told by the artist's father, Vladek. The storyline shifts ground back and forth between the recent past, in which the formerly estranged

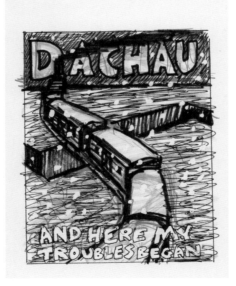

son interviews his father about the persecution of the Jews in Europe before and during the Second World War, and the distant past of Vladek's vivid memories of courtship, marriage, military service, pogroms, life in hiding, forced marches, and the nightmare of the extermination camps. The book's subtitle, *A Survivor's Tale*, refers first and most obviously to the father, but the appellation applies equally to the son, who has inherited a dark historical burden and hopes to free himself by opening it up and examining its every detail. Fundamental to the latter's struggle is coming to terms with the reality that suffering does not necessarily ennoble the victim. The Vladek who responds to the cartoonist's persistent queries is often petty and manipulative. Worse, it is revealed, he burned the wartime diaries of his first wife, Anja, forever cutting their son off from his most direct access to that shattered and shattering period and to her. She is the mother mourned in the parenthetical chapter "Prisoner on the Hell Planet"—a much earlier, four-page comic inserted into the narrative—which describes the artist's nervous breakdown and his mother's subsequent suicide.

Book I, *My Father Bleeds History*, which recounts the onset of Nazi terror, closes with an image of Spiegelman cursing his father as a "murderer" for this act of destruction. Book II, *And Here My Troubles Began*, describes Vladek and Anja's internment, separation, and liberation, and ends with an image of the grave in which they are ultimately reunited. Under it appears the signature of the artist, who has survived the traumatic legacy they left him by dedicating himself to an unsparing but eventually forgiving record of their collective experience.

Other war-haunted stories of Spiegelman's age have responded to a similar compulsion to examine the fascist era through imaginative

reconstruction and so lay personal if still only partial claim to its moral dilemmas. Disconcerting and ironic play with the object of their horrid fascination is the common denominator of much of this work. David Levinthal has photographed blurry scenes of the Blitzkrieg staged with plastic soldiers and tanks, thus eliding boyish bellicosity with a gritty Robert Capa-like realism. Anselm Kiefer has reenacted sea battles in his bathtub and Panzer-division maneuvers on empty studio floors as well as having himself pho-

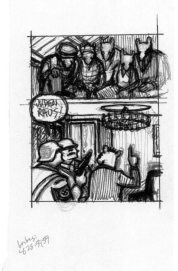

tographed raising his arm in the Nazi salute in places Hitler's troops once occupied. Sigmar Polke has likewise been photographed goose-stepping with manic élan, and often incorporates symbols of the fascist past into his pictures, as has the cartoon-inspired artist Jörg Immendorff. The Russian team of Vitaly Komar and Alexander Melamid also belongs on this list for its pastiches of socialist realist history painting.

All of these artists have in one way or another appropriated "debased" artistic forms for use in fine art formats. Spiegelman is unique in having realized his project not only within the conventions but within the aesthetic and social context of his chosen models. A veteran of San Francisco's underground comix scene and of New York's cartoon industry—he was creator of the Garbage Pail Kids, Topps Gum Inc.'s gleefully impudent bubble-gum card rejoinder to the market onslaught of the cloying Cabbage Patch Kid dolls—Spiegelman is thoroughly at home with the "trashiness" that supposedly rots immature minds but definitely causes conservative brains to short-circuit when thinking about his craft. Moreover, he plays with fire even more aggressively than his previously mentioned contemporaries, aligning the stripes of a concentration camp prisoner's uniform, for example, with computer bar codes on the

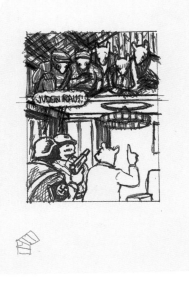

back of the boxed set of *Maus* or titling one of its sections "Auschwitz: Time Flies." Spiegelman's mixed feelings about the harsh ironies of his endeavor are summed up in a self-portrait that nonetheless insists on his satiric prerogatives. In it he slouches mousemasked over his drafting table, at the foot of which bodies are piled as they were in the camps but also like crumpled wastepaper. This is not a sick joke but evidence of the heartsickness that motivates and pervades the book; it is the gallows humor of a generation that has not faced annihilation but believes utterly in its past reality and future possibility.

Spiegelman's conformance to comic-strip structure is not just a matter of loyalty to his much condemned métier. The simple but readily reconfigured grid of the standard comic-book page permits a more orderly story progression and a higher density of visual information than any single surface tableau or montage could possibly accommodate. A collector of graphic serials of all types, from Sunday funny pages and pulpy Big Little Books to the wordless picture novellas of Milt Gross, Lynd Ward, and Frans Masereel,

Spiegelman has cultivated an appreciation of how much any one frame or image can convey, and how little each within a sequence should at times vary for maximum narrative emphasis. Accordingly, when the plot of *Maus* unfolds in the situations where the artist plays a part, the pictures generally succeed one another at the ordinarily even pace of the present tense. However, when Vladek's memories take over, the intervals are generally more disjunctive, with oversized dramatic views, explanatory notes, diagrams, and tipped or otherwise irregular boxes frequently interrupting his discursive account of events and breaking this episode's usual eight-frame grid.

On occasion Spiegelman runs images of Vladek telling the story parallel to images of the story he tells, in which case the larger drawings of remembered events operate almost like thought balloons next to the smaller drawings of the conversation between father and son. An especially effective spread in Book II shows a scene of Spiegelman and his father sorting through old family photographs, overlaid with drawn facsimiles of those pictures that accumulate at odd angles until their profusion fractures the vertical and horizontal template of the story frames and brings the confusion of past and present cascading to the bottom margin and into the reader's lap. In some instances Spiegelman unifies a page or part of a page by allowing a pictorial element from one frame to continue into an adjacent frame, effecting a kind of visual enjambment or run-on. For example, in the page following the one just described, the image of Vladek slumped on the couch with photos scattered at his feet is pieced together in four abutted close-ups covering five-eighths of the whole. In other cases Spiegelman uses a dominant motif such as bunk beds or uniforms, or a consistent direction or density of hatching, to coalesce the separate sections of a given sheet.

Such overall conceptualization and varied phrasing are the essence

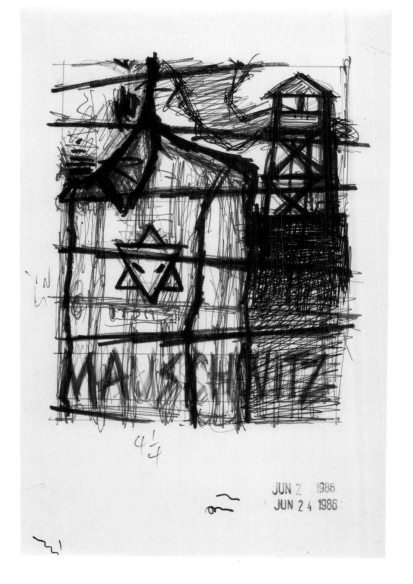

of comic-book art. For *Maus*, it is especially crucial given the extent of research Spiegelman quotes. In his determination to "get it right" the artist became a practical scholar of his medium while pursuing every conceivable avenue leading to or from his focal point in Vladek's recollection. In addition to the graphic precedents already cited, the artist's referents encompass cartoons and gag photos gleaned from old magazines; that industry staple, war comics (including Nazi examples); snapshots taken by the artist when he visited his parents' native Poland; archival materials covering everything from how shoes were sewn to the look of buildings and cars during the war; and postcard portfolios and booklets of art made by the Nazis' captives.

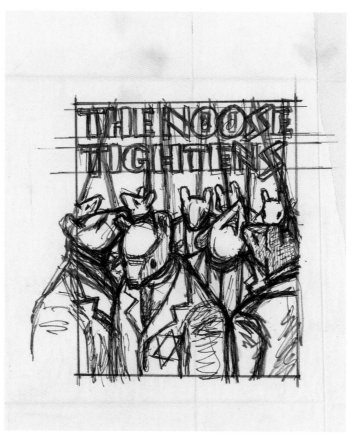

Seen in related clusters, the enormous quantity and variety of drawings Spiegelman has made and preserved document the distillation of the diverse but interconnected components of *Maus*. Spontaneous warm-ups, meticulous revisions, overlays, and outtakes—a great many of them remarkable as individual works—testify to the painstaking work required to pack the book as full of information and insight as possible while retaining its overall coherence. Here novel adaptations of signature trade devices were indispensable to Spiegelman's visual syntax. The Dick Tracy "Crime Stopper" inserts, for example, are the acknowledged precursors of the boxes and medallions he uses to explain the Auschwitz exchange rate of cigarettes for bread, and to chart the floor plans of secret hiding places in the ghetto as well as plans of the crematoria, or to map the grounds of the camps or the rail lines between them. Intersplicing macrocosmic views and microcosmic de-

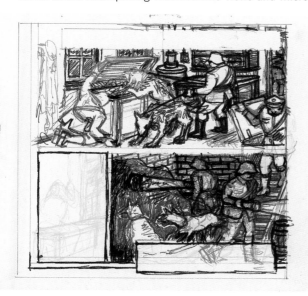

tails, firsthand description and library finds, Spiegelman shows how a cataclysm befell the stable provincial society into which his parents were born and how a huge and hellish system was organized to consume their "small" lives. The agonizing incremental choices between escape into the memory of hope of normalcy and the conscious reckoning with the Final Solution's planned indignities and chance cruelties, heretofore best described in Bruno Bettelheim's analytic memoir *The Informed Heart*, have now been depicted by Spiegelman with unmatched completeness and concision.

Maus is presently on two bestseller lists—first as fiction and second as nonfiction. That dual status says something about its importance but also about its misunderstood nature. Although a Mickey Mouse muse no doubt looked over the artist's shoulder while he wrote and drew this book—a recent lithograph by Spiegelman shows Disney's character behind a mouse-cartoonist pondering his rodent model—*Maus* is not an entertainment, nor is it a modern Aesop's fable or an *Animal Farm* allegory of totalitarianism. It is a work of history and of autobiography undertaken in a revisionist period when the very idea that any history, much less a narrative one, has broad public value or a legitimate claim to the truth is under constant assault on several fronts. **Despite its seemingly eccentric,** if not aberrant, match of form and content, *Maus* is a radically traditional work of art—traditional in its comprehensive understanding and innovative treatment of the medium's conventions, and traditional in its faith to art's capacity to accurately describe physical and psychological realities over time. Spiegelman's sober graphic manner—criticized by some as insufficiently developed or stylish and overlooked by others who "read" his pictures as if they were merely settings for the text—is a result of trial and error followed by a firm aesthetic decision. His other options are evident in his previous as well as contemporaneous work, and in the outside sources he called upon. Eschewing the psychedelic scratchboard buzz of "Prisoner on the Hell Planet," the problematic cuteness of his earliest versions of *Maus*, and the Fritz Eichenberg-inspired-chiaroscuro mannerism of other proto-*Maus* experiments, Spiegelman also forswore the expressionism found in the most sophisticated of the concentration

camp drawings, like those of Fritz Taussig (pen name: Fritta), who ran the inmate studios at the "model" village of Terezin and left behind fantastic and frightful representations of that fake utopia's brief existence. If any one example most guided Spiegelman it would seem to have been that of the modest and unskilled sketch artist Alfred Kantor, whose post-liberation journal is an appallingly explicit composite of collaged "souvenirs," maps, and captioned vignettes of daily life and death in Auschwitz. The lesson Kantor teaches and Spiegelman confirms with greater scope—and in the face of much wider choices—is that one does *not* stylize horror. Not so much out of respect for the dead, but to communicate to the fullest possible extent the unrelieved actuality of the crimes committed. A signal achievement of the documentary genre and a prototype of what one might call "comix verité" in honor of its equally prosaic cinematic equivalents, *Maus* underscores the easily forgotten aesthetic axiom that nothing is as difficult or artful as discretion, or as hard to imagine as facts.

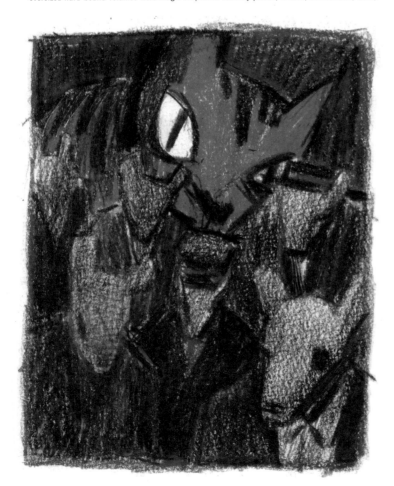

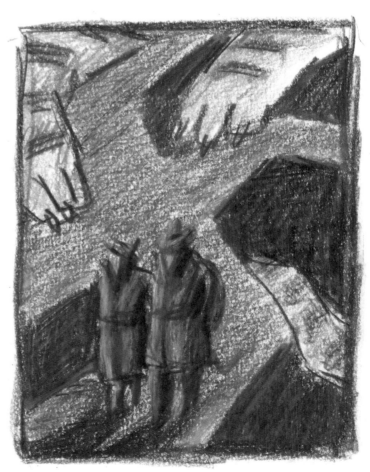

Of Maus and MoMA
A postscript by Robert Storr, 2012

I am dyslexic. As far back as I can remember I have had trouble reading and writing even though in adulthood I have, in the main, made my living doing both. Many people who find their way into the art world have the same problem with varying degrees of severity. Eventually most work their way out of the corner in which this disability places them—the dunce's corner—but some of the tools at their disposal compound their predicament in the minds of those for whom deciphering letters and ordering numbers poses no difficulty and even offers puzzle-solving pleasure. That, at any rate, was my case. The means I turned to as a way of opening up worlds beyond the small one where I was born was an immediate source of vexation for the people around me—relatives, teachers, "concerned" neighbors—who hoped against hope that I would become a good student, in other words, win spelling contests, effortlessly add, subtract, multiply, and divide, and transform myself into a well-behaved book worm. Instead I became a comic-bookworm.
With a twist; by special arrangement with a shop near my house that was run by two childless women gifted in dealing with the disaffected offspring of more traditional couples, my mother and father agreed to purchase books for me every time I read one from start to finish under the exceedingly patient guidance of the two bohemian merchants. The books among which I was given to choose from constituted the conventional children's literature of the day, but the books that really caught my eye were in the back to the store; imported English mystery stories with lurid covers and something otherwise unknown in Midwestern American towns in the late 1950s: Tintin.
With their clearly delineated, remarkably detailed contour drawings and rich, subtle color these oversized hard-bound volumes were magic carpets to faraway places; Russia, the Balkans, Tibet,

Africa, Arabia, desert islands, the Moon, and, last but not least, foreign Belgium. Of course, this was also the heyday of Slam-Bang-Boom-Zoom American-style adventure strips—Superman, Batman, and the rest—but my mentors didn't carry domestic pulps most likely believing that they would rot youthful minds. And they were right. While mine was already pretty well corrupted by the stash of garish comics I bought with my own money despite adult protests from all sides, I nevertheless gradually came around to the realization that I loved the quaintly dressed boy wonder Tintin more than the hypermasculine, body-stockinged Super Heroes because I could more easily imagine myself as him than them and because the balance of words and images suited my limited skills by affording me the opportunity to "read" the pictures and, by way of visual and logical inference, slowly "translate" them into the dense but legibly lettered text balloons.
Thus I escaped my semi-illiterate misery, traveling the world and conquering lexical monsters, until I was able to read books without drawings. In due course—I am speaking of the mid-1960s—countercultural "funnies" restored the word-image balance in my imagination adding outrageously explicit depictions of sex and drugs to my febrile fantasy life effectively chasing the Belgian Boy Scout away. Well not quite. Much as others my age hid their skin magazines and Head Comix from censorious older eyes, I hid my "innocent"—if you discount Hergé's overt racism—Tintins from my peers fearing that they would make fun of failure to outgrow such childish things. And so on a given afternoon or evening I might trek through exotic jungles or chase villains in foreign capitals with Tintin or dream of wild orgies involving tantalizingly foul acts and obscene language I'd never encountered before Crumb's alter egos introduced me to them. In the polymorphous perversity of adolescence and its aftermath, the obvious distinctions between the two cartoonists mattered less to me than their crisp

penmanship and prosaic draftsmanship and the marvels revealed by the combination of the two. Both Hergé and Crumb were insatiable describers and I, an insatiable scopophiliac bedeviled by the written word, could never get enough of what they had to show and tell me.

"Maturity" hasn't diminished my appetite for the comics though it has altered and expanded my taste for them. Moreover, an unexpected professional opportunity in midlife gave me the chance to act publicly on behalf of that passion. Thus, one of the first exhibitions I organized after being appointed curator of painting and sculpture at the Museum of Modern Art in New York was devoted to a single comic book. Previously, MoMA had never recognized the comics as a legitimate art form in its own right, although it had never occurred to me that the comics were anything less. Nor have I ever considered the comics an inherently debased commercial genre from which more exalted, "aesthetically disinterested" forms may freely borrow when its suits their convenience—usually meaning when they need a sudden jolt of vulgar graphic energy—despite the view of some observers, including many of the most ardent advocates of contemporary "comix," that such condescending attitudes were at the core of the inaugural exhibition mounted by Kirk Varnedoe (the man who hired me at MoMA) when he ascended to the position of chief curator of painting and sculpture in 1990.

Art Spiegelman's polemical assault on Varnedoe's *High & Low: Modern Art and Popular Culture* gave lead-pipe blunt force to that argument against MoMA's presumed aesthetic elitism although an overcautious curatorial populism better explains the brouhaha. (Varnedoe actually loved comics.) Indeed, at the time of the show's opening it was not at all hard to see why Spiegelman and his cartooning cohort were so upset with the treatment that they and their medium had received from the experts on 53rd Street—after all, as Spiegelman and other critics noted, none of the original comics quoted in the works of Roy Lichtenstein, Andy Warhol, Öyvind Fahlström, and other "high art" stars of the show were displayed on their own as objects of intrinsic merit—nevertheless the truth of the matter remained that by no means everybody at the museum looked down on Krazy Kat, Popeye, Mickey Mouse, and the rest of the cartoon pantheon.

In part prompted by a desire to correct the misperception that MoMA was universally hostile to the comics but more than anything to draw public attention to the recent completion of the second volume of his seminal work and to celebrate it as a paradigm-shifting breakthrough in the history of art generally—the first in depth treatment of the historical catastrophe of genocide in the "tragicomix" mode—I proposed to Art Spiegelman that we present a process-oriented grid of his working sketches, a selection of his sources ranging from the anti-Nazi satires of Arthur Syzk to German combat comics of the war era, and the totality of the finished original drawings for *Maus* parts I and II, drawings which in their detailed, soul-shattering plainness and vividness echoes in an entirely different context and for entirely different purposes the straightforward clarity of Hergé, Crumb, and other masters who eschewed decorative arabesques and show-stopping pyrotechnics for the sake of narrative complexity and thrust.

At the tortured heart of the small, but densely installed exhibition presented in Projects galleries just off the main lobby of MoMA from December 1991 into January 1992 was a fundamental artistic and museological paradox.

The works on the wall were not "The Work." No more certainly than the collages used to produce Max Ernst's surrealist masterwork *Une semaine de bonté,* were what one confronts on the image-conflating pages of the published fascicles. Rather Spiegelman's drawings were the unique handmade predicates for a mass-produced, inexpensively printed book that was "The Work." And which, by virtue of being a book, one would normally avoid reading while standing up in a public exhibition space but instead pore over while seated in the relative privacy of a library or subway car if not the greater privacy of one's home. For Spiegelman the drawings on view had no status as "art" in any traditional museum or gallery sense of the term. Regardless of how beautifully realized they are—and *Maus* is perhaps the most paradoxically beautiful response to the Holocaust since Paul Celan's "Todesfuge" *and Alain Resnais' harrowing Night and Fog*—these sheets are deprived of much if not most of their at once intimately and collectively painful meaning when lifted out of their narrative matrix and presented one by one as precious artifacts since the essence of "The Work" is fundamentally and dramatically sequential, and therefore rigorously formatted according to the requirements of the story and the ingenuity of the storyteller.

The art of comics consists not merely of combining words and pictures in a single frame or strip, but in how all the pieces come together. As a collaborative effort involving an artist and a curator, both of whom grew up on comics, *Making Maus* was a compromise on the way to defining a medium that museums now embrace though once shunned. For their part, practitioners of this quintessentially modern form of simultaneous textual and pictorial art were correspondingly wary of the museums' muscle bound institutional embrace. At stake was the potential blurring of distinctions between aesthetic specifics—in this case traditional painting and sculpture—and another thing—graphic storytelling, and a consequent misunderstanding and deformation of the medium cartoonists fiercely, protectively cherished. Aside from recognizing the comics for their intrinsic qualities, a major benefit of bringing them into museums was precisely their potential for breaking down the conventional distinctions between conceptual and perceptual practices—between the structure of thought and visual structure—that have bedeviled critical discourse in America since the middle of the twentieth century. For as the shifting layouts of any page of the comics make instantly clear—and as Spiegelman has spelled out in every way he could—from the styles of drawing and lettering, to the shape of a text balloon, to the shape and sequence of frames, to the overall matrix of words and images that compose that page as a whole, in comics form *is* content.

It was my hope in 1991 that, as the first MoMA exhibition of comics *as* art rather than as an inspiration for art, *Making Maus* might initiate a process of reevaluation that would eventually lead to MoMA's full recognition of this quintessentially modern medium. This would, I hoped, result in the creation of its own department much as was done for film, another genre whose identity is determined by the contradictions of its simultaneous existence as a means of artistic expression and of mass entertainment, its divided territory as a site of independent, artisanal invention and corporate, industrial production. Consistent with that goal I tried to interest colleagues in the Department of Drawings in the curatorial process that, largely driven by Spiegelman's fervor, finally led to the *Masters of American Comics* exhibition jointly mounted by the Museum of Contemporary Art and the Hammer Museum in Los Angeles in 2005—but to no avail. By 2005 I was out of MoMA and unable to pursue any further campaign for such recognition. But I persist in believing that there is a place for comics in any museum of modern or contemporary art, and the evidence that they have become among the most fertile fields for young artists continues to grow. Someday soon the citadels of culture will be forced to open their gates and let "the barbarians" in—only to discover how sophisticated they are. When that happens at MoMA, I will be proud to say that I was in the advance party that prepared the way. And I trust that, as leery as he was of crossing the threshold, Spiegelman will likewise be proud to have been the first of his guild to have done so.

Robert Storr is an artist, critic, and curator, who currently serves as the Dean of the Yale University School of Art. Formerly, he was the Senior Curator of Painting and Sculpture at the Museum of Modern Art, New York.

THIS PAGE AND FACING PAGE: Sketchbook studies for *Four Mice* lithograph portfolio, colored pencil, 1991.

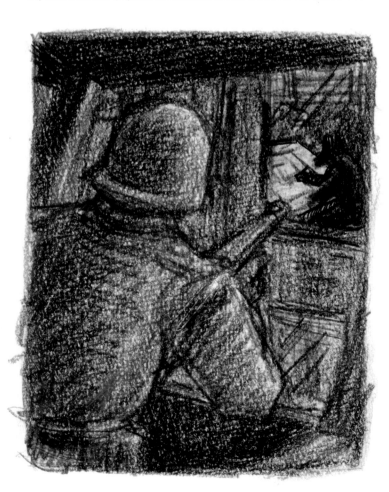

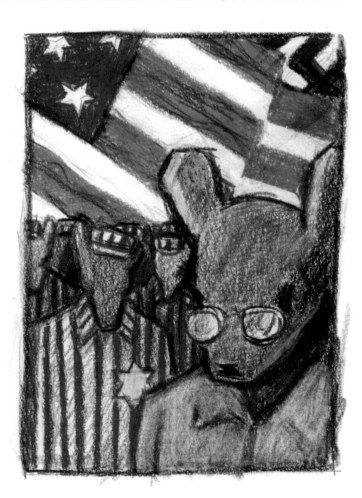

1963

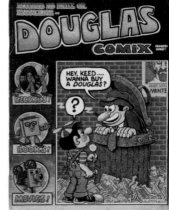
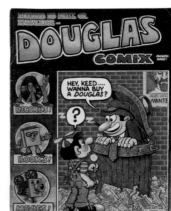

1965

1969

1972

1972

WHOLE GRAINS
A BOOK OF QUOTATIONS

1973

FATSO JOKES

1972

Mid 1970s
(Art for an endless gag strip, designed for the "wings" of Topps' short-lived *Super Blony* bubble gum wrappers.)

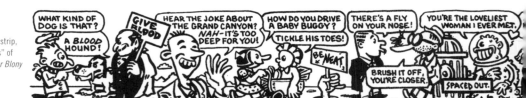

1948 Birth of Art Spiegelman on February 15 in Stockholm, Sweden, to Vladek and Anja Spiegelman, Polish Jews who survived the Nazi death camps.

1951 Family immigrates to the United States, settling first in Norristown, PA, then moving to New York City, settling in Rego Park, NY, in 1957.

1960–1961 Draws first comic strips.

1963–1965 Publishes and prints two issues of *Blasé*, his own satire zine, in an edition of fifty copies.
Attends High School of Art and Design, a trade high school in New York City with a cartooning major. Edits school paper, *Highlights*.

1964 Sells first drawings to the *Long Island Post*, a local weekly newspaper.

1965–1968 Attends Harpur College, State University of New York in Binghamton, studying art and philosophy. Staff cartoonist for college paper.

1966 Begins drawing unsigned one-page psychedelic comix leaflets.
Work begins to appear in underground magazines and newspapers like *The East Village Other* and *The Realist*.
Hired by Woody Gelman as a creative consultant for the Topps Chewing Gum company, an association which will last until 1989.

1967 Writes his first essay on comics aesthetics, "Bernard Krigstein's Master Race: The Graphic Story as an Art Form," for an art history class, later published in the school's literary magazine.

1968 Psychotic episode leads to one-month incarceration in Binghamton State Mental Hospital. Ends university studies.
His mother, Anja Spiegelman, commits suicide.

1969 Begins working as cartoonist and illustrator for men's magazines *Cavalier, Dude, Gent,* and *Nugget*.

1971 After several trips, settles in San Francisco, capital of US underground comix activity. Contributes to comix like *Young Lust, Real Pulp, Bijou Funnies,* and *Bizarre Sex.*

1972 Three-page strip, "Maus," Spiegelman's first comic on the subject of his parents' memories of the Nazi era, appears in *Funny Aminals* no. 1.

1973 Co-edits *Short Order Comix* no. 1 with Bill Griffith. It includes the autobiographical strip "Prisoner on the Hell Planet" (later incorporated into chapter 5 of *Maus I*).

1974–1975 Co-founds, with Bill Griffith, *Arcade*, a quarterly "comics revue."
Teaches at San Francisco Academy of Art.

1975 Moves back to New York City.
Begins contributing drawings to the *New York Times* op-ed pages, including the first comic strip-format work ever published on that page.

1977 Delivers *Language of the Comix*, a lecture series, at the Collective for Living Cinema in NYC that leads to decades of lecturing about the medium.
Belier Press publishes *Breakdowns: From Maus to Now*, a large-format anthology of his significant early strips.
Marries Françoise Mouly, a French architecture student visiting New York.

1978 Starts Raw Books & Graphics with Mouly. They publish an annual map of their SoHo neighborhood and paper ephemera by cartoonist friends.
Begins work on book-length version of *Maus*.
Contributes strips to *Playboy* (an association that lasts through 1983).
Designs cover for German edition of Boris Vian's *I Spit on Your Graves*, the first of eleven Vian covers published between 1978 and 1989.

1979–1987 Teaches comix history and studio classes at New York's School of Visual Arts.

1980 Spiegelman and Mouly found *RAW*, the magazine of avant-garde comix. A boldly designed oversize publication, it soon establishes itself as the leading international comix periodical, featuring artists such as Mark Beyer, Gary Panter, Charles Burns, Joost Swarte, Mariscal, and Jacques Tardi. They self-publish eight issues of the magazine between 1980 and 1986.

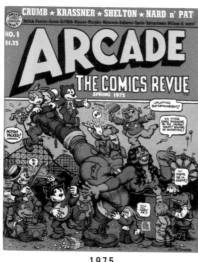

1975

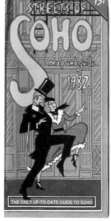

1979

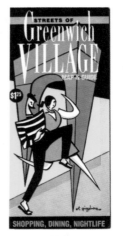

1982

1993

1988

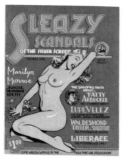

1974

1979

1980

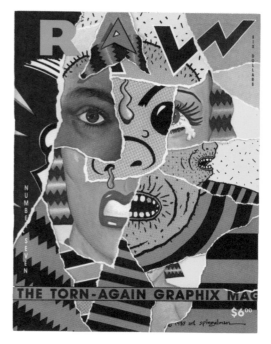

1985

First chapter of *Maus: A Survivor's Tale* is serialized in *RAW* no. 2 as a small booklet inserted in the magazine. Subsequent chapters appear in the following issues as a work-in-progress.

1982 Receives the Yellow Kid Award from the International Comics Festival in Lucca, Italy, for work on *Maus*; *Playboy* Editorial Award for best comic strip, and *Print* magazine's Regional Design Award for *RAW*. His father, Vladek Spiegelman, dies.

1983 Included in and acts as adviser for the *Comic Art* show at the Whitney Museum of American Art in New York. *RAW NY* show at Tokyo's Seibu Gallery.

1986 Pantheon publishes the first six chapters of *Maus* as a book. The book is translated into twenty-seven languages. Receives National Book Critics Circle nomination and the Joel M. Cavior Award for Jewish Writing.

1987 Travels to Poland with German film crew who make a ZDF television documentary about his researching *Maus II*. First child, Nadja, is born.

1988 *Maus I* wins the award for Best Foreign Album at the Angoulême International Comics Festival. The second volume will receive the same award in 1993. *Art Spiegelman: Of Cats and Mice*, a forty-five minute documentary film by Georg Stefan Troller is aired on ZDF television in Germany and subsequently aired by ARTE in France on their first night of broadcasting.

1989 *RAW* shifts to digest-size format published by Penguin. Three issues appear between 1989 and 1991.

1990 Receives Guggenheim Fellowship for continuing work on *Maus*. German version of *Maus* is awarded a Sonderpreis (special prize) at the Erlangen International Comic Salon.

1991 *Maus II* serialized on weekly basis in the English-language *Forward*.

Pantheon publishes *Maus II*. The Museum of Modern Art in New York exhibits *Making Maus*. Curated by Robert Storr, it presents the final drawings and preparatory studies for the two volumes of *Maus*. *Maus* appears in the *New York Times* hardcover fiction bestseller list and after a letter from the author is moved to the non-fiction list. Second child, Dashiell, is born.

1992 Receives special Pulitzer Prize for the two *Maus* books, as well as the LA Times Book Prize for fiction and National Book Critics Circle nomination for best biography. Becomes contributing editor/staff artist for the *New Yorker* where his strip "A Jew in Rostock," reporting on neo-Nazi attacks in East Germany, appears.

1993 Valentine's Day *New Yorker* cover, a Hasidic man and a Black woman embracing, becomes a succès de scandale. The magazine publishes another thirty-six covers by the artist between 1993 and 2002.

1994 *The Complete Maus* CD-ROM, focused on the making of *Maus*, is released. Designer and editorial advisor for Avon Books' comix adaptation of Paul Auster's *City of Glass*.

1995 Illustrates and designs *The Wild Party*, Joseph Moncure Marsh's long-forgotten 1928 narrative poem. Co-edits, with R. Sikoryak, *The Narrative Corpse*, a "chain comic" by sixty-nine artists. Awarded an honorary doctorate of letters by his alma mater, the State University of New York at Binghamton. *Maus* included in New York Public Library's centennial exhibition, *Books of the Century*.

1996 On the tenth anniversary of the book publication of *Maus I*, Pantheon issues *The Complete Maus* as one volume. Receives Cultural Achievement Award from National Foundation for Jewish Culture.

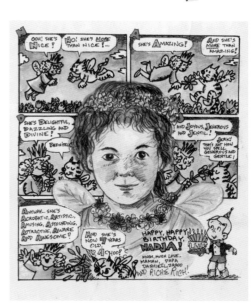

1994

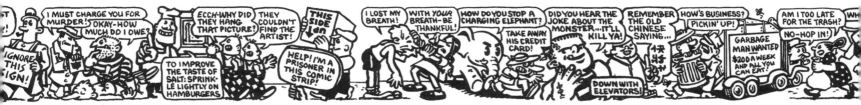

1994

1994

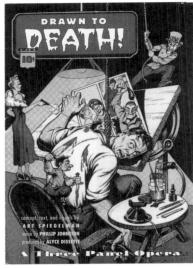

2000

1998

2001

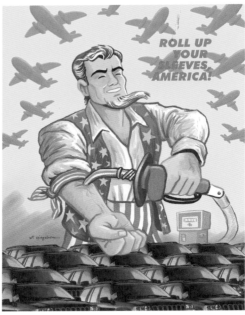

2002

2002

2006

1997 Children's book, *Open Me…I'm a Dog!* appears on *Publishers Weekly* picture books bestsellers list. Receives the 2008 Firecracker Alternative Book Award in 1998 for best kids book.
Delivers *Comix 101* slide lecture in his studio to a selected group of about forty important US museum curators and collectors to advocate in favor of comics art receiving museum recognition, which eventually bears fruit in the 2005–2006 exhibition *Masters of American Comics*, jointly presented in the Museum of Contemporary Art and the Hammer Museum in Los Angeles.
Commissioned as comix editor for *Details* magazine, sending cartoonists on assignment as visual reporters.

1998 *Art Spiegelman: Comix, Essays, Graphics and Scraps*, is exhibited at Museu de Arte Contemporânea de Niterói in Rio de Janeiro. The show then travels to the Kulturgeschichtliches Museum in Osnabrück, Germany.

1999 Inducted into the Will Eisner Comics Industry Hall of Fame, San Diego, CA.

2000 *Drawn to Death: A Three Panel Opera* workshopped at St. Ann's Warehouse in Brooklyn, New York.
Co-edits, with Françoise Mouly, *Little Lit: Folklore and Fairy Tale Funnies*.

2001 Co-edits, with Françoise Mouly, *Little Lit: Strange Stories for Strange Kids*.
Drawn to Death: A Three Panel Opera workshopped at Dartmouth College in Hanover, NH.
Co-authors with designer Chip Kidd *Jack Cole and Plastic Man: Forms Stretched to Their Limits*, an expansion of an earlier essay in the *New Yorker*.
A few days after September 11, in collaboration with Françoise Mouly, he conceives of a "black on black" cover for the *New Yorker*, which she executes—it will be included in the American Society of Magazine Editors list of the top ten magazine covers of the past forty years.

2002 Begins drawing a series of full-color, broadsheet-sized comics pages called *In the Shadow of No Towers*, commissioned by *Die Zeit* in Germany.
After being rejected by several American periodicals with which Spiegelman had enjoyed an association, the series begins running in the United States in the *Forward*. The approximately monthly series also runs in the *London Review of Books* (United Kingdom), *Courrier International* (France), *La Repubblica* (Italy), and *De Standaard* (Belgium).
In conjunction with an exhibit in Milan's Nuage gallery, a collection of his *New Yorker* material appears in Italy, with an introduction by Paul Auster, under the title *Baci da New York*. It is later published in France by Flammarion and in Germany by Zweitausendeins.

2003 Co-edits, with Françoise Mouly, *Little Lit: It Was a Dark and Silly Night*.

2004 Publishes *In the Shadow of No Towers* as a book collection.
Subject of a half-hour documentary for ARTE television, *Art Spiegelman: Der Spiegel der Geschichte*.
Called a "Michelangelo and a Medici" of comics in "Not Funnies," a *New York Times Magazine* cover feature about contemporary comics by Charles McGrath.

2005 Named Chevalier des Arts et des Lettres by the French government.
Named one of *Time* magazine's 100 Most Influential People.
Is one of fifteen artists included in the *Masters of American Comics* exhibition, which originates as a split show at the Hammer Museum and the Los Angeles Museum of Contemporary Art. It then travels to the Milwaukee Art Museum and, without Spiegelman's work, to The Jewish Museum in New York.

2007

2007

2009

2009

2009

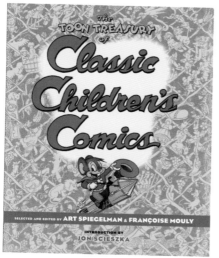

2009

2009

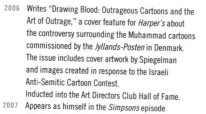

2010

2011

2006 Writes "Drawing Blood: Outrageous Cartoons and the Art of Outrage," a cover feature for *Harper's* about the controversy surrounding the Muhammad cartoons commissioned by the *Jyllands-Posten* in Denmark. The issue includes cover artwork by Spiegelman and images created in response to the Israeli Anti-Semitic Cartoon Contest.
Inducted into the Art Directors Club Hall of Fame.

2007 Appears as himself in the *Simpsons* episode "Husbands and Knives."
Art Spiegelman: Conversations, a collection of interviews edited by Joseph Witek, is published.
Invited to be a Heyman Fellow of the Humanities at Columbia University, where he teaches "Comics Marching into the Canon," a special semester-long seminar held at his studio.

2008 Publishes a new edition of *Breakdowns: Portrait of the Artist as a Young %@?*!* with a lengthy comics introduction revisiting the personal events and aesthetic concerns behind his early work.
Serves as editorial advisor to Françoise Mouly's Toon Books imprint of comics for early readers, where he publishes *Jack and the Box*.

2009 Co-edits *The Toon Treasury of Classic Children's Comics* with Françoise Mouly.
Be A Nose, a set of three facsimile sketchbooks, published by McSweeney's.
Solo exhibition, Galerie Martel, Paris.
Publishers Book West Design Award, 2008.
Winner of the Grand Prix Soleil d'Or, Festival BD de Sollies-Ville.

2010 Collaborates with avant-garde dance troupe Pilobolus to produce "Hapless Hooligan in Still Moving," a comics-dance performance piece that debuted at the Joyce Theater and remains part of the Pilobolus repertoire.

Edits and provides introductory essay for *Lynd Ward: Six Novels in Woodcuts*, a two-volume boxed set.
Art Spiegelman: Traits de mémoire, a 45-minute documentary film by Clara Kuperberg and Joelle Oosterlinck made for ARTE in France.
Receives honorary doctor of fine arts degree from Rhode Island School of Design.

2011 Wins the Grand Prix at the Angoulême International Comics Festival.
Pantheon publishes *MetaMaus*, a book and DVD set featuring extensive commentary about the making of *Maus* to mark the twenty-fifth anniversary of the first volume of *Maus*, alongside a new edition of *The Complete Maus*. *MetaMaus* receives a National Jewish Book Award in the United States, as best biography, autobiography, and memoir.

2012 Produces a stained-glass window public art project for the High School of Art and Design, his alma mater. The project is inaugurated in September 2012 in the school's new facilities.
Prepares retrospective exhibit *Art Spiegelman: Co-Mix*, which opens in Angoulême in January 2012 and travels later that year to the Centre Pompidou in Paris and the Museum Ludwig in Cologne. Spiegelman also curates the simultaneous exhibition, *Art Spiegelman: Le musée privé*, covering comics history from the nineteenth century to the present, for the Cité Internationale de la Bande Dessinée et de l'Image in Angoulême.
Receives Germany's Siegfried Unseld prize for lifetime achievement.

2013 Retrospective exhibit *Art Spiegelman: Co-Mix* travels to the Vancouver Art Gallery in February and the Jewish Museum of New York in November.
Looks forward to settling his estate and becoming an underground cartoonist again.

2012

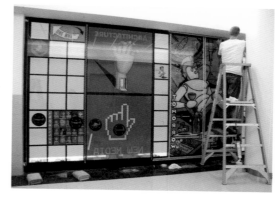

2012

Art and Françoise, unknown photographer, circa 1978.

136

Art and Françoise, photo by Nancy Crampton, 2000.

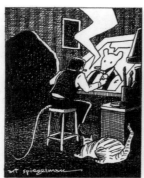

Bio page for *The National Cartonists Society Album*, 1996
(with 1992 *New Yorker* self-portrait).

SELECTED WORKS

Whole Grains: A Book of Quotations. Co-edited by Bob Schneider.
New York: Douglas Links, 1973.

Breakdowns, From Maus to Now: An Anthology of Strips.
New York: Belier Press, 1977.

Maus I: My Father Bleeds History. New York: Pantheon, 1986.

Maus II: And Here My Troubles Began. New York: Pantheon, 1991.

The Complete Maus. CD-ROM. New York: Voyager, 1994.

Joseph Moncure March, *The Wild Party*. Illustrations, design,
and introduction by Art Spiegelman. New York: Pantheon, 1994.

The Complete Maus. New York: Pantheon, 1997.

Open Me ... I'm a Dog! New York: HarperCollins, 1997.

Jack Cole and Plastic Man: Forms Stretched to Their Limits.
With Chip Kidd. San Francisco: Chronicle Books, 2001.

In the Shadow of No Towers. New York: Pantheon, 2004.

Breakdowns: Portrait of the Artist as a Young %@?!*.
New York: Pantheon, 2008.

Jack and the Box. New York: Toon Books, 2008.

Be a Nose! San Francisco: McSweeney's, 2009.

MetaMaus: A Look Inside a Modern Classic.
New York: Pantheon, 2011.

SELECTED ESSAYS/WRITTEN WORKS

Master Race: The Graphic Story As An Art Form. Essay in The
Harpur Review, 1968. Expanded version, revised with John Benson
and David Kasakove, published in *Squa Tront* no. 6, 1975.

The Art That Doesn't Know Its Name, *Soho Review of Books*,
December 25, 1978. Review of *Smithsonian Collection
of Newspaper Comics*.

Comix: An Idiosyncratic Historical and Aesthetic Overview.
Print magazine Nov-Dec 1988.

The Organization Man in The Gray Flannel Jungle.
Introduction to *Harvey Kurtzman's Jungle Book*, 1986.

Winsor McCay: Beautiful Dreamer. *USA Today*, June 23, 1987.
Review of *Winsor McCay: His Life and Art*.

My Strange Adventure With Harvey Kurtzman.
Introduction to *Harvey Kurtzman's Strange Adventures*, 1990.

Polyphonic Polly: Hot and Sweet. Foreword in *Polly and Her Pals*, 1990.

Art Every Sunday, The *New York Times Book Review*, October 2, 1994.
Review of *The Comic Strip Art of Lionel Feininger*.

Comics After The Bomb. Introduction to Kejji Nakazawa's
Barefoot Gen: A Cartoon Story of Hiroshima, 1995.

Symptoms of Disorder/Signs of Genius. Foreword in Justin Green's
Binky Brown Sampler, 1995.

Addams Artistic Values. The *New York Times*, September 29, 1996.
Review of The New York Public Library's Charles Addams Gallery.

A Real Eye-Opener. Foreword in *The Unexpurgated Carl Barks*, 1997.

Grosz Anatomy. The *New Yorker*, August 25, 1997.
Review of exhibition catalog, *The Berlin of George Grosz*.

Dirty Little Comics. Introduction to *Tijuana Bibles:
Art and Wit in America's Forbidden Funnies, 1930s–1950s*, 1997.

Horton Hears A Heil. The *New Yorker*, July 12, 1999.
Essay on Theodor Geisel's WW2 political cartoons.

Emergency Session of The United Cartoon Workers of America.
The *New Yorker*, January 22, 2001.

Ballbuster: Bernard Krigstein's life between the panels.
The *New Yorker*, July 22, 2002. Review of *B. Krigstein;
Volume One (1919-1955)*, 2002.

Drawing Blood: Outrageous cartoons and the art of outrage.
Harper's, June 2006.

EDITOR/CO-EDITOR/CONTRIBUTOR

Douglas Comix, 1972.

Short Order Comix 1 (1973). Co-edited by Bill Griffith.

Short Order Comix 2 (1974). Co-edited by Bill Griffith.

Sleazy Scandals of the Silver Screen.
San Francisco: Cartoonists Co-op Press, 1974.

The Apex Treasury of Underground Comics.
New York: Links Books, 1974.

Arcade, The Comics Revue 1 (spring 1975)–7 (fall 1976).
Co-edited by Bill Griffith.

RAW. All co-edited by Françoise Mouly:

RAW 1, The Graphix Magazine of Postponed Suicides. 1980.

RAW 2, The Graphix Magazine for Damned Intellectuals. 1980.

RAW 3, The Graphix Magazine that Lost Faith in Nihilism. 1981.

RAW 4, The Graphix Magazine for Your Bomb Shelter's Coffee Table. 1982.

RAW 5, The Graphix Magazine of Abstract Depressionism. 1983.

*RAW 6, The Graphix Magazine that Overestimates the Taste
of the American Public*. 1984.

RAW 7, TheTorn-Again Graphix Mag. 1985.

RAW 8, Graphic Aspirin for War Fever. 1986.

*Read Yourself RAW, The Graphix Anthology for Damned
Intellectuals*. New York: Pantheon, 1987.

RAW (vol. II, no. 1), *Open Wounds from the Cutting Edge of Comics*.
New York: Penguin, 1989.

RAW (vol. II, no. 2), *Required Reading for the Post-Literate*.
New York: Penguin, 1990.

RAW (vol. II, no. 3), *High Culture for Lowbrows*.
New York: Penguin, 1991.

The Narrative Corpse. Co-edited by R. Sikoryak.
New York: Gates of Heck/Raw Books, 1995.

Little Lit: Folklore and Fairy Tale Funnies. Co-edited
by Françoise Mouly. New York: Joanna Cotler Books, 2000.

Little Lit: Strange Stories for Strange Kids.
Co-edited by Françoise Mouly. New York: Joanna Cotler Books, 2001.

Little Lit: It Was a Dark and Silly Night. Co-edited
by Françoise Mouly. New York: Joanna Cotler Books, 2003.

Big Fat Little Lit. Co-edited by Françoise Mouly.
New York: Puffin, 2006.

Wacky Packages. New York: Abrams, 2008.

The Toon Treasury of Classic Children's Comics.
Co-edited by Françoise Mouly. New York: Abrams, 2009.

Lynd Ward: Six Novels in Woodcuts. New York:
Library of America, 2010.

SELECTED EXHIBITIONS

- Art Spiegelman, Museum of Cartoon Art,
 Port Chester, New York, 1986.

- Art Spiegelman, Smith Gallery, London, 1987.

- Maus, Martyrs Memorial Museum of the Holocaust,
 Los Angeles, 1988.

- Making Maus, Museum of Modern Art, New York, 1991.

- The Road to Maus, Galerie St. Etienne, New York, 1992.

- Galerie St. Etienne, traveling exhibition:
 Fort Lauderdale Museum of Art, 1992.
 The Jewish Museum of San Francisco, 1993.
 Joods Historisch Museum, Amsterdam, 1994.
 University of Missouri, St. Louis, 1994.
 Le Musée d'Art et d'Histoire du Judaïsme, Paris, 1995.
 Kunstraum Düsseldorf, 1995.
 St. Lawrence University, Canton, NY, 1995.
 National Museum of American Jewish History,
 Philadelphia, 1996.

- La Scrittura di Maus, La Centrale dell'Arte, Rome,
 traveling exhibition, 1994–97.

- Art Spiegelman: Comix, Essays, Graphics and Scraps:
 Museu de Arte Contemporânea de Niterói, Rio de Janeiro, 1998.
 Kulturgeschichtliches Museum, Osnabrück, 1998.

- Art Spiegelman: Portrait of the Artist as a Young %@&*!,
 Museum of Contemporary Art Detroit, 2009.

- Art Spiegelman, From Raw Books to Toon Books,
 Galerie Martel, 2009.

- Art Spiegelman: Co-Mix, organized by the Festival International
 de la Bande Dessinée d'Angoulême:
 Musée de la bande dessinée, Angoulême, 2012.
 Centre Pompidou, Paris, 2012.
 Museum Ludwig, Cologne, 2012.
 Vancouver Art Gallery, 2013.
 Jewish Museum of New York, 2013.

136

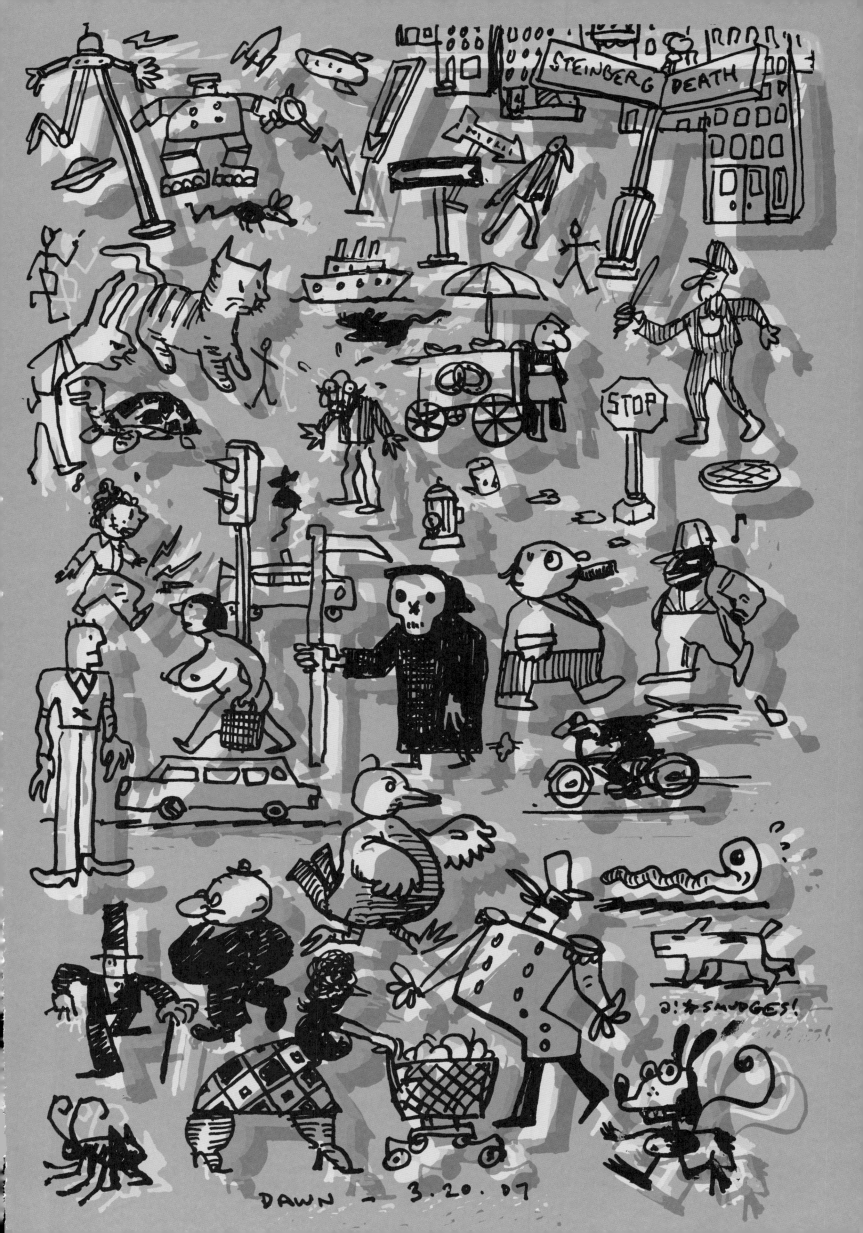

STEINBERG DEATH

STOP

∂!⨁SMUDGES!

DAWN — 3.20.07